THE
NATIONAL GALLERY
LONDON

KU-256-225

THE
NATIONAL
GALLERY
LONDON

PHILIP HENDY
FORMER DIRECTOR OF THE
NATIONAL GALLERY

LONDON
THAMES AND HUDSON

*Any copy of this book issued by the publisher
as a paperback is sold subject to the condition
that it shall not, by way of trade or otherwise,
be lent, re-sold, hired out, or otherwise
circulated without the publisher's prior consent,
in any form of binding or cover other than that in
which it is published and without a similar
condition including this condition being imposed
on a subsequent purchaser.*

*First published in Great Britain in 1960
Fourth edition (revised) 1971*

*All rights reserved. No part of this publication
may be reproduced or transmitted in any form or
by any means, electronic or mechanical, including
photocopy, recording or any information storage and
retrieval system, without permission in writing
from the publisher.*

© *1960 Thames and Hudson Ltd, London*

Printed in Great Britain by Jarrold and Sons Ltd, Norwich

*ISBN D 500 18006 7 clothbound
ISBN O 500 20002 5 paperbound*

CONTENTS

THE CONCEPTION
Page 7

THE FOUNDATION
Page 15

THE YEARS IN PALL MALL
Page 22

EARLY YEARS IN TRAFALGAR SQUARE
Page 26

CHANGES IN THE KEEPERSHIP
Page 31

THE SELECT COMMITTEE OF 1853
Page 38

CHARLES EASTLAKE
Page 41

WILLIAM BOXALL
Page 50

FREDERICK BURTON
Page 56

THE TWENTIETH CENTURY
Page 62

THE TATE GALLERY
Page 68

THE POST-WAR YEARS
Page 71

THE PLATES
Page 79

THE PICTURES IN MONOCHROME
Page 273

LIST OF ILLUSTRATIONS
Page 305

PLAN OF THE GALLERY
Page 319

THE CONCEPTION

If you stand today in Trafalgar Square with your back to Nelson's Column and Whitehall, you will see the building which composes the north side of the Square looking very much as it did when the public entered it first on 9 April 1838. It was then a brand-new building recently visited by a new young Queen. Standing on the site of the old King's Mews, it was the second side to be built of a new square, christened seven years before, which had come at the tail-end of the great plan made during the Regency for giving new order and classical shape to the centre of London. John Nash, who had planned the Square, as he had planned Regent Street and Regent's Park, as well as a new thoroughfare to link Whitehall with Bloomsbury and the Gallery to be built with the British Museum, opened in 1759, had submitted a design for this new building. But the street was never made and Nash was defeated in a limited competition by William Wilkins, the architect already of Downing College, Cambridge, and of University College, London. Wilkins was criticized then, as he is now, for his lack of virile accent or cohesion; but to give distinction to yet another of his wide horizontal façades he luckily had the assistance of a more accomplished architect who had been thirty years dead. He was able to graft onto his placid and not ungraceful elevation some of the elegant Corinthian columns from Carlton House, the short-lived palace that Henry Holland had designed for the Prince Regent. As soon as the Regent had become King George IV, Carlton House had been demolished, to make room for the terrace of great houses which now bears its name.

Since 1838 this composite façade has gained some of the dramatic accent Wilkins could not give it from the battle between wind and smoke which is always waged over the white Portland stone. While the south front remains neutral, the prevailing wet west wind is always washing its western facets whiter, while the chimneys of London are encrusting the protected eastern facets with jet. This patinated classical front, the conventional grandeur of the rooms behind it and the decorous routine which now guards their contents, combine to give the impression of a National Gallery which has been there from the beginning unchanged. The impression is misleading. The National Gallery as we know it is both a little older and very much newer than the familiar façade, which is the only thing that has remained unchanged since 1838.

Behind it, to begin with, the building was only one room, or fifty feet, deep. This train-like plan was less unsuitable, however, than it might seem. The building was designed to house two institutions, and did house them, end to end, for thirty years. They were the Royal Academy, founded in 1768, which was transferred westward from Somerset House in the Strand, and the National Gallery, founded in 1824, which was transported eastward from 105 Pall Mall. Each occupied the half of the building near to its original home.

Though this cohabitation was uncomfortable from the first, it followed a pattern of evolution familiar both in the Old World and in the New. It is the artists, whose need of study is most imperative, who make the first articulate demands for old pictures. The French Royal Academy had exhibited intermittently since the seventeenth century in the Louvre, where many pictures of

the royal collection were hung; and, when the French Republic had made of these a national museum, the painter David had been appointed head both of the commission which administered it and of the school which occupied other rooms in the Palace. There were older precedents in Italy, and in those days the Pope maintained on the Campidoglio in Rome both a collection of pictures and a school for artists.

In England the public for a national gallery had to be created, or, if it existed, had yet to find the means of expression. The landowners who made up Parliament had their own great collections of pictures in their country houses; they were not interested for the most part in a public collection in London. One of the first of these great country-house collections was made at Houghton by the first Prime Minister, Sir Robert Walpole. When his grandson was about to sell it in 1777, the radical John Wilkes, then Member of Parliament for Middlesex, suggested in the House of Commons its purchase for the nation and the building of a gallery in the garden of the British Museum, which had been opened in Montague House on its present site. But Parliament was far from ready; the pictures went to Catherine of Russia and are now in the Hermitage Gallery. It was in and about the Royal Academy, which is not only an exhibiting society but a school, that the idea of a public gallery found a succession of articulate supporters.

Sir Joshua Reynolds, its first President, had some such idea, and is said at one time to have offered to lend his own collection if the Academy would take over the building then about to be vacated by the older Society of Artists. The building became instead the Lyceum Theatre, now a dance hall. As soon as

9

Reynolds was dead, the idea was taken up with greater enthusi-
asm by the new Professor of Painting, James Barry. It was he
perhaps who was the first to use the words National Gallery. He
suggested the purchase first of Reynolds' little collection, then of
Italian pictures from the great Orléans collection, recently
brought from Paris and partly for sale. Next he wanted a picture
gallery built in the court of Somerset House, and money set
aside regularly for buying pictures from the Academy's surplus
funds. Unfortunately Barry was always as tactless as he was
fervent. When caution triumphed and his fellow Academicians
insisted that the profits be devoted not to buying pictures for the
young painters but to providing pensions for the old, he became
so offensive that he was expelled.

Other Academicians, John Opie, for instance, took up the
idea; but it assumed many different forms. When it came to
practical proposals, the painters' attitude to the 'old masters' was
always a divided one; they were torn between the desire for in-
spiration and the fear of competition. It was left to others in a
more detached position to evolve a practicable scheme.

It was in the attempt to reconcile the conflicting interests that
the British Institution for the promotion of the Fine Arts in the
United Kingdom was founded in 1805. The scheme was taken
to King George III by Benjamin West, the second President of
the Royal Academy; but the man who had done most to pre-
pare the scheme was Sir Thomas Bernard. Six years before,
Bernard had been almost equally energetic as a founder of the
Royal Institution, which flourishes still. He was Treasurer of
the Foundling Hospital, which had a small collection of pic-
tures given by the artists to form a public gallery. He would have

liked the British Institution to be a public gallery on a national scale, its pictures not given by the artists but bought from them by the wealthy subscribers. There were to be pictures by the 'old masters' as well, for the modern painters to copy. This necessity to copy plays a large part in the history of the national collections.

Some of the events which led up to the foundation of the Institution are described in the invaluable *Diary* of Joseph Farington, R.A., of which a large part was published in eight volumes in 1922–25. Thus in his diary for 23 April 1805: 'West came [to the Academy] in the evening. On our way home He desired me to be at His house tomorrow evening at 8 to hear a Plan read which had been drawn up By Mr. Bernard for the establishing a National Gallery of painting & for encouraging Historical Painting. – West had invited Sir George Beaumont [of whom more below], Wm. Smith [politician, friend of Opie] and Payne Knight [owner of a magnificent collection of coins and bronzes which he was to bequeath to the British Museum] to meet him, and meant to ask Lawrence [R. A., the leading portrait painter] and Smirke [R. A., father of the architect of the British Museum and Reading Room].' The subscribers came forward handsomely, the 'Shakespeare Gallery' built by Alderman Boydell in Pall Mall was acquired, rechristened, and opened the following year. But Farington records (6 June 1806) the wish of Lord Dartmouth, another of the founders, who had helped to get approval of the Institution from the King, to add to it larger premises 'where something like a National Gallery might be begun.'

The premises at 52 Pall Mall were possibly as suitable as those to be occupied later by the infant National Gallery, when it did

come into existence; but for one reason or another they never housed a permanent collection. The works of art which were bought by the Governors were presented to churches and other public institutions, including the National Gallery. They were mostly pictures bought at handsome prices from living British artists. Exhibitions of the work of these were held, competitions were promoted and prizes given; but what is most appropriate to this narrative is the long series of exhibitions of old pictures which continued to be held almost until, in 1869, the Royal Academy moved into the reconstructed Burlington House, and thus acquired larger and better-lit premises for this purpose.

Those who had wanted to make a national gallery of the British Institution had found their efforts once more frustrated by the artists. No doubt there were many who shared the sentiments of Smirke, as quoted by Farington (15 August 1815): 'The bringing forward the works of the great artists of former periods is calculated to induce those who have money to lay out to purchase such works from seeing the unlimited admiration of them – instead of encouraging the British Artists of this period although this was the professed design of the Institution at its commencement.' Perhaps there were others who shared with a younger and very much greater painter, John Constable, the nobler fear that he expressed in an often quoted letter of 6 December 1822: 'Should there be a National Gallery (which is talked of), there will be an end of the art in poor old England, and she will become, in all that relates to painting, as much a nonentity as every other country that has one. The reason is plain; the manufacturers of pictures are then made the criterion of perfection, instead of nature.'

Constable's opinion of the effect of other national galleries was formed on scant evidence, for he is not known to have visited the Continent. But it draws our attention to what had been happening there. In this half-century and more in which England had been labouring with the idea without achieving a birth, most of the great national galleries of the Continent had opened their doors; in Vienna in 1781, in Paris in 1793, in Amsterdam in 1808, in Madrid in 1809, in Berlin in 1823. The idea was by no means a new one, for in 1737 the last representative of the house of Medici had presented the great collections in the Uffizi at Florence to the State of Tuscany. The galleries already mentioned were all formed in this way either by the magnanimous gesture of the reigning house or by confiscation, in the case of the Louvre. As early in the Revolution as 1791 the Louvre Palace had been consecrated to the arts and sciences, and it soon housed the French royal art treasures.

In England, nearly a century and a half before, the Puritan regicide Parliament had committed the enormity of dispersing abroad almost the whole of the collection of King Charles I. This had been the greatest collection of pictures in the world. Much of it is now in the Louvre, the Prado and the Kunsthistorisches Museum; but two great series of paintings were retained and later restored to the Crown: Mantegna's *Triumphs of Caesar* from Mantua, now exhibited at Hampton Court, and Raphael's 'cartoons' for tapestries in the Vatican which have been lent by the Crown for many years to the Victoria and Albert Museum.

Next to Charles I as patron of the arts in the history of the English monarchy comes the Prince Regent. Patron of

Lawrence and Wilkie, he was an avid and discerning collector of Dutch pictures, mostly now at Buckingham Palace. Replanning London on a regal scale to rival Napoleon's Paris, he saw it also as a centre of the arts. There was a plan for attaching to Carlton House a huge gallery of casts for the benefit of student artists and there was vaguer talk of adding either a new Royal Academy or a National Gallery – the terms were often confused and still are; but the funds were wanting. The Prince Regent became President of the British Institution; and, after his accession as George IV, he was quoted in Parliament as the first to have suggested the step which led to the creation of the National Gallery.

This had to be brought into existence by means that were new. A collection had to be found or made, and paid for, a gallery had to be bought or built. And these things seemed after all to be outside the scope of the British Institution.

THE FOUNDATION

Early in 1823 one of its Governors, Sir George Beaumont, formally made an offer, of which there had been talk for some time, to give his collection to the nation as soon as a gallery was built. Beaumont was the owner of one of the greatest landscape paintings in the world, Rubens' *Le Château de Steen* (page 197). He was also the owner of one of the most sparkling and dramatic topographical paintings, Canaletto's *The Stonemason's Yard* (page 185); he may even have been the author of the sky which covered a large part of Canaletto's for many years, until this picture was cleaned in 1955. He was himself a painter, and very confident of the correctness of his taste. Constable's biographer C. R. Leslie remarks: 'It is curious that, throughout the whole of his intercourse with Constable, Sir George assumed the character of a teacher.' Of the four Claudes in which he so much delighted, *Hagar and the Angel* seems to have compressed into its small dimensions all the mingled grandeur and pathos that Claude knew how to obtain by half dissolving trees and water, sky and mountains in the blue morning light. No wonder that, after giving the little picture to the nation three years later, Beaumont begged to have it back until he died. But another, *The Death of Procris*, might well not even be 'ascribed to Claude' in the catalogue of the French School if there were not a drawing of the same composition in his *Liber Veritatis*; and there is dispute over the attribution to Nicolas Poussin himself of the *Landscape: A Man washing his feet at a Fountain*. Of the two Rembrandts, the little *Deposition* in monochrome is perhaps more certain of an undisputed permanent place in Rembrandt's

œuvre than the powerful *Jew Merchant*, though the writer does not share the doubts which have been expressed. But a look into the mouth of this gift-horse from the perspective of more than a century should not detract from our feeling of gratitude to this most disinterested of men. To the owner there is all the difference in the world between a gift and a bequest, and such a lover of pictures as Beaumont could hardly have offered a more touching sacrifice. Two years after the foundation of the Gallery, though the condition attached to his promise had not been fulfilled, his gift was made. Meanwhile, a few months after the promise was given, the House of Commons was reminded of it by the future Lord Dover, when he urged that steps should be taken to prevent the famous Angerstein collection from leaving the country.

The collection of John Julius Angerstein, who died in 1823, was much more important than Beaumont's. It contained two remarkable Italian pictures of the sixteenth century: Titian's *Venus and Adonis* (page 286), a version from the Colonna Palace in Rome of the more famous picture in the Prado Museum, painted for King Philip II of Spain, and *The Raising of Lazarus* by Sebastiano del Piombo, which Angerstein had bought in London at the sale of the Orléans collection. Sebastiano's enormous picture, No. 1 in the National Gallery, had been acquired by the Regent Duke of Orléans from Narbonne Cathedral, for which it had been commissioned by Cardinal Giulio de' Medici. But it had a famous day in Rome when it was exhibited, six days after Raphael's death, with Raphael's *Transfiguration*, also commissioned by the Cardinal. Michelangelo seems to have assisted Sebastiano in the competition by

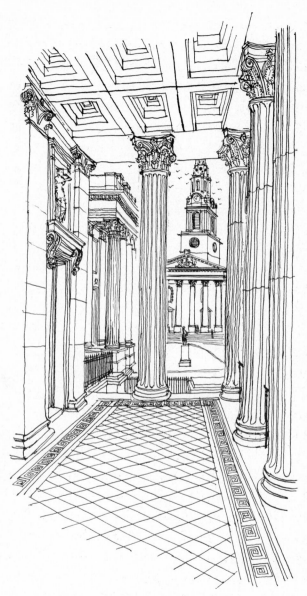

St Martin-in-the-Fields seen from Wilkins' Portico

supplying drawings for three or four of the principal figures. There are two sheets of drawings in the British Museum and one at Bayonne. Rubens' *Rape of the Sabines* (page 291) is one of the most vigorous and delicate of his figure compositions, even if not, like *Le Château de Steen* (page 197), in so rare a category as that of really great landscapes; and the collection contained the first acquired – and the greatest – of that series of landscapes by Aelbert Cuyp which was to make London the envy of every gallery in Holland. The two cabinet-sized Rembrandts, the limpid, jewel-like *Woman taken in Adultery* (page 213) and *Adoration of the Shepherds* (page 295), full of Christmas warmth and painted more broadly although only two years later, have provided the Gallery with two such Protestant renderings of New Testament themes as only Rembrandt knew how to make.

The splendid nucleus of the Angerstein collection is still, as then, the five pictures by Claude. The great contrasting pair from the Duc de Bouillon's collection, *The Marriage of Isaac and Rebekah* and *The Embarkation of the Queen of Sheba* (page 300), as well as the vivid *Cephalus and Procris reunited by Diana* (page 234), make this the finest group of landscapes by Claude which is anywhere to be seen. The collection includes among its English pictures seven which made the beginnings of a worthy representation of our own eighteenth-century school: the six which together form by far the most brilliant work of its founder, Hogarth's *Marriage à la Mode* (page 303), and Reynolds' *Lord Heathfield* (page 261), supreme example of the first President's talent for heroic characterization. The Claudes and the Hogarths remained for long the most popular pictures

in the collection. Claude combined like no other painter the sophisticated Englishman's love of landscape and nostalgia for the South, and so enabled him to accept the Classical by a thoroughly romantic interpretation. Before the middle of the century English collectors had come to own a large proportion of the paintings by Claude which had left Rome. Hogarth, who was now hallowed by the passage of sufficient time, summed up with Cockney humour and native love of anecdote the middle-class distrust of foreigners and of abstractions in art. So there was never any need to justify the purchase of the collection by Parliament in 1824. This was the foundation of the National Gallery.

Angerstein had come from Russia in his boyhood. At twenty-one he became an underwriter in Lloyd's, which was by then acquiring the aspect of an association. When he retired he was looked upon as the father of the modern Lloyd's, having persuaded it to abandon its ancient coffee-house and establish itself in the Royal Exchange. The invaluable Farington, early in their acquaintance, took careful stock of his host's position and summed it up on 19 June 1803: 'Mr Angerstein is much respected for his good heart & intentions, but is considered deficient in Education, & very embarrassed on all occasions when He is required to express himself. – His fortune is not esteemed to be of the first rate, perhaps not more, if so much as £100,000, but His expenses will be borne by His income *from business* which must be very considerable. Mr Angerstein might have been at the head of popularity in the City, but has chosen to associate chiefly at the West End of the town, so that He is one who, the Citizens say, *comes among them* for what He can get.'

Later entries in Farington's diary record, besides excellent dinners of which the now nostalgic menu is sometimes given in full, wise and generous words and deeds of Angerstein which were otherwise unchronicled; he earned his title of philanthropist not only by published subscriptions to public charities. It goes without saying that he was a Governor of the British Institution. He had had his portrait painted by Lawrence, who thought it to be one of his best and took it with others to Rome in 1819 to show to the Pope. A few months after Angerstein's death, George IV ordered from Lawrence a copy which was presented to the Gallery by William IV in 1836. It has been said that he was a new type of collector in that his acquisition of pictures was also an acquisition of social prestige. His was certainly not the first collection which was intended to bring prestige to its owner; but as a self-made man of foreign birth 'considered deficient in Education' he may well have relied on his pictures to express for him something that he did not know how to express himself. They were certainly the chief instrument of the peculiar position which he made for himself 'at the West End of the town.' Several of the leading artists and collectors were often to be found at 100 Pall Mall, where he kept open house and hospitable board and built a gallery for his collection. As the collection increased, more and more visitors were allowed to see it, until not to have seen Mr Angerstein's pictures was to be socially unfinished. There were far greater picture galleries in London, such as that of the Marquis of Stafford, later first Duke of Sutherland, at Cleveland House. But Sutherland, who was first Vice-President and then President of the British Institution and was in 1835 to become a

Trustee of the National Gallery, was perhaps the only aristo-cratic owner who admitted visitors to see his works of art. In any case the Stafford Gallery (now known as the Bridgewater House collection) would never be for sale. The Angerstein collection had become equally an institution and had to be preserved.

For the first ten years it was preserved in the house in Pall Mall, which was opened to the public on 10 May 1824.

It was intended from the beginning that the new National Gallery should grow; but there was no plan for the expansion, and even less space. The first acquisition, of 1825, was the tiny, sweet *'Madonna of the Basket'* by Correggio (page 169); but the next year saw the purchase not only of Poussin's brilliant *Bacchanalian Revel before a Term of Pan* (page 233) but also of Titian's great *Bacchus and Ariadne* (page 286), which inspired Poussin in Rome. Painted in 1522–23 for the study of Duke Alfonso d'Este at Ferrara, it had been appropriated by the Papal Legate, Cardinal Pietro Aldobrandini, when the little state of Ferrara passed to the Papacy. It had been in England about twenty years when it was acquired for the Gallery. A little more mature than its two fellows from the same series in the Prado, this is the greatest of all bacchanals, painted when the Renaissance was young and the reading of Ovid and Catullus still brought fire to the blood. It must be the most intensely coloured and richly textured picture in the world.

In the same year, probably, Sir George Beaumont made the promised gift of his collection. In 1828 Lord Stafford presented the largest of all the Gallery's great pictures by Rubens, the *Peace and War* (page 290) painted as a gift to King Charles I, after Rubens' visit to England. In 1831 the nation inherited the collection of the Rev. William Holwell Carr, another Governor of the British Institution who had made a promise somewhat similar to Beaumont's.

William Carr had painted a great deal as a young man, be-fore obtaining an exceptionally well-endowed living in Corn-

wall. He married an even better endowed wife, adding Carr to his name after her estate, and turned collector. He was not, apparently, above a bit of dealing. Farington (3 April 1814) tells a story of a piece of sharp practice over a picture by Andrea del Sarto – probably not the *Madonna and Child with St Elizabeth and St John* (page 284) that he was to bequeath. But Farington's gossip may have been coloured by dislike of his too sharply expressed opinions: in the teeth of Lawrence and other connoisseurs he held, for instance, that Angerstein's Correggio, *The Agony in the Garden*, was a copy – as indeed it has proved to be; the original is in the Wellington Museum at Apsley House.

The Holwell Carr Bequest included some pictures still fundamental to the Gallery's reputation: Titian's early *Holy Family with a Shepherd* (page 286), Tintoretto's dynamic *St George and the Dragon* (page 288), a Claude as beautiful as any, *David at the Cave of Adullam*, and the freshest and finest and most intimate of all the Rembrandts, *A Woman bathing in a Stream* (page 214).

The pictures in the National Gallery, hung frame to frame, now reached from floor to ceiling. But their congestion was only a minor difficulty. The demolition of Carlton House and the building of Carlton House Terrace involved a wider plan which included the site of 100 Pall Mall. Mr Angerstein's Gallery, as it was still often called, was due for demolition so that a foot passage could be enlarged into what is now Carlton House Gardens, leading to the Terrace from Pall Mall. Those responsible for the Crown Lands seem to have had little compunction about the Gallery. By 1831 they had pulled down the King's Mews in the newly-christened Square, and in that

year the Trustees adopted Wilkins' design for the building to go on their site. But the rebuilding did not begin until the summer of 1833, and meanwhile the building activities in Pall Mall were rendering No. 100 unsafe. Early in 1834 the collection had to be hurriedly bundled into another house, No. 105, which was even less suited for its exhibition. There the National Gallery was re-opened in March.

It continued to grow. Two pictures by Correggio were bought that year from Lord Londonderry, who had bought them in Vienna from Murat's widow. The famous *Mercury instructing Cupid before Venus* (page 284) was another picture from the collection of King Charles I. Having come with the huge Mantuan collection to London, it had been bought at the Royal sale by the Duke of Alba and transported to Spain, to find its way back to London eventually via Naples and Vienna. Soft and luxurious idyll that it is, one can imagine that it was glad to settle down. In 1836 a gift from King William IV included two huge pictures attributed to Guido Reni, Reynold's large equestrian portrait of Lord Ligonier now in the Tate Gallery, and three portraits by Lawrence, of which one was of his friend and benefactor *John Julius Angerstein*.

Angerstein had given much encouragement to Lawrence throughout his career and had helped to arrange his disordered finances. In turn Lawrence, who himself made perhaps the greatest of all private collections of drawings, gave Angerstein advice over the formation of his collection. He had succeeded West as President of the Royal Academy and, since he had had much to do with the purchase of the Angerstein collection, there had seemed to be no fitter person for a Trustee of the new

Gallery. He had died in 1830, and in 1831 Martin Archer Shee, who had succeeded him as President, became Trustee more or less *ex officio*. The new President was less friendly. As the building in Trafalgar Square neared completion, he protested formally that the National Gallery should have no place in it at the expense of the Royal Academy's school.

However, the move was made imperative by the acquisitions of that year. These included Reynolds' huge *Three Ladies adorning a Term of Hymen*, bequeathed by Lord Blessington in 1823 to 'the National Gallery intended to be formed in London', and three very large purchases, of which one was Murillo's *The Two Trinities* (page 206), perhaps the best of his works. The Trustees had also accepted a little set of pictures by Lancret, *The Four Ages of Man* (page 300), and fourteen less important pictures from the large bequest of Lieut-Col. J. H. Ollney and, from a body of subscribers chaired by Beechey, Constable's *Cornfield*. The artist had just died, and this memorial picture was the first of his to enter the national collection. The transfer of pictures was carried out in the winter of 1837–38, and in April 1838 the new National Gallery was opened in Trafalgar Square.

EARLY YEARS IN
TRAFALGAR SQUARE

The President of the Academy had done no more than his duty. He could not be equally loyal to both institutions, for the building was not big enough to contain both. It does not seem to have been planned with very much consideration for either. The dome with its tall stone drum, which provides a central feature for the façade, had then at least an interior function also, for it housed on several days a week the shivering model and the life-class of the Royal Academy. But, below, it had to be supported on heavy piers which obstruct the access to the space behind. In those days at least, these obstructions may well have seemed less obvious, for the space round and behind them was a high, wide hall. At either end of this was the first short flight of a staircase leading up to the main floor through an arch between two pilasters. The stairs on the east led to the Royal Academy, those on the west to the National Gallery. On the west the remainder of the stairs mounted within a corridor which divided what is now one Room into two. It is not surprising that these were criticized as too small, especially when they contained the pictures most beloved by the public: Hogarth's *Marriage à la Mode* series, Wilkie's *Village Festival* (now in the Tate Gallery) also from the Angerstein collection, and others by British painters. The crowds that gathered caused obstruction in the corridor, at the end of which were the other three Rooms. As they do still, these led one into the other, with Sebastiano's great *Raising of Lazarus* at the end.

That was the extent of the National Gallery until 1860, when the hall was divided horizontally to make a big room on the Main Floor behind the dome. And that was the extent of the National Gallery until 1869. In the autumn of every year it was closed for six weeks, when hired men were brought in to make the necessary rearrangements, the pictures were cleaned and the very small caretaker staff had its holiday. During the remainder of the year the Gallery was closed on Sundays, while on two weekdays admission was restricted to the fifty students who were allowed to copy the pictures at one time. Since there was no artificial light, the hours of admission on the four public days were not very long in winter. It was within this meagre framework, and amid disputations of which the violence must have been partly due to a reasonable dissatisfaction with every-thing, that the great development of the collection was to take place.

The National Gallery had grown into one of the great collections of the world long before it had acquired an adequate setting.

During the first thirty years the administration was perhaps not very much more adequate than the building. When the national collection came into existence no one could have been more suitable to be its first Keeper than the Superintendent of the British Institution. This was William Seguier. The name seems to have been pronounced 'Segar', for, like many other French Huguenot families, the Seguiers had been in England since the seventeenth century. William Seguier was in partner-ship with his brother John in an establishment which under-took the restoration and the valuation of pictures. They were

very highly regarded and had under their care to some extent or other a large proportion of the great private collections. William, who had married a well-endowed lady and made his own picture collection, seems to have been less concerned with the practical work of the business than his brother. He was thus free to become the adviser of George IV and, under William IV and the young Victoria, the official conservator of the Royal picture galleries. Among the many private collections of which he had had the supervision was that of Mr Angerstein. At the National Gallery his duties were not expected to be arduous. Col. G. S. Thwaites was appointed as Assistant Keeper and Secretary. In proportion to the dimensions of building and collection and to the simplicity of administration in those days, this would seem an adequate establishment.

From the first, since it was directly under the Treasury, the National Gallery has been a government department; but the appointment of these two officers was followed within a few weeks by that of a body of Trustees. The six appointed in 1824 included Beaumont and Lawrence. The Earl of Liverpool and F. J. Robinson, the future Earl of Ripon, were the Prime Minister and Chancellor of the Exchequer who had been responsible for bringing the Gallery into existence. The Earl of Aberdeen was to become Foreign Secretary and Prime Minister; Lord Farnborough, whose generous bequest in 1838 included among other pictures Rubens' effulgent little *Sunset Landscape* (page 291) and Gainsborough's *The Watering-Place* (page 265), was then Paymaster-General. The first formal meeting of the Trustees in 1828 was no doubt due to the addition to their number the year before of Lord Aberdeen's friend

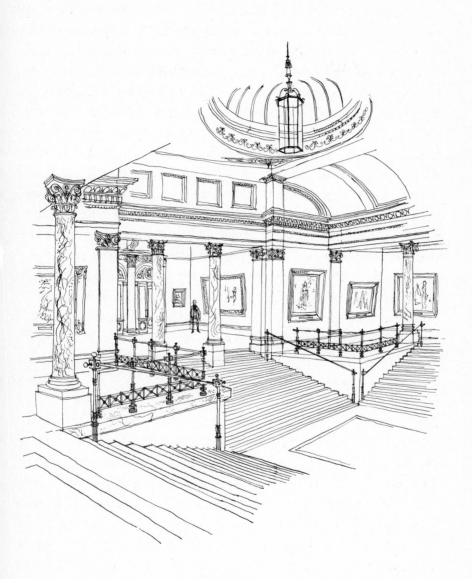

The Staircase by Taylor

Sir Robert Peel. He was then Home Secretary and Leader of the House of Commons. For all his political activity, he had time to make for himself the great collection of Dutch and Flemish pictures of the seventeenth century, the purchase of which from his son in 1871 was to form the real nucleus of the Gallery's magnificent Dutch collection. It included five of the Dutch paintings reproduced in this book, together with Rubens' *Le Chapeau de Paille* (page 194). He had time also to become the dominating influence in the Gallery's administration. Under the wing of such men it would seem that the new institution could have acquired all that was needful. In the absence of any regular purchase grant, for instance, it was very handy to be able to obtain funds through the Chancellor of the Exchequer or through the Prime Minister himself as First Lord of the Treasury. But in fact the availability of funds thus depended upon the degree of political optimism in Downing Street, and the Keeper was left to his own devices when Parliament was not sitting.

CHANGES IN THE KEEPERSHIP

When William Seguier died in 1843, Peel, then Prime Minister and First Lord of the Treasury, was responsible for the appointment to the Keepership of Charles Lock Eastlake, R.A.

At the age of fifteen Eastlake had declared his determination to be a painter with a characteristic seriousness that led his parents to take him at once from school and send him to London as the pupil of Benjamin Haydon. He was determined not only to paint but to be a history painter. When Napoleon was imprisoned on Elba, he went to study in Paris, and when Napoleon re-entered Paris, he escaped just in time and returned to his native Plymouth. When Napoleon followed him to Plymouth in the *Bellerophon*, Eastlake, by rowing constantly round the ship, managed to make studies of the fallen tyrant. The resulting large portrait in oils, exhibited in London and the provinces, brought the artist a thousand pounds. With this in 1816 he set off for Rome. Here Eastlake lived until 1830. With his habitual method, he travelled to Rome through a succession of towns where great pictures were to be seen, including Siena, where Gothic painting had its finest hour. In 1818 he spent three months in Greece. When he had visited London in 1828 for his election as A.R.A., he went back to Rome via Belgium, Holland and Germany. He returned in 1830, to live in London, by way of Vienna. He was determined not only to be a history painter but to know the history of the art.

In London he was a prolific and very popular painter, especially in the first eleven years, which culminated in his large *Christ lamenting over Jerusalem*. This is now in the Reference

Section of the Tate Gallery, together with the earlier and even larger *Lord Byron's Dream* and three other pictures.

He took an unusual degree of interest from the first in the technique, theory and history of painting; but in 1833 and again in 1836 he refused a Chair in the Fine Arts at London University which must have been proposed largely in order to take advantage of his exceptional knowledge. In 1840, however, his translation appeared of Goethe's *Theory of Colours* and in the following year he began his administrative career as Secretary to the Royal Fine Arts Commission. This was appointed by Peel to consider the rebuilding and decoration of the Houses of Parliament. Its President was Prince Albert, who thus made his début as patron of the arts in England. Though the Prince's discreet hand is rarely visible, he most certainly had considerable influence on the subsequent development of the Gallery. After his death Queen Victoria at his wish presented most of a not exceptionally distinguished group of early German, Netherlandish and Italian pictures which he had collected.

Eastlake thus undertook the Keepership under good auspices; but his tenure, begun reluctantly, did not last long. After a little more than a year in office he published a printed pamphlet in the form of a letter to Peel on 'the unfitness of the present building for its purpose'. The defects are set out under the five headings of 'The inconvenient arrangement, or disposition, of some of the rooms. Insufficient space for the due exhibition of even the present collection of paintings. Insufficient room for the accommodation of those desirous of studying in the Gallery. Want of offices. The imperfect system of ventilation and warming the

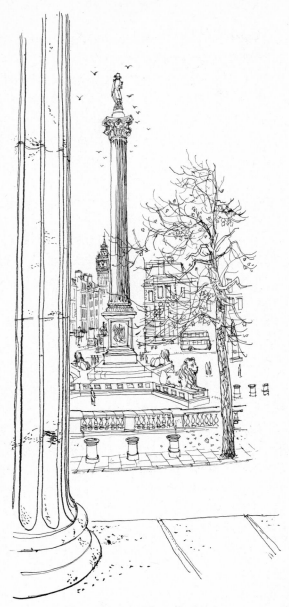

Trafalgar Square seen from the Portico

rooms.' Some of the Rooms at least were heated by open coal fires. After enlarging upon these defects, discussing in a broad and practical way the essentials of a good picture gallery, its site included, and reminding the Prime Minister of the claims in such a building of modern British painters, he ends: 'it will appear that the time is ripe when a more capacious and suitable building is necessary for the purposes of a National Gallery.'

In the hopes that must have lain behind the production of this pamphlet he had some justification in criticisms of the Gallery and its management that had been frequently voiced in Parliament from the first. Several Committees of the House of Commons had already made inquiries and practical suggestions but without any effect. Thus a Committee of 1836 had recommended the purchase of pictures not only by Raphael but by his Italian predecessors; but Lord Aberdeen, though he had long been President of the Society of Antiquaries, did not want 'antiquarian and medieval pictures' and Peel told Eastlake 'I think we should not collect curiosities.' It had been before Eastlake's appointment that Raphael's *St Catherine of Alexandria* (page 165) had been bought, in 1839, apparently by the Treasury without consultation of the Trustees but presumably on Seguier's advice; and two years later the great altarpiece from Lucca by Francia, who was one of the first of the fifteenthcentury Italians to acquire popularity in England. Perhaps as a Bolognese he could be considered a precursor of the Trustees' favourite painters, the Carracci and Guido Reni.

The Magdalen in the style of Guido had been bought in 1840, and it is hard to believe that the three further pictures attributed

to him which were bought by Eastlake in 1844 and 1845 represented anything but the wishes of the Trustees. Perhaps *Lot and his Daughter* (page 299) and *Susannah and the Elders* were bought at the Penrice sale to balance Rubens' *The Judgment of Paris* (page 193) from the same collection. Giovanni Bellini's *Doge Leonardo Loredan* (page 278), perhaps the most dignified and convincing of all idealized portraits of the ruler of a State, and the charming little early Raphael, *The Dream of Scipio* (Cat. No. 213) are more in keeping with the policy which Eastlake was to develop when, at a later date, he obtained a free hand.

The purchase of *A Man with a Skull* – now catalogued as in the style of the Netherlands-born Nuremberger Nicolas de Neufchâtel – as *A Medical Professor* by Holbein, whose signature it then bore, was a strange error on the part of those responsible; for there were many good pictures by Holbein in English collections. But it was hardly bad enough to justify the screams of abuse which followed.

These, however, were mild beside those to be heard and read on the subject of pictures cleaned during the autumn closing of 1846. William Seguier had attempted to combat the effects of the London atmosphere and especially its tendency to make varnish 'bloom' by mixing with his mastic resin a great deal of boiled linseed-oil. This gave brilliance for a time, but it was a rich golden colour when it was applied and it darkened rapidly. Thus Eastlake inherited a collection which he knew to be much darkened and distorted, and he inherited at the same time a traditional belief among the public, which Seguier had done much to foster, that the golden tone was the finishing touch of

beauty in the original structure of all 'old master' paintings. Eastlake employed as cleaner William Seguier's brother John, and they did no more than reduce the thickness of this super-imposed layer and reveal some of the fresher and more original beauties of colour and tone and brushwork; but the results provoked a violent outcry. Much of what was said about individual pictures in a series of controversies between 1846 and 1852 may be read in the *Catalogue of the Exhibition of Cleaned Pictures* of 1947, issued as a result of similar controversies of 1936–37 and 1946–47.

Perhaps then even more than now it could have been argued that such destructive manifestations were not the best way to extract from Parliament the money that it rarely gives very willingly to the service of the arts; but the London art world has always been apt to forget its larger interests for the sake of internecine feud. The controversy of 1846–47 was at least note-worthy for the contribution of John Ruskin. Bearing the first laurels that had just come to him with the publication of the second volume of *Modern Painters*, he weighed into the attack with much rhetorical exaggeration and all the condescending moral superiority of his youth, but with constructive ideas about the formation of a historical collection and its proper exhibition. His ideal that it should be possible for the whole collection to be 'hung in one line, side by side' was one to which the National Gallery was not to attain until after World War I, at the hands of Sir Charles Holmes; but Eastlake was fully in sympathy with it, as he was with much of the rest.

Meanwhile, he was being held responsible not only for the very moderate degree of picture cleaning which he advocated

but for many things over which he had little or no control. He was painting and he was on the point of bringing out his great *Materials for the History of Oil-Painting*, still a standard work today and containing enough learning to be the lifework of a smaller man. In his Secretaryship of the Fine Arts Commission he had another administrative post which he may well have found more creative. He resigned the Keepership in November 1847, and was quickly succeeded by his friend Thomas Unwins, R. A., who was Surveyor of Pictures to the Queen.

There were to be more than five years of bitter controversy along much the same lines. In the midst of them Eastlake returned to the National Gallery as a Trustee, when in 1850 he was elected President of the Royal Academy. They were to be far from fruitless years, for the acquisitions include Titian's *The Tribute Money* (page 287), the subject of more controversy but fully vindicated by the cleaning of 1937, and Rembrandt's *Portrait of the Painter in Old Age* (page 217), perhaps the most moving of all his great series of self-portraits and the greatest of some fifteen Rembrandts in the national collection. But in retrospect these years seem above all the prelude to the Select Committee of 1853, not the last but the most searching of the long series of such Parliamentary committees of inquiry which punctuate the history of the Gallery.

Under the chairmanship of William Mure, M.P., a classical scholar who had proposed its appointment, the Select Committee sat for four months in 1853, interviewing innumerable witnesses and deliberating upon its intended recommendations. Its Report, of 1,010 pages containing the verbatim evidence and the lengthy recommendations, evokes admiration for the men who conducted the inquiry and elucidated its findings; for these lie at the foundation of the great National Gallery which came to be constructed. It had first to deal with the perennial controversy which had once more broken out into renewed violence the year before over the cleanings done during the recess. For any verdict that they wished to pronounce, the Committee had more opinions than evidence, and in the end

they contented themselves with remarking upon the conflicting nature of these from 'witnesses, whose fervent love of art seems to have kindled some personal animosity.' They suggested a number of formalities to be observed in future over cleaning which showed that they expected cleaning to go on. This subject of cleaning was closely bound up with that of the building and its site; for everyone agreed that these were causing the pictures to deteriorate. Shared as it was with the Royal Academy, the building was totally inadequate in size, badly ventilated and used for the convenience of too many people with too little interest in the pictures. There was a barracks immediately behind the section occupied by the Gallery, and its occupants seem to have had a right of way through the ground floor. These, with the workhouse and wash-house of the Parish of St Martin's, which lay immediately behind the Royal Academy, were on the site of eventual exten-sion. The Report accordingly recommended that the building should be abandoned to the Academy, for which it was still vociferously claimed, and the collection removed to a new building at Kensington Gore. Here the Commissioners of the Great Exhibition of 1851 were the owners of land upon which a cluster of other museums was eventually erected. That the National Gallery was not the first on the new site is reason to be grateful to the national conservatism and unwillingness to devote funds to artistic ends. Wilkins' façade, subjected to continuous abuse throughout the nineteenth century, has contributed much in this century towards the affection which Englishmen have come to have for their National Gallery. Its central position is an even greater asset. As a penalty for

remaining in Trafalgar Square the pictures had to be glazed, and to remain glazed for nearly a century. Only a very few are glazed now, and in the meantime the air and the inhabitants of London have grown noticeably cleaner round them.

CHARLES EASTLAKE

The recommendations of the Report concerning administra-
tion and purchases led to a Treasury Minute of the following
year which was necessarily more exact and of more constitu-
tional significance. Meanwhile the Report laid down broadly
but clearly a policy for purchase: 'In order to understand or
profit by the great works, either of the ancient or modern schools
of art, it is necessary to contemplate the genius which produced
them, not merely in its final results, but in the mode of its opera-
tion, in its rise and progress, as well as in its perfection ... What
Chaucer and Spenser are to Shakespeare and Milton, Giotto
and Masaccio are to the great masters of the Florentine School;
and a National Gallery would be as defective without adequate
specimens of both styles of painting, as a National Library
without specimens of both styles of poetry.' This was a revolu-
tionary injunction. It implied the making of a new kind of
collection, going far beyond the boundaries of contemporary
taste. It was a clear mandate for the policy which we may assume
to have been already that of Eastlake, as it was certainly that of
Ruskin and of the painter William Dyce, R. A., though these
in their turn had little sympathy with the riper kinds of painting.
Dyce had come in contact in Rome with the Nazarene sect of
painters and was, like them, a forerunner of our own Pre-
Raphaelites. Early in 1853 he had put before the Prince Consort
in a letter the absurdities of the Gallery's administration and the
need for a national collection which represented the whole
field of painting. Incidentally, he was responsible, apparently,
for the purchase of the Krüger collection of early German

pictures, which was bought during the ensuing interim. It contained the charming picture by the Master of the Life of the Virgin reproduced on page 152.

The Report recommended the appointment of a Director. This new post was offered to Eastlake in 1854. At first declined, it was accepted two months later on his own terms; and these helped to formulate the Treasury Minute of 1855. In this there was a promise of the regular annual purchase-grant recommended by the Report. It was to be spent preferably on the purchase of pictures abroad. The Director's decision was to be final, over both the purchase of pictures and the management of the Gallery. He was to be assisted in the administration by a resident Keeper and Secretary to the Board, and in the purchase of pictures by a Travelling Agent. The Trustees remained, as an advisory body, in liaison with the world in general, and with the Government in particular. As Keeper and Secretary the Minute nominated Ralph N. Wornum, a portrait painter who in 1847 had compiled with Eastlake's help an official catalogue of the collections; and as Travelling Agent, Otto Mündler. This post unfortunately was suppressed three years later, though Mündler, a critic and collector of great ability, had filled it to the Director's satisfaction.

Had Eastlake not lost the services of Mündler so early, his ten years as Director might possibly have been spent a little differently. As it was, he passed them almost exclusively in discovering pictures for sale, examining them and negotiating for their purchase and delivery. That he pressed forward in this way and left to his successors the problem of achieving space for their exhibition was no doubt part of his wisdom; but it was even

more fortunate than he knew. While England had been missing so many opportunities on the Continent, Dr Waagen, the first Director of the Berlin Gallery, with whom Eastlake was in friendly correspondence, had been vigorously working with method and scholarship at the formation of a great historical collection of pictures. Founded in its present form in 1823, the Berlin Gallery was to be conspicuous for both these qualities over more than a hundred years. Dr Waagen, however, was now dead, and there was a pause in the formation of the Berlin collection until after the victory of Prussia in the Franco-Prussian War. Eastlake, with an annual grant of £10,000 at his disposal, and more to be obtained at a pinch from a Parliament which had considerable sympathy with his proceedings, thus had no serious rival in the market. This exceptional position could not last long. He took full advantage of it, setting about his task with imaginative boldness and methodical determination.

While he studied every picture that he bought with great care, making notes upon its condition, he was ready to make block purchases if they were the surest or the most economical means of acquiring what seemed most desirable. Thus in his first year he bought for £2,189.16.6. from Baron Galvagna in Venice ten North Italian Renaissance pictures which included Giovanni Bellini's best-preserved *Virgin and Child* (page 278). In 1857 he made a much more important and more comprehensive purchase, of pictures from the Lombardi-Baldi collection. From about 1838 Francesco Lombardi and Ugo Baldi had been making in Florence a collection of early pictures, mostly Tuscan, which in less than ten years came to number about a hundred.

Eastlake stated in his Report for 1857/8 (printed in 1867) that he first inspected this collection in 1855, but he must have been interested in the purchase when it was brought to the notice of the Trustees in 1847, during his Keepership. In 1853 there had even been protracted negotiations; but these came to nothing. The owners insisted on selling the collection in its entirety, and it was probably with a view to disposing of the unwanted residue of this collection as well as of the Krüger collection of early German pictures which had been bought *en bloc* in 1854 that an Act of Parliament was passed in 1856 enabling the Trustees to sell 'Works of Art belonging to the Public'. Eastlake, however, succeeded the next year in arranging for the purchase of only thirty-one pictures from the Lombardi-Baldi collection; indeed there were not really more than twenty-two pictures, for the larger number includes as separate items the nine smaller compartments of the great composite Gothic altarpiece in the style of Orcagna (page 273). However, even for twenty-two pictures the price paid, £7,035, does not seem high by the standards of today!

When it was first hung in the National Gallery the collection as a whole must have offered something of a shock to contemporary taste, and in his Report Eastlake felt that he had to lean upon the Treasury Minute to which he owed his appointment: 'The unsightly specimens of Margaritone and the earliest Tuscan painters were selected,' he wrote, 'solely for their historical importance, and as showing the rude beginnings from which, through nearly two centuries and a half, Italian art slowly advanced to the period of Raphael and his contemporaries.' The signed retable, or altar frontal, by Margarito of Arezzo (page

44

273), probably of the third quarter of the thirteenth century, is still perhaps the earliest picture in the collection; though a rival claim might be made for a little panel presented in 1934, *The Virgin and Child with two Angels* (Cat. No. 4741) which was for a long time associated with the name of Giunta Pisano. To us these seem attractive and dignified examples of Romanesque crafts-manship, and the *Crucifix* (page 83) of only a very few years later already belongs to the great tradition of Italian painting. When working on a larger scale its unidentified author is not a match for Cimabue, the founder of the Tuscan school; but in colour and expression he foreshadows Duccio, the great Gothic master of the next generation. This was well represented in the Lombardi-Baldi group of pictures, most brilliantly by Duccio's triptych, *The Virgin and Child with Saints* (page 273). In the twentieth century the Gallery was to inherit a small picture from the Florentine studio of Giotto; but he and the great Sienese painter Simone Martini cannot really be said to be represented. According to a tradition dating at least from Vasari's day Cimabue was then believed to be the author of the monumental *Virgin and Child with six Angels* from Sta Croce in Florence which is now attributed to a follower of Duccio. The sheer grandeur of this great panel is the principal reason for believing that it may be an early work by Pietro Lorenzetti; for even from that distant age few painters as great as this are still anonymous. Another important Tuscan Gothic work is *The Coronation of the Virgin* (page 273) attributed to Agnolo Gaddi. Its austere but graceful design, its pale, joyous colouring give it the quality of a sacrament. Still partly Gothic, in its gay colour and elaborate technique of coloured glazes over gold and silver

leaf, is the one great picture of the early Florentine Renaissance which came with the Lombardi-Baldi collection: Paolo Uccello's splendid battle-picture which is described on page 86. Botticelli's early *Adoration of the Kings* also came from that source.

Between these two mass acquisitions Eastlake bought Veronese's *The Family of Darius before Alexander* (page 289) from the Pisani Palace in Venice. This was rightly one of the most famous of all Venetian pictures and was regarded by many as Veronese's greatest work. It was not easily extracted from Count Vettor Pisani because of family pride and fear of the local reaction, and the price paid, £12,280, was considered a record at that time. Indeed it caused a storm in Parliament, which put an end to the employment of Mündler as Travelling Agent, much to Eastlake's disappointment and just indignation.

Italian fifteenth-century pictures still cost virtually nothing by the standards of today, and the large Veronese was certainly less of a bargain than the great altarpiece with *The Martyrdom of St Sebastian* (page 103) by the Pollaiuolo brothers, which was bought at much the same time from Marquis Roberto Pucci in Florence. This cost £500. Even that, however, was regarded as expensive by Eastlake's detractors, who were still loud in their complaints. They had a weapon in a Florentine certificate to the effect that the picture had been ruined by harsh cleaning. It is on the whole in excellent condition, and the certificate may well have been connected with the difficulties which already existed in obtaining an export licence. Other fifteenth-century pictures acquired during the same interval were *The Virgin and Child with two Angels* (page 275) now ascribed to Verrocchio, three panels from Perugino's altarpiece for the Certosa di Pavia (page 275),

46

and van Eyck's *Portrait of a Young Man* (page 280), who was probably a musician. Four Italian pictures which had been bought (for £2,078!) at the Northwick sale in 1859 included Botticelli's *Portrait of a Young Man* (page 106), then believed to be a self-portrait by Masaccio.

The studies which Eastlake had made for his *Materials for the History of Oil-Painting* (1847) had given him a special interest in the technique of the early Netherlandish painters. His most comprehensive purchase of all, that of the forty-six pictures of the Edmond Beaucousin collection bought for £9,205 in Paris in 1860, included not only Bronzino's *Allegory* (page 170) formerly in the collection of a King of France, and Titan's *Madonna and Child with St John and St Catherine* (page 286) once at the Escorial, but the two portraits now ascribed to Campin (page 280), Rogier van der Weyden's *The Magdalen Reading* (page 280) and Mabuse's *A Man with a Rosary*. In 1860 Eastlake bought the Gallery's one picture by Fra Angelico (page 85) and *The Entombment* by Dieric Bouts (page 145), then attributed to Rogier.

In 1861 he bought *The Baptism of Christ* (page 275), the first of the three pictures by Piero della Francesca, then scarcely known, which alone distinguish the National Gallery from the other great collections outside Italy.

The long list of 1862 must be headed by Piero di Cosimo's *A Mythological Subject* (page 123) and the *Portrait of a Young Man* (page 166) by Andrea del Sarto. That of 1863 included Bellini's *Agony in the Garden* (page 278), that of 1864 *The Virgin and Child with St Anne* (page 279) by Gerolamo dai Libri, with its companion *St Roch* by Morando. In 1865, his last year,

Eastlake bought what are still the Gallery's most exquisite panels by Memlinc, *St John the Baptist* and *St Lawrence* (page 143), Raphael's *Garvagh Madonna* (page 284) and the bust-portrait of Philip IV of Spain by Velazquez (page 293).

Eastlake died at Pisa in 1865. It is largely since his time that art history has grown up. It has done so with easy methods of quick travel and, above all, with the growing use of photography. It is also an accumulative process which has made it possible for a university student of today to be superficially much more knowledgeable than the learned man of a century ago. Eastlake was not an art historian in the modern sense. His learning was profound; but it was technical rather than historical. He had, above all, a type of understanding which cannot be acquired by the study of photographs. Consequently, of the 139 pictures which he purchased, a quite high percentage are to be found catalogued today under a different name from that under which they were bought. It is a much smaller percentage, however, which is not to be found on exhibition. And it is a still smaller percentage which is not fundamentally in good condition. He had the pick of the market in Italy, where he went every year in search of pictures; and he picked the best-preserved after deliberate study and notation. Many of the pictures that he bought in Italy he was careful to have restored before they were sent to London. There he seems to have preserved discretion in his cleanings; he was careful not to provoke any further controversy on his head. But he passed on to his two immediate successors a tradition of close examination and careful conservation which has given the National Gallery above all a collection of pictures in which the percentage of

original paint preserved is distinctly higher than in most of the galleries founded since.

Eastlake made a collection of his own, and in relation to this his behaviour was equally outstanding. In 1861 he gave to the Gallery what would certainly be today the most valuable of his pictures, *The Annunciation* by Filippo Lippi (page 97), because he was able in that year to buy its less attractive pendant for the Gallery. When he died, he left the instruction that the Gallery should be able to purchase any picture from his widow at the price which he had paid for it. Thus the Gallery came to possess a further small group of fine pictures from several schools including the *St Michael* by Piero della Francesca and Tura's towering *Virgin and Child enthroned* (page 112). Lady Eastlake presented Pisanello's *The Virgin and Child with St George and St Anthony Abbot* (page 276) in his memory.

WILLIAM BOXALL

Eastlake was succeeded by William Boxall, R. A. Boxall was a successful portrait painter, less travelled and less of a scholar than his predecessor. He did not know Italy as Eastlake had done. Yet three important pictures bought there were among the purchases of his first year, above all Baldovinetti's lovely *Portrait of a Lady in Yellow* (page 101). It was not long before he had acquired the two unfinished pictures by Michelangelo, *The Entombment* (page 162) in 1868 and *Madonna and Child with St John and Angels* (page 284) in 1870. Eastlake had wanted the Trustees to buy the Madonna in the days of his Keepership.

It was now becoming much more difficult to obtain the export of great pictures from Italy, while there was an obvious need of some reorientation of the acquisition policy with regard to foreign schools. Rubens and Rembrandt were already well represented. There were nine pictures from Rubens' own hand and eleven from Rembrandt's – not to mention *Christ blessing Children*, now attributed to Maes, for which a high price (£7,000) had been paid in 1866. There were also quite enough examples already of that then strangely overvalued Flemish artist, David Teniers the Younger. Otherwise, however, the Flemish and, more particularly, the Dutch Schools were poorly represented. Now, in 1869, Boxall bought one of the best of the dozen masterpieces which Pieter de Hoogh achieved during his short period of excellence, *A Woman and her Maid in a Courtyard* (page 297); and in 1871 he brought the representation of the Dutch school of the seventeenth century more than level with that of the Italian Renaissance. Sir Robert Peel throughout his stormy and single-

minded political career had given much of his time to the affairs of the Gallery; he had also made a large collection of pictures, mostly Dutch. This his son and successor now sold to the nation *en bloc*. The purchase of these eighty pictures for £75,000 was the largest yet made for the Gallery. It was made by the Govern-ment on the understanding that the regular purchase-grant of £10,000 was to be temporarily suspended.

The sixty-nine Flemish and Dutch pictures in the Peel col-lection were by thirty-two painters. It was thus that the Gallery acquired Rubens' *Le Chapeau de Paille* (page 194), van Dyck's *Triumph of Silenus*, and the other two great examples of de Hoogh (pages 229, 297), as well as *The Avenue, Middelharnis* and *The Ruins of Brederode Castle* (pages 230, 298), among four pictures by Hobbema, three landscapes by Cuyp (page 222, Cat. Nos. 822 and 824), Koninck's *Extensive Landscape with a Hawking Party* (page 218), the first of those placid estuary scenes by van de Cappelle and Ter Borch's *A Young Woman playing a Theorbo to two Men*. The Peel collection also contained pictures by a score of lesser Dutch masters, including seven by Willem van de Velde the Younger and five by Wouwermans. Sir Richard Wallace was thus inspired to present in the same year that historic little picture, Ter Borch's *Ratification of the Treaty of Münster* (page 296).

In 1873, though there was no regular grant, a special grant of £1,500 was made for the purchase of Mantegna's great grisaille *The Triumph of Scipio*.

Meanwhile it had become even more vital to the public that what had been acquired should be displayed. In 1857 a Com-mission had reverted to the recommendation of an earlier Select

Committee of 1848 that the Academy should be ousted and a new and larger building erected for the Gallery on the Trafalgar Square site. But ten years later nothing had been done and the idea was mooted that it should be the Gallery that removed itself, to Burlington House. Perhaps it was this threat that produced the promise that the Academy should be moved the following year. By March 1869 it had gone, and the National Gallery had spread itself into the exhibition Rooms on the east side.

This, however, was plainly not enough. Boxall almost immediately demanded of the Chancellor of the Exchequer the new building recommended more than twenty years before. Eventually E. M. Barry was appointed architect. He had finished the work of his father Sir Charles on the Houses of Parliament, but it is in the Floral Hall at Covent Garden and the rebuilding of the Theatre there in its present form that one recognizes the antecedents of the new National Gallery. Barry's enlargements, which were opened in 1876, comprised the whole of the block lying behind the east half of the original building, with the glass Dome and its adjoining 'chapels' in the centre, and the two great Rooms on the north and east sides.

One great improvement was the introduction of central heating by hot-water pipes running under grids in the floors, instead of the open fireplaces which had served the original building. There was still no thought of artificial light, but the problem of lighting by day was studied with care. Inevitably, the principal aim was to minimize reflection from the glass which covered every picture, so it was thought best to admit the light from as high as possible – above the highest of the pictures, which were still hung one above another, to a considerable height. Thus

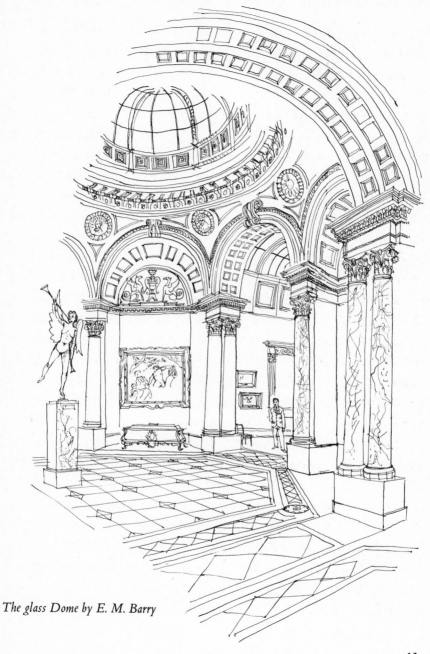

The glass Dome by E. M. Barry

practical considerations agreed all too well with the contemporary taste for grandiosity. Rising on the site of the old workhouse and wash-houses, Barry's extension represents the Victorian Renaissance style at its most grandiose, erudite in its combination of classical features from a variety of periods and splendid in its use of marble and gold. Having involved a difficult problem of maintenance from the beginning, it defied modern tastes for more intimate and neutral settings, not to mention the need for air-conditioning.

The new rooms made it possible to display the large Wynn Ellis Bequest. But there was a stronger reason for the Government's tardy recognition of the Gallery's need of expansion. This was the necessity of making some provision for the great number of British pictures which had been given or bequeathed. When in 1847 Mr Robert Vernon, who had made a fortune as an army contractor in horses and had become a generous patron of contemporary art, presented 157 British pictures to the nation, there had been nothing to do but insist, to his discomfort, on their remaining at his house near the British Institution, 50 Pall Mall. In 1850 they were moved across Pall Mall to Marlborough House. Here they were joined two years later by the contents of the little Museum of Manufactures, germ of the great Victoria and Albert Museum, and soon after by a much more valuable collection of pictures, the great Bequest by J. M. W. Turner of all his pictures remaining in his possession. In 1859 this heterogeneous collection was moved to the new South Kensington Museum. But there the growth of more appropriate collections soon made it desirable to attach the pictures to where they belonged. Their arrival in Trafalgar Square in 1875, together

with several early pictures of value which the Museum had acquired, including Giovanni Bellini's *St Dominic* (page 130), meant that the enlarged building was not much better in proportion to the needs of the collection.

From 1880, however, those visitors who were willing or able to pay sixpence were admitted on the copying days, and in 1887 further additions were opened which had been designed by Sir John Taylor. The staircase had been redesigned, for the last time, with a central flight leading to a new Room on the central axis of the building, with three little Rooms round it and a large Room across the end. This was the extent of the building until the present century. From 1896 admission on Sunday afternoons was a further concession to the public.

FREDERICK BURTON

Boxall had not waited to see the first enlargement; he had retired in 1874. He had been succeeded by Frederick William Burton, R. H. A., who was then fifty-eight and was to hold the post of Director for twenty years and retire six years before he died. In 1851–58 he had practised his rather slight talent for portraiture in watercolours in Munich, where the Alte Pinakothek offered the example of a great and growing collection, systematically maintained in a building which had been designed on rather rigid principles but in due proportion to its need.

Burton, with his Keeper, Eastlake, nephew and namesake of the first Director, seems to have run the Gallery with admirable system and to have applied himself to the enlargement of the collection with a vigour which was now traditional. The regular purchase grant was still suspended as the result of the acquisition of the Peel collection, but he was not long in obtaining a special grant a little larger than the former annual grant for the purchase of fourteen Italian Renaissance pictures at the sale of Alexander Barker. These included *The Nativity* by Piero della Francesca (page 108), Botticelli's *Venus and Mars* (page 105) and two frescoes from the Petrucci palace, the 'Palazzo del Magnifico', at Siena: Signorelli's *Triumph of Chastity* (page 275) and Pinto-ricchio's *Scenes from the Odyssey*. The cost of these masterpieces and the ten other pictures was £10,395.

In 1875 use was first made of a bequest of money which the Gallery had received some years before, the Lewis Fund of £10,000 bequeathed by Thomas Denison Lewis, who had died in 1849. This first bequest of money to the Gallery became avail-

able after the death of the testator's sister in 1862, but the interest had been allowed to accumulate. In 1875 two English pictures were bought, Gainsborough's large early landscape *Cornard Wood* (page 303) and Crome's *Windmill near Norwich* (Tate Gallery). In 1876 the Lewis Fund provided the Gallery's first portrait by Frans Hals, who was not represented in the Peel collection. This was the *Middle-aged Woman with Hands Folded* (page 294).

In 1876 there was an increased special grant of £5,000 to buy four Brescian portraits, three by Moroni and one by Moretto, and the great Wynn Ellis Bequest of ninety-four pictures was handed over. These included two little masterpieces of the fifteenth century, Antonio Pollaiuolo's lyrical *Apollo and Daphne* (page 275) and the brilliant *Portrait of a Man* (page 281) of 1462 by Dieric Bouts. The representation of the Dutch School was still further enriched by, among many others, two Cuyp landscapes, *The Large Dort* and *The Small Dort,* four river scenes by van de Capelle, a landscape by Hobbema and three by Jacob van Ruisdael, including the splendid *Extensive Landscape with a Ruined Castle and a Village Church* (page 297). Canaletto, already represented by his masterpiece *The Stonemason's Yard* from the Beaumont collection and the great view of the Grand Canal bequeathed by Lord Farnborough in 1838, was now represented by three more pictures, including *The Feast Day of St Roch.*

In 1878 and 1879 the grant was restored at half its former strength; but in 1880 it was raised once more to £10,000. This total of £20,000 in three years secured the purchase, among other things, of Botticelli's early tondo with *The Adoration of the*

Kings and his late canvas with *The Mystic Nativity* (page 275), of Perugino's altarpiece, *The Virgin and Child with St Francis and St Jerome,* of Leonardo's *Virgin of the Rocks* (page 117) and of Veronese's unusual *St Helen: Vision of the Cross* (page 289) with its echoes of Parmigianino and Raphael.

In 1882 the grant was increased to £15,600 for the purchase of pictures at the Hamilton Palace sale in London. This yielded two more large Renaissance altarpieces, Botticini's *Assumption of the Virgin*, then attributed to Botticelli, and Signorelli's *Circumcision,* and a number of small Italian pictures which included Cima's little *St Jerome in a Landscape* (page 125). The most famous of the pictures acquired at this sale is the full-length portrait by Velazquez, *Philip IV of Spain in Brown and Silver* (page 293), bought for £6,300.

It was at the Hamilton Palace sale that use was first made of the Clarke Bequest, £24,000 bequeathed by Mr Francis Clarke in 1856 and put at the Gallery's disposal after the death of his son in 1879. Pontormo's *Joseph in Egypt* (page 285) and Tintoretto's *Christ washing his Disciples' Feet* were bought at the Hamilton Palace sale; and in 1883 two predella scenes by Duccio, *The Annunciation* (page 273) and *Jesus opens the Eyes of a Man Born Blind.* Like *The Transfiguration,* which is described below (page 81), these came from the predella of Duccio's great *Maestà* painted in 1308–11 for the high altar of Siena Cathedral. Antonello's *Portrait of a Man* (page 119) and Mantegna's *Samson and Delilah* (page 276) were among the other pictures bought that year. Early in 1884 the great *Assumption of the Virgin* (page 275) by Matteo di Giovanni, a ravishing example of Sienese painting, was bought in Siena, and at auction in London a very small

picture of great importance to the Gallery, Giorgione's *Adoration of the Magi* (page 173).

In 1885 two great prizes were won, *The Ansidei Madonna* (page 284), a large early altarpiece by Raphael, and van Dyck's great portrait of Charles I on horseback (page 292); but only with much effort and a great deal of pressure upon the Government in circumstances which can be seen now to show the tide of fortune setting against the Gallery. There was no doubt about the im-portance of either picture. Raphael was regarded as the apogee of all painting and the Gallery had no picture by him on the full scale. Van Dyck had always been greatly venerated in England, and this picture stood for the very source of that veneration, his employment by King Charles I and his court. But they were at Blenheim Palace, and the Duke of Marlborough asked prices which were unheard of in that day. He had made his intention to sell a number of pictures known to the Trustees and Director, and they had chosen twelve, including also seven pictures by Rubens. Among these were his *Perseus and Andromeda*, which eventually went to Berlin, and two full-length portraits of Helena Fourment, which were bought by Baron Alphonse de Rothschild. For the twelve pictures, the Duke asked £400,000 and when the Gallery had cut its list to five pictures, including only one by Rubens, the price was still £165,000.

When it got about that the Government would not consider the expenditure of such a sum, there were memorials to the Prime Minister, Mr Gladstone, one signed by Sir Frederick Leighton, P. R. A., and thirty-six other Royal Academicians, another signed by Sir Richard Wallace and more than a hun-dred laymen; there was a deputation to the Chancellor of the

Exchequer headed by the Duke of Westminster and including Robert Browning; there was a resolution signed by sixty-four Members of Parliament. And in the end these two pictures were bought: the Raphael for £70,000, the van Dyck for £17,500. It was not long before American collectors were to come into the market, and prices were already rising to heights which only they would be willing to pay.

The purchase-grant was restored to £10,000 in 1890; but in that very year there was a new crisis over three full-length portraits from Longford Castle which the Earl of Radnor would only sell together: Holbein's *The Ambassadors* (page 159), Moroni's *A Nobleman* and the Spanish *Don Adrian Pulido Pareja* which bears the false signature of Velazquez and is now ascribed to his son-in-law, del Mazo. This was perhaps the first time that private contributions were made towards specific pictures. Lord Rothschild, Sir Edward Guinness and Charles Cotes each gave £10,000 on condition that the balance of £25,000 was found by a special grant. From the annual grant were bought Tintoretto's *Origin of the Milky Way* (page 181) and the first of the four great decorations by Veronese from Cobham Hall, *Allegories of Love* (pages 182, 289). The others in the series were acquired the next year. One was given by Lord Darnley, while his price of £5,000 for Tintoretto's truncated masterpieces and the three great canvases by Veronese made these also virtually a gift.

When Burton retired in 1894, the era inaugurated by the Treasury Minute of 1855 came to an end. By the edict of Lord Rosebery, who was Prime Minister that year, the powers of making all decisions reverted to the Trustees. In these fifty years,

however, the three independent Directors had carried out the task which had been set them. They could even be said to have done more. They had strangely neglected the French School, which was even then rising to its greatest heights, but with this all-important exception they had made the National Gallery of all galleries in the world the best representative of the history of European painting.

Burton was succeeded by E. J. Poynter, who had been born and trained as a painter in Paris but had settled in England in 1860. Soon recognized as an outstanding painter and critic, he was appointed in 1871 the first Slade Professor at University College, London, and later the Principal of the National Art Training School at South Kensington. Here he was also jointly responsible for the acquisitions of the Museum. In 1896 he succeeded Millais as President of the Royal Academy, a post which he occupied for more than twenty years. He resigned the Directorship of the National Gallery in 1904. During his years of office he had achieved some valuable purchases. Mantegna's early *Agony in the Garden* (page 276), Antonello's *St Jerome in his Study* (page 277) and *St Giles and the Hind* by the Master of St Giles were bought in his first year. Three pictures by Goya were bought in 1896, the two greatest portraits by Rembrandt, those of *Jacob Trip* and his wife *Margaretha de Geer* (page 295) in 1899 and Titian's *Portrait of a Man* (page 177) in 1904.

Nevertheless, Poynter's ten years as Director would have been more fruitful if the Trustees had been more willing to take his advice. They celebrated their new powers of decision over purchases almost immediately by refusing to buy Titian's *Rape of Europa* when it was offered by the Earl of Darnley. Now in the Isabella Stewart Gardner Museum in Boston, this picture has been described by more than one writer as the greatest in the United States. In virtually perfect condition, it is certainly the best preserved of all the great series of *poesie* which Titian painted for the Spanish Royal House. Poynter did not easily persuade

the Trustees to acquire Titian's *Portrait of a Man* when this was offered by Lord Darnley in its turn, and it was the difficulties over this picture which led to his resignation.

In 1897 the Keepership of the newly founded Tate Gallery had been added to the duties of the National Gallery Director. At first the new Gallery was directly under the same Board of Trustees; but it may be best to defer any further mention of the Tate Gallery for the time being.

The Directors of the nineteenth century had not unwisely left the acquisition of pictures of the English school largely to chance. Embarrassed as they were by bequests of countless British pictures, they could assume that some works of genius would emerge from the stacks of mediocre canvases. The Turner problem had solved itself with what may then have seemed an embarrassing thoroughness, and in 1888 Constable's daughter Isabel in the name of three of the painter's children had generously given to the nation a large number of his pictures. Unfortunately the splendid series of sketches, considered unfit to compete with finished paintings, went to the South Kensington Museum; but the group which came to the Gallery included, among others, *The Cenotaph at Coleorton, in memory of Sir Joshua Reynolds* (now at the Tate Gallery), painted for Sir George Beaumont, whose grounds it represents. In 1886 Mr Henry Vaughan had given *The Hay-Wain* (page 304), the only 'six-footer' by Constable in the Gallery. It bears in its frame a replica of the gold medal awarded to him in connection with it at the Paris Salon in 1824.

The new century begins with Vaughan's bequest of the remainder of his collection, which included Gainsborough's

charming study of *The Painter's Daughters chasing a Butterfly* and a group of less important pictures by Constable. Perhaps the most beautiful Constables came with the bequest of George Salting in 1910. These included *Weymouth Bay* (page 270). The 192 pictures of the great Salting Bequest were of almost every school; they included Campin's *Virgin and Child before a Fire-Screen* (page 132), Ruisdael's *An Extensive Landscape with a Ruined Castle and a Village Church* (page 297) and Jan Steen's *Skittle Players outside an Inn* (page 226).

The bequests of the twentieth century, if less historic, are greater than those of the nineteenth. In 1916 the last of the collection of pictures which had been bequeathed in 1894 with a life interest to his widow by the redoubtable archaeologist and diplomat Sir Henry Layard arrived from the Palazzo Cappello in Venice. If it included no great masterpieces, there were many interesting pictures from Venice and the Veneto, Tura's *Allegorical Figure* (page 276), for example, the remains of Gentile Bellini's *Sultan Mehmet II* (page 278), Montagna's *Three Saints* and that large dark canvas with *The Adoration of the Kings* of the Bellini school, now attributed to Carpaccio.

There have been many minor bequests; but the most generous of the century was the Mond Bequest of 1924. Consisting almost entirely of Italian pictures, this included the large early altarpiece from Città di Castello by Raphael, two panels with *Scenes from the Life of St Zenobius* by Botticelli, which have companions in Dresden and New York, Giovanni Bellini's moving *Pietà* and one of the most touching of all Titian's works, the little *Madonna and Child* (page 287), painted in his extreme old age.

Although the list of the Gallery's great Italian altarpieces was now necessarily complete, it was not until very recently that the name of Giotto, invoked by the Select Committee of 1853, could be entered legitimately in the catalogue. The one picture in England which could be attributed to Giotto had been allowed to go to Berlin; but the little *Pentecost* unexpectedly bequeathed in 1942 by Mrs Coningham was recognized instantly as one of a well-known series undoubtedly from Giotto's studio. Others from the series are at Munich, New York and Boston (Gardner Museum). As to Masaccio, Eastlake may have had the Committee's admonition in mind when he bought the *Portrait of a Young Man* (page 106), now attributed to Botticelli; but it was to be *The Virgin and Child with Angels* (page 94), known to him probably in Miss Woodburn's collection as the work of Gentile de Fabriano, that became established after its purchase in 1916 as the corner-stone of the Gallery's great collection of Italian Renaissance paintings.

In 1950 Masaccio's elder and frequent partner Masolino came to be represented by his *St John the Baptist and St Jerome* (page 90), together with *A Pope and St Matthias*, which is now the pendant but which formed the back of the same panel until this, like the others of the series, was sawn in half. In 1959 a second picture by Uccello was bought, *St George and the Dragon* (page 88), formerly in the Lanckoronski collection. Though this is a small picture – indeed, painted in oils on canvas, it might be claimed as the earliest Italian easel-picture to have survived – it is perhaps the quintessence of the early Florentine Renaissance; and as such it puts the seal upon the great series of pictures from that epoch which above all distinguishes the

English national collection. Italy has been called 'the school of Europe', and it was the Italian Renaissance which bridged the gulf between Antiquity and modern times. The National Gallery makes this fact clear more fully than any other museum. Several Italian museums are, of course, much richer in Italian pictures; but none in Italy is very rich in the work of other national schools.

Important additions have also been made since the war to the Gallery's collection of Early Netherlandish pictures. Several years before any early Italian picture of equal significance had been acquired, in 1842 Jan van Eyck's *Marriage of Giovanni Arnolfini and Giovanna Cenami* (page 134) was bought on the advice of William Seguier. Eastlake at one coup had acquired the two virile portraits ascribed to Campin and the fragmentary *Magdalen Reading* by Rogier van der Weyden. With these, groups of pictures by Bouts and Memlinc, David and Massys and Mabuse, single pictures by Bosch and Bruegel, the National Gallery already clearly showed what profundities the Netherlandish painters could create with more empirical methods as they looked at nature with a new consciousness of the meaning to be found in her appearance. But there was no complete religious painting by van der Weyden until his brilliant *Pietà* (page 137) came from the Powis collection in 1956; no great example of an Early Netherlandish triptych until Memlinc's *Donne Triptych* was transferred from the Duke of Devonshire's collection in the following year.

It was the grafting of Netherlandish vision and methods upon the rather more abstract ideas and schematic design of the Tuscans that produced the adventurous, comprehensive

painting of the great Venetians in which the National Gallery is also rich. It was the new comprehensive means of expression for which so many painters seem to have been waiting, in Flanders and Holland, in Spain and France. Of what was produced in the next century in these countries by such men as Rubens and van Dyck, Rembrandt and Cuyp, El Greco and Velazquez, Poussin and Claude the National Gallery has a well-balanced representation. In the case of Dutch painting as a whole it has, again, almost as fine a representation as any gallery in Holland.

Unfortunately the eighteenth century was too near to be regarded until recently as historically valuable, and the English love of Venice resulted in a magnificent series of Venetian scenes by Canaletto and Guardi but in little more, until the altarpieces of this period were almost out of reach. Giovanni Battista Tiepolo's *modello* for the large *Trinity appearing to St Clement* (page 290) at Munich was bought, however, in 1957, and in 1958 a full-scale altarpiece by Tiepolo's compatriot Pittoni. In the nineteenth century Tiepolo was no doubt placed on the same level as Boucher and Fragonard, whose work was left to the deep purses of such frivolous eccentrics as the Marquis of Hertford in Paris. Fortunately the Hertford collection was brought to England, away from the Commune, by Sir Richard Wallace. The Wallace Collection, where Watteau and Lancret, Boucher and Fragonard, can be seen as they can nowhere else, among the furniture and ornaments which were their intended setting, is some compensation for the weak representation of the French eighteenth century in Trafalgar Square.

THE TATE GALLERY

To speak of later paintings is to remember that the greater part of National Gallery history in the twentieth century is the history of the Tate Gallery; for that was founded as an annexe to the National Gallery and attained complete independence, by Act of Parliament, only in 1955. The functions of the two must always, of necessity, overlap.

When it was opened in 1897 'the Tate', as it has been fondly called from the first, was designed to receive yet another collec-tion of contemporary British painting from Sir Henry Tate, who generously financed the building; but it was intended also to draw off from Trafalgar Square the British pictures by more or less contemporary artists. Thus almost the whole of the Vernon Gift, the already swelling Chantrey Bequest – until recently used to acquire only the work of Royal Academicians – and many other British pictures were transferred to the Tate. They were followed in 1910, after Sir Joseph Duveen, Senior, had provided rooms for their reception, by the greater part of the oil-paintings in the Turner Bequest. Thus it is to the Tate Gallery that one has to go to see the work of the greatest of British painters.

This in itself represented an important change in the functions of the Tate. By 1915 it had been decided that it should house the national collection of British painting and, after World War I, two hundred British pictures of all periods were trans-ferred. World War II proved an even more significant land-mark, for in the course of it nine bombs falling within the area of the National Gallery caused a reduction in exhibition space

which was not entirely made good until a few years ago. Since the exhibition of the British school is primarily the responsibility of the Tate Gallery, more than three hundred British pictures have been transferred there since 1946, and the occasion has been taken to revise the select representation of the school in Trafalgar Square. At present almost all the British pictures there are of the great period, the century and a quarter which lies between the first works of Hogarth and the last of Turner.

In 1917 the National Gallery received from Sir Hugh Lane, who had been drowned in the sinking of the *Lusitania*, a bequest of French pictures from all periods of the nineteenth century. Even before Lane died, the problem thus posed had been solved by a promise to construct a further room at Millbank. The bequest was now sent there *en bloc*, and the Tate was provided with a second official name as the National Gallery of Modern Foreign Art. Four pictures from the Lane Bequest are reproduced here, Manet's *La Musique aux Tuileries*, Pissarro's *View from Louveciennes*, Monet's *Vétheuil: Sunshine and Snow* and Renoir's *Les Parapluies* (pages 254, 249, 253, 246). Renoir's great picture was brought to the National Gallery in 1935 and the others were among a group which came in 1950–53. At least the Manet and the Renoir reproduced are among the great French pictures of the nineteenth century. Representing yet another rediscovery of the beauty of nature and painted with a joy in painting which resembles the Venetian, they are mirrors reflecting the authentic face of France.

There must have been some heartburnings in Trafalgar Square about their immediate disposition. Otherwise it seems difficult to explain the National Gallery's act of the following

year, when it bought a number of less important nineteenth-century French pictures at the sale of the painter Degas in Paris and retained them for itself. These included three pictures by Ingres, the full-length portrait by Delacroix, *Baron Schwiter* (page 242), and three fragments from Manet's second version of *The Execution of Maximilian*. Five years later Mr Samuel Courtauld created a fund for the purchase of paintings by French artists of the later nineteenth century and made provision for the National Gallery to take its choice of the purchases made by the Fund's Trustees; but it was not until 1950–53 that a group of Courtauld Fund pictures was taken to Trafalgar Square, when a room was filled with French pictures of their kind. These include two large pictures by Degas, the early *Petites Filles Spartiates provoquant des Garçons* and *La La à la Cirque Fernando, Paris* (page 302); and, above all, the greatest picture bought from the Courtauld Fund, Seurat's *Baignade*.

THE POST-WAR YEARS

The National Gallery and Tate Gallery Act of 1954 gave no definition of the word 'modern' in defining the functions of the two Galleries, while it made the Trustees of the Tate Gallery owners for the first time of all the pictures under its roof. The Tate, however, could not, if it would, fill the most serious gaps among the National Gallery's nineteenth-century pictures. In 1956 Delacroix's *Ovid among the Scythians* (page 301), a picture much prized by Baudelaire, was bought, and in 1964 Courbet's brilliant study for his *Demoiselles aux bords de la Seine*. In 1953 Cézanne's *La Vieille au Chapelet* (page 257) was bought, and in 1962 a late landscape, *Dans le parc du château noir*. The Gallery can never attain to such a wealth of French nineteenth-century painting as many of the great American museums enjoy, but it is still possible for it to achieve a representation of what is now the latest school of 'old masters' in due proportion to the Gallery's greatness.

This is only one of the many problems which face the National Gallery today. That the Trustees and staff are fully aware of this has been made plain since 1958 in a series of reports published at deliberately irregular intervals in which some of the ordeals and achievements of these years are described and the paramount needs of the future are set out.

Inspired perhaps by these Reports, the Government has in recent years taken several steps which together enable the Gallery to face the future without too much despair at the fantastic rise in the price of works of art. In 1955 and 1957 special grants were made to save from export El Greco's

brilliant sketch for *The Adoration of the Name of Jesus* (page 292) in the Escorial and Poussin's *Adoration of the Shepherds*. The Finance Act, 1956, allowed the Chancellor of the Exchequer to accept works of art in payment of Estate Duty, and it was by these means that were acquired van der Weyden's *Pietà* and Memlinc's *Donne Triptych*, together with two other pictures from the Duke of Devonshire's collection, *An Old Man* by Rembrandt and the great double portrait by Jordaens. In 1959 the grant-in-aid was increased from £12,500 to £100,000, and a generous additional grant was made towards the purchase of Uccello's *St George and the Dragon* (page 88). The price of about £126,000 paid for this picture is by no means high for the present day; but a comparison with some of the prices which were paid for pictures of similar character in the past will help to measure the problems of the European museum which wishes to remain a living growth.

As to the building, the ancient barracks were removed long ago, in 1901, and before the war additional rooms had gradually provided almost as much exhibition space to the west of the centre as there had been since 1876 to the east. There remains space for further expansion to the north on the barrack site and the Government has recently bought a new site to the west; but for some years building developments are likely to be confined to the reconstruction of what was destroyed during the war and the remodelling of the rest.

The war left the Gallery with few panes of glass in its ceilings, with much of the roof-work deteriorated, with the floors of the exhibition storey damaged by fire and water and with one Room totally destroyed together with a staircase adjoining it

and the space below it on the Ground Floor. The pictures had been safely stored in Wales, deep in a mountainside where air-conditioned chambers had been built in a slate-quarry; and at the end of the war enough of the National Gallery building remained water-tight for all the pictures to be brought back to Trafalgar Square almost before hostilities had been concluded. It was even possible to put a number of pictures back on exhibition at once, and this number was rapidly increased as the ceilings were temporarily repaired.

The policy was to return as many pictures as possible to the public which had been so long without them, whatever the appearance of the building. This coincided well with the fact that priority in reconstruction work had to be given to other buildings; but it did not of course make the work of reconstruction easier when the turn of the Gallery came. It has never been closed to the public and reconstruction has proceeded in stages.

However by 1961 there was even one more Room open to the public than in 1938, and this additional Room made the complete circulation of the building possible for the first time. The building has been much improved throughout, with air-conditioning brought to thirteen Rooms, of which eight have been totally remodelled. These are all on the West side of the building, and beneath them the Ground Floor has been completely remodelled to allow of a greatly increased Reference Section. This was opened in the Spring of 1964. The Reference Section is air-conditioned and the pictures there are all shown by artificial light on movable screens. It is approached from the Main Floor, where a single Reference Section Room contains a

staircase. On the Main Floor there continues to be natural lighting by day, modified in the new and remodelled Rooms by the addition of lay-lights. Fluorescent lighting has been installed throughout the Main Floor, and the walls covered with silk damask.

There are some two thousand pictures in the collection – a small number compared with that in such great national collections as the French or the Austrian or the Spanish. About half the number are exhibited on the Main Floor, the other half in the Reserve Collection below. In 1966 the policy was resumed of lending to regional galleries throughout England. The loans service, which has been largely suspended of recent years, is arranged in conjunction with the Arts Council.

By means of air-conditioning the climate of London has been defeated at last, and in the air-conditioned rooms the pictures have been freed from the glass which has covered all the pictures in the Gallery for more than a hundred years. Air-conditioning is the only final solution of the problem of picture-conservation, which since the war has been carefully studied at the National Gallery. Founded in 1946, the Conservation Department has established a routine of inspection and first aid treatment which has done much to slow the inevitable process of deterioration. By thorough cleaning and restoration it is also gradually transforming the appearance of a collection which was previously much obscured by dirt and discoloured varnishes – and in many cases by the overpainting of original paint. Discoloured varnish, which in the case of the picture itself can be discounted to some extent by the eye, makes it more than usually difficult to reproduce pictures satisfactorily in

colour. For reproduction in this book as many cleaned pictures as possible have been chosen, and some of these are striking examples of the transformation which pictures may undergo at the hands of the Conservation staff. For instance, Bronzino's *Allegory of Time and Love* (page 170) and Titian's 'Noli me tangere' (page 178), since they were freed from much brown varnish and from additions made by improving restorers, have become very different pictures.

The fundamental problems of conservation are being studied by the Scientific Department, with the assistance of the Honorary Scientific Advisory Committee, a body of distinguished scientists who advise the Trustees on all scientific aspects of the Gallery's administration. This Department, also virtually founded in 1946, has already done a good deal of research into the properties of both varnishes and the solvents which are needed to remove them. Old pictures painted in tempera or oil depend for their full beauty, as no other work of art, upon a surface layer which is not necessarily a part of the original. The practice of varnishing is thus hundreds of years old; yet the traditional varnishes maintain their full efficiency for a surprisingly small number of years. Within a short time they lose much of the brilliance which they originally imparted and cease to give full protection from the atmosphere; and in a few more years they are often so discoloured that the appearance of the picture may be seriously distorted. The Scientific Department is working for the development of a varnish or a system of varnishing which will function more efficiently and thus enable pictures to retain their original appearance for as long as possible without the intervention of the cleaner.

Meanwhile the Scientific Department by analysis of pig ments and media is building up a body of knowledge about the technique of the old masters which is of growing assistance to both restorers and art historians.

The routine work of X radiography and photography by infra red or ultra violet light has been taken over by the Photo graphic Section of the Publications Department. This Depart ment has also greatly developed since the war. The National Gallery as a whole is financed, except for Trust Funds, by the Treasury. The Chancellor of the Exchequer is directly re sponsible for it to Parliament and its accounts are audited by the Comptroller and Auditor General. The Publications Department, however, was financed at its foundation more than thirty years ago from the Lewis Fund. It now employs a private firm of auditors and is responsible only to the Board of Trustees. Out of the considerable income which it is able to make by an exceptional enterprise in colour reproduction it has been able to finance not only a series of learned and detailed catalogues of the collection, school by school, but an accom panying series of books of large scale reproductions in which every picture in the collection will be reproduced in black and white.

Such books are of course the product of the art historians of the Gallery staff. A team of Deputy and Assistant Keepers is applying consummate learning to this task. Up to date cata logues covering virtually the whole of the collection are now in print, and the scheme should be completed very shortly. It is difficult for me to express my full debt to the authors of sections both published and unpublished without seeming to involve

them in some reponsibility for the personal views which I have expressed in the anthology that follows. I have borrowed much of their scholarship; but for what is not scholarly they are in no way to blame. For many of the facts given in this introductory chapter I am also indebted to *The Making of the National Gallery* (1924) by Sir Charles Holmes.

THE PLATES

DUCCIO (active 1278; died 1319) *Italian School*
THE TRANSFIGURATION Panel
Catalogue No. 1330 Height 0·44 m. (17⅜")
Width 0·46 m. (18⅛")

Christ only stands erect; so that, though he is a little nearer than Moses and Elias, his head is the apex of the design; and he alone is composed. He appears as the *Salvator Mundi*, and his mantle of ultramarine blue and robe of deep rose colour, both streaked as they have been in Byzantine painting with gold, are a departure from the Gospels:

'And after six days Jesus taketh Peter, James, and John his brother, and bringeth them up into an high mountain apart, And was transfigured before them: and his face did shine as the sun, and his raiment was white as the light. And, behold, there appeared unto them Moses and Elias talking with him' (Matthew, XVII, 1–3).

The moulding still surrounding the picture served to separate it from the others in the predella of an elaborate altarpiece, Duccio's *Maestà*, still at Siena. The National Gallery has two more scenes and others are in Washington, D.C., and in the Frick Collection, New York. The altarpiece was commissioned in 1308 for the high altar of Siena Cathedral. It was specified in the contract that Duccio should paint it all with his own hand. When it was completed, in 1311, it was borne from his studio to the Cathedral with ceremony and great rejoicing.

It does indeed represent the quintessence of painting in tempera. The thirteenth century had seen fresco-painting establish itself in Italy as the equal in monumental quality of the mosaic of the Byzantines, more quickly executed and more subtly adaptable to the humanistic awakening of the times. The Florentine Cimabue and, before him, Guido of Siena had painted great panel pictures in the same sweeping manner. Confining himself apparently to panels, Duccio further humanized their Byzantinesque tradition by developing the narrative element and the sense of space. He painted more intimately, with flowing, Gothic line and softer, more varied colour.

These panels represent the last phase of his art, when the design is looser, and line and modelling and colour are still more softly fused. In *The Transfiguration* the upper part of St John's body has been destroyed and the restorer has sketched an idea of the missing part in monochrome.

This panel was given to the Gallery by R. H. Wilson in 1891.

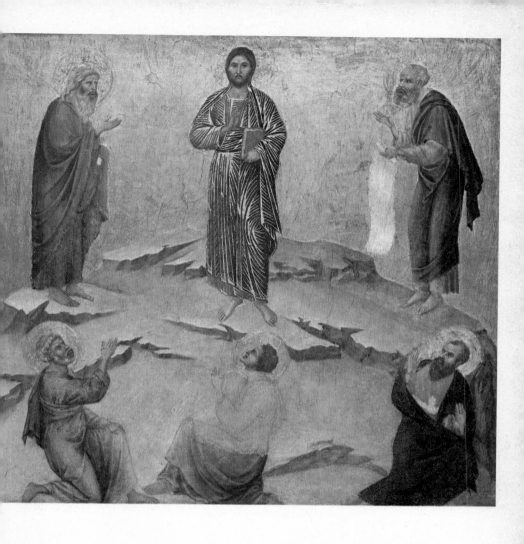

THE MASTER OF SAN FRANCESCO (active 1272) *Italian School*
THE CRUCIFIX Panel
Catalogue No. 6361 Height 0·92 m. $(36\frac{1}{8}'')$
Width 0·70 m. $(27\frac{5}{8}'')$

In the almost square centre of the Cross the three Maries form a group on one side of the body, St John and the good Centurion on the other. The compression of these groups and their very much smaller scale emphasize the majesty already given to Christ's figure by the broad sweep of the form. Thus the Cross itself is a background in both senses of the word, psychological and physical. Its square centre expresses the sorrow and contrition of Christ's followers, while the shape of the whole, with its complex grandeur, its burnished gold and pure ultramarine blue, is richly hieratic. It is the visual equivalent of great church music.

The 'Master of San Francesco' has been so christened by art historians after the picture of *St Francis with two Angels* in the Museum of S. Maria degli Angeli near Assisi. The only dated picture among the group of panels attributed to him is the huge 'Crucifix' of 1272 now in the National Gallery for Umbria, Perugia. The London *Crucifix* is on a minia-ture scale by comparison; but there are very close analogies between the two in drawing and in colour. Intended to be seen at much closer quarters, it is more complex in design and subtler in quality, with delicate nuances of colour.

This is the earliest among the great pictures of the Collection, and by its whole character emphasizes the religious origin of European painting. There were already narrative scenes painted in fresco on the walls of churches; indeed the tradition of narrative fresco painting probably went back almost to the earliest Christian times. Nevertheless, a picture of this kind, hieratic in intention, decorative in effect, is more typical of the late thirteenth cen-tury, and could not have been painted during the Renaissance. In Piero della Francesca's *Nativity* one can see virtually the same colours used two centuries later to create a convinc-ing impression of atmosphere. In the *Crucifix*, design and expression are all that matters.

The picture was unknown until 1925, when it entered the collection of Adolphe Stoclet in Brussels. It was bought through Agnew's from his son, Philippe Stoclet, in 1965.

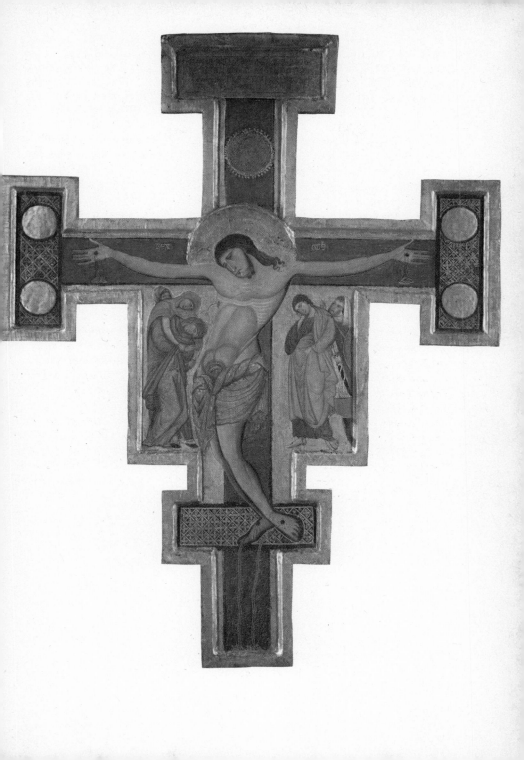

FRA ANGELICO (1386/7?–1455) *Italian School*
CHRIST GLORIFIED IN THE COURT OF HEAVEN Panel
Catalogue No. 663 Height 0·32 m. ($12\frac{1}{2}''$)
Width 0·73 m. ($28\frac{3}{4}''$)

In a radiance of gold above the blue dome of Heaven, Christ appears as at the Resurrection, bearing the standard and showing His wounds. He is surrounded by the Angelic Host, a tongue of flame on every forehead.

The closely-packed host is all of one blond type and dressed in a tunic of the same design. But the closeness of the ranks is used to point the lovely freedom of movement of those with their toes upon the blue; the gestures are tirelessly varied and every face is luminous. Not one of the host but plays his full part; and the changes among the few radiant colours are rung as musically as with a peal of bells.

Angelico was to become one of the great painters of the Florentine Renaissance. This comparatively early design, which explains as well as any other picture the origin of the name by which he came to be known, shows at least how well the joy of his faith was matched by the purity of his means of expression.

This is the central panel of five in the Gallery which form a continuous scene in a predella more than seven feet wide. Angelico passed much of his life in the friary of San Domenico near Florence and became its Prior. This was the predella of the high altarpiece, which he painted probably about 1435. The main panels, still in the church, were overpainted by Lorenzo di Credi about 1501. The predella was bought in 1860 from the nephew of the Prussian Consul in Rome.

84

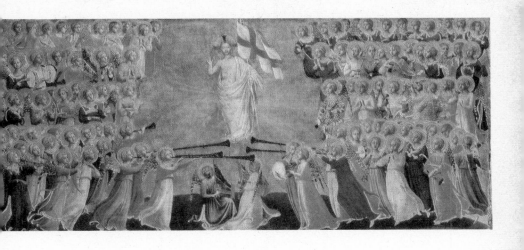

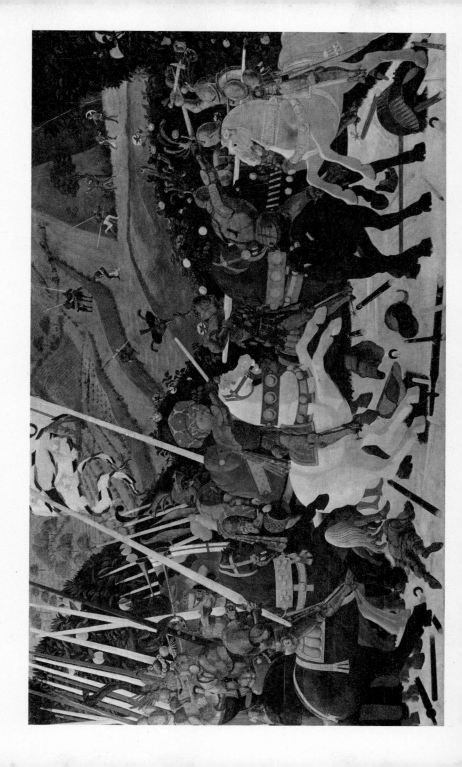

PAOLO UCCELLO (1397–1475) *Italian School*
NICCOLÒ DA TOLENTINO AT THE BATTLE OF SAN ROMANO Panel
Catalogue No. 583 Height 1·82 m. $(71\frac{1}{2}'')$
Width 3·20 m. (126")

When Uccello painted this picture and its companions in the Uffizi and the Louvre he must have been about sixty. His only pictures on a large scale which have survived in fair condition, they show a preoccupation with design and craftsmanship which is probably characteristic.

An inventory of 1492 shows that they represent *The Battle of San Romano*, in which the Florentines claimed to have defeated the Sienese. Niccolò da Tolentino, hero of the day, is probably the knight in the centre.

They were painted for the newly built Medici Palace (now Palazzo Riccardi) in Florence. Separated probably by wooden pilasters, they formed a more or less continuous design, with the National Gallery picture, in which the movement is from left to right, on the left.

It was bought with the Lombardi-Baldi collection in Florence in 1857.

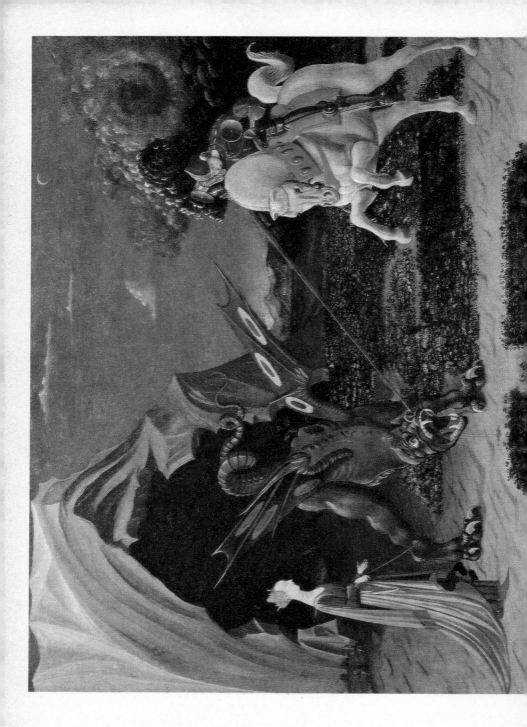

PAOLO UCCELLO (1397–1475)
St George and the Dragon
Catalogue No. 6294

Italian School
Canvas
Height 0·565 m. (22¼″)
Width 0·74 m. (29¼″)

The crescent moon, which is almost a signature in Uccello's latest pictures, is not the source of a logical scheme of lighting but the key to the magic of the scene, to the eerie radiance which distinguishes it from the sunlit pictures which fill the rest of the Room. From behind the hero, whose battle colours of white and red are those of his charger and its trappings, an electrical disturbance in the sky directs his lance unerringly. Wounded, the dragon becomes submissive and St George bids the princess fasten her girdle round its neck, so that they can lead it off into the town. The dragon lived in a lake, which Uccello has depicted as a pool in the cave, and the town had been regularly buying peace from it first with two sheep for its meal and then, when mutton grew scarce, with one sheep and an equally tender human. Fortunately, St George of Cappadocia was passing when the lot fell upon the princess.

It was a common thing for two or more episodes from the same story to be illustrated in one picture. But the unique way in which Uccello here has combined two episodes in a single intensely unified design is characteristic of his aims. He has come down to us through history as the painter of perspective, though he would seem to have mastered its principles only after others had done so, including Masaccio who had now long been dead. His triumph here is to have organized the entire design in depth in a way which had never been achieved before. Even the pink profile of the princess is a foil to the tenebrous depth of the cave and everything else in the picture is charged with dynamic movement both into space and towards the unity of the design.

This is the earliest picture in the Gallery which is painted in oils on canvas. Tentatively, it might perhaps be described as one of the first easel pictures, portable pictures in detachable frames intended to be hung wherever most convenient or pleasing.

Brought from Italy to Vienna towards the end of the last century, the picture was bought in 1959 from Count Lanckoronski for about £126,000.

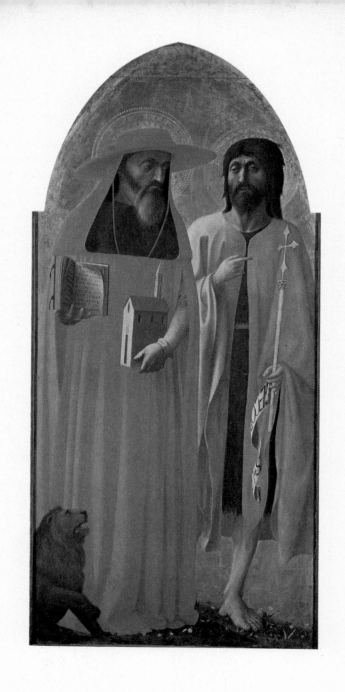

MASOLINO (c. 1383–1432?)
ST JOHN THE BAPTIST AND ST JEROME
Catalogue No. 5962

Italian School
Panel
Height 1·14 m. (45″)
Width 0·55 m. (21½″)

This is the left wing of a triptych, of which the centre is now in Naples, the right wing in Philadelphia. The triptych was painted both sides. All the panels have been sawn in two, but each museum possesses both pictures. The other National Gallery painting seems to be largely assistant's work.

The triptych was painted for S. Maria Maggiore in Rome about 1426–30, after Masolino had felt the young Masaccio's influence; indeed Masaccio has been considered the author of this panel.

In the second half of the seventeenth century the six pictures were in the Farnese Palace in Rome. The two centre pictures were sent to Naples in 1760; the other four became part of the large collection of Napoleon's uncle, Cardinal Fesch; soon after 1845 these two were acquired probably by Sir R. Shafto Adair, from whose descendant, Major-General Sir Allan Adair, they were bought in 1950.

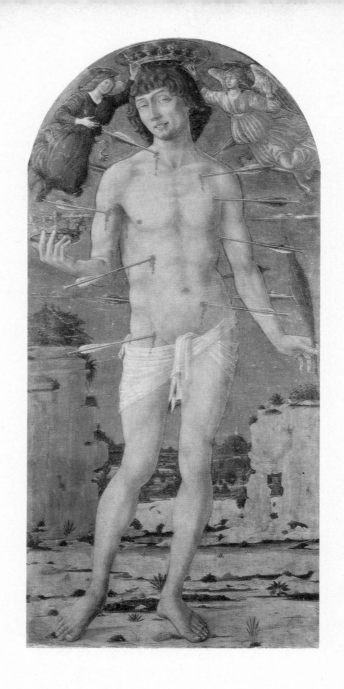

MATTEO DI GIOVANNI (active 1452; died 1495) *Italian School*
St Sebastian Panel
Catalogue No. 1461 Height 1·265 m. $(49\frac{3}{4}'')$
Width 0·60 m. $(23\frac{1}{2}'')$

Matteo probably came from Borgo Sansepolcro, the birthplace of Piero della Francesca; but he lived at Siena and worked in the Sienese tradition.

In the thirteenth and fourteenth centuries the Sienese and the Florentine had been only varieties of the same Tuscan tradition, and the artists of each could be influenced by the other, with advantage to both. But the direction which Masaccio gave to the Florentine Renaissance, its scientific exploration of the appearance and the moods of humanity and of nature, the very oil technique which it gradually adopted for the essential conquest of atmosphere were incompatible with the aristocratic remoteness from the world which the Sienese maintained, with their abstract quality of expression, the high priority which they continued to give to decorative values. Two so divergent traditions could hardly survive in such proximity.

This is one of the last competent examples of tempera. It was bought for £571 in 1895.

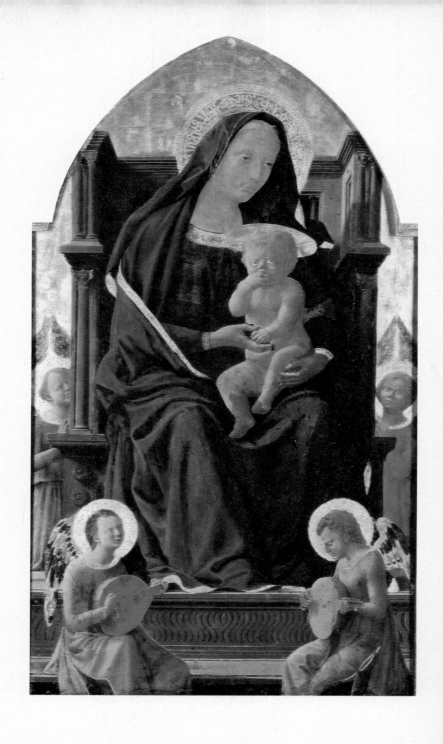

MASACCIO (1401–27/9) *Italian School*
THE VIRGIN AND CHILD WITH ANGELS Panel
Catalogue No. 3046 Height 1·355 m. $(53\frac{1}{4}'')$
 Width 0·73 m. $(28\frac{3}{4}'')$

The frame must have been Gothic, like the shape of the panel, the ground of the picture is gilded and pounced, according to tradition, and the wings of the Angels are laid in gold-leaf and parti-coloured with glazes. But they wear these little appendages with a bad grace, rapt as they are in the general mood of tragic solemnity, sounding low notes. Above them the solid Child scowls as he stuffs the purple grapes into his mouth, and finds them bitter; while His mother leans over to protect him, heavy with foreboding.

Her throne, built in the severe Florentine *pietra serena*, might have been designed by Brunelleschi, who had already introduced the architecture of the Renaissance in Florence. Her bulk equally belies the gold, her outlines implying as much solidity and space behind them as before, the heavy forms and the deep shadow spelling revolution from the Gothic tradition, with its graceful calligraphy and decorative colour. In spite of its remnants of tradition, this panel stands for the birth of the painting of the Renaissance.

It is the centre of Masaccio's one fully-documented work, the altar-piece, painted in 1426 in Florence, for the Carmine church at Pisa. Masaccio was then about twenty-five. He died when he was about twenty-seven.

This centre panel has now been in England for at least a hundred years. It was bought for the Gallery for £9,000 in 1916.

FILIPPO LIPPI (c. 1406–69)
THE ANNUNCIATION
Catalogue No. 666

Italian School
Panel
Height 0·685 m. (27")
Width 1·52 m. (60")

Out of the dark cloud at the apex comes the hand of God. The hand is in a faint globe of light, the first of a pullulation of such globes which diminish in size until the last and smallest encloses the Dove hovering above the Virgin's knee. A flash of gold comes from the hand; another from the Dove; another is a little explosion from the Virgin's brilliant rose gown.

Gabriel's mission is thus a ceremonious one. He comes as to a royal audience, a great cloth of gold completely enveloping the Virgin's high-backed throne and acting as carpet on its marble plinth beneath her feet.

The luxury of effect is made subtle by infinite gradations of soft light; it is given meaning by sharp, hard qualities of form and design; in itself it is achieved only by devoted crafts-manship. But the resulting impression makes it easy to believe the old stories about Fra Filippo. According to Vasari he was apt too often to pursue pleasure at the expense of his painting.

This picture and its pendant with *Seven Saints* came, like Uccello's *Battle,* from the Medici (now Riccardi) Palace in Florence. Hence the Medicean emblem carved in the stone panel beneath the vase of lilies: three feathers in a diamond ring. They remained in the Riccardi Palace until nearly the middle of the nineteenth century, and were acquired by the Gallery in 1861.

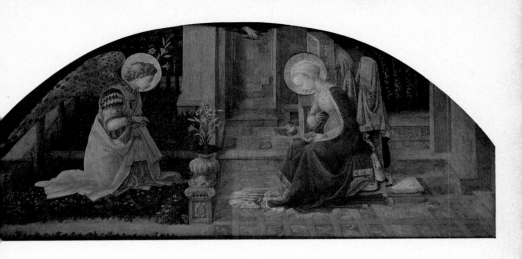

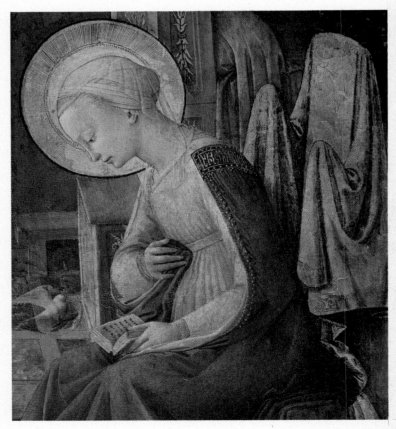

SASSETTA (Stefano di Giovanni, 1392?–1450) *Italian School*
St Francis renounces his Earthly Father Panel
Catalogue No. 4758 Height 0·875 m. $(34\frac{1}{2}'')$
 Width 0·525 m. $(20\frac{3}{4}'')$

The scene is Assisi, where Francis was born in 1182 and died in 1226. Just before this incident, the future Saint had taken goods from his wealthy father and given the proceeds of the sale for the repair of his favourite church. His father, frustrated in other attempts to restrain his son, has now brought him before Bishop Guido. The result is only the final renunciation of his heritage by Francis, who is soon to found the mendicant order which bears his name. The splendid gown which he has worn is now over his father's arm and the undergarments at his feet. Francis stands naked between the knees of the Bishop, who draws round him his cape of green brocade while he holds up the other hand at the enraged merchant.

This is one of eight *Scenes from the Life of St Francis,* of which six more are also in the Gallery, the eighth at Chantilly. They are from the back of an altarpiece with five wings. On the front were a *Virgin and Child* now in the Louvre and *Four Saints,* in full length, of which two are in the Louvre and two in the Berenson collection near Florence. With the eight scenes on the back was the full-length figure of *St Francis Triumphant* also in the Berenson collection.

The altarpiece was commissioned from Stefano for the high altar of S. Francesco at Borgo Sansepolcro in September 1437. The elaborate contract stipulates that it is to be handed over within four years at Siena, where the artist lived; but that he is to go to Sansepolcro to set it up and make good any damage done during its journey. All the conditions were fulfilled, though not until June 1444. The seven panels were bought for the Gallery for £43,000 in 1934.

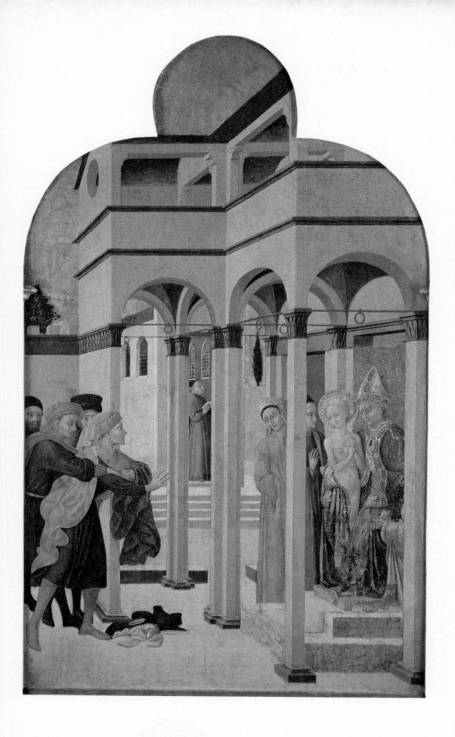

ALESSO BOLDOVINETTI (c. 1426–99) *Italian School*
Portrait of a Lady in Yellow Panel
Catalogue No. 758 Height 0·63 m. ($24\frac{3}{4}''$)
 Width 0·405 m. ($16''$)

Whether it is behind the rose skirt glimpsed at the base or behind the little pyramid of pearls which provides the pale silhouette with such a surprising apex, the blue is the same unvarying blue in tone. Nevertheless it is far away behind the figure and somehow charged with atmosphere. And, though the silhouette is so bright and so clean cut, there is an extra brilliance along its edge as if the lady were set against the high sky of noon. This is a portrait *en plein air*.

The living quality of the light, which must originally have been dazzling, is due not only to the high key of the thin colour but to the lively texture of the surfaces. Where the portrayed light falls upon the forms portrayed, the actual light is caught by paint applied in raised dots. This is in fact a *pointilliste* technique; though the dots are contrasted, not as in 'impressionist' pictures in colour, but in tone, above all with the areas of faint shadow got by smooth, cool glazes and with the unbroken sky.

These subtleties of light and colour and texture are subtleties of form, for they enable Baldovinetti to build the full impression of a living, tangible personality upon the starkest outline. They are so subtle, so nearly imperceptible that they only reinforce the outline's wonderful distinction, its statement of nothing but the integral and dignified facts of character; yet they come from the study of nature, from the obervation of form in the pure light of day. In this picture, for all its sophistication, Baldovinetti treats colour and light and form as all one, and all as part of nature.

It is not surprising that it was bought and for long catalogued as the work of Piero della Francesca, especially as the Florentine dealer from whom it was bought for £160 in 1866 said that it came from Ascoli on the other side of Italy. Baldovinetti can be certainly traced only in Florence.

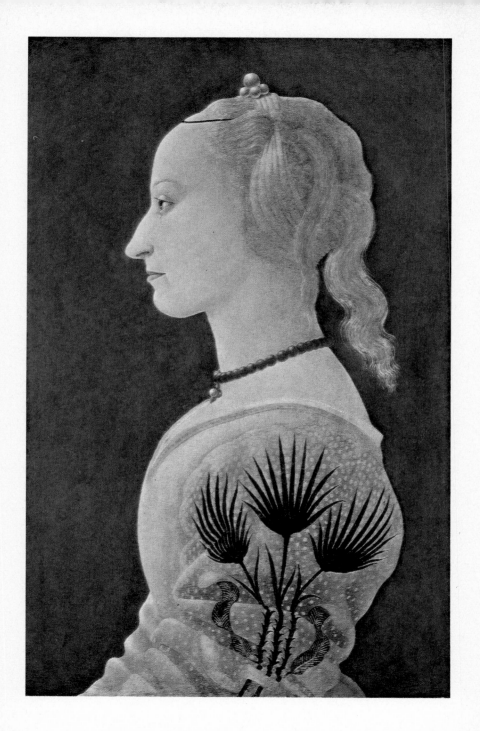

ANTONIO (*c.* 1432–98)
AND PIERO (*c.* 1441–*c.* 1496) *Italian School*
DEL POLLAIUOLO
THE MARTYRDOM OF ST SEBASTIAN Panel
Catalogue No. 292 Height 2·915 m. ($114\frac{3}{4}''$)
 Width 2·025 m. ($79\frac{3}{4}''$)

Before his execution the Saint was cruelly used by archers as a popinjay. This happened
outside Rome; hence the Roman ruin and in the distant town the two columns like those
of Marcus Aurelius and Trajan. But, though Antonio Pollaiuolo was more than once in
Rome, this panorama reminds one of the valley of the Arno near his native Florence.
Homely, in spite of its vastness, and glittering with reflections of the luminous sky from
the moving objects on the plain, the landscape must have been as much of a surprise in its
realism as any of the figures. Except for a few rare examples in the fourteenth century, land-
scape had so far lacked this earthy poetry.

Similarly, though the grouping of the figures is naively symmetrical, the two archers in
the centre foreground – clothed and naked, front and back – are objectively observed, as a
sculptor might have observed them at a time when anatomy was a new and enthralling
science. Their pose is chosen to give them not grace but depth and weight as well as move-
ment: their outlines seem the result of the play of their own muscles rather than of the
artist's preconceived idea of style.

Often the painting itself is unprecedently free and painterly. Local passages, the decora-
tion of a bow or the spray of a distant waterfall, are handled with delight not so much in
design and craftsmanship as in making the very quality of the paint seem identical with
that of the thing painted. This amounts to a supreme subtlety in representing form.

All these are perhaps reasons for divining in the more vital parts of the painting the hand
of Antonio Pollaiuolo, a sculptor of proven mastery in bronze who is known to have been
also a painter. It is first recorded, however, in 1510, as the work of Antonio's younger
brother Piero. He too is recorded as a sculptor, but his authenticated pictures are without
this exceptional vitality.

The altarpiece is said to have been painted in 1475 for the Oratory of St Sebastian in the
SS. Annunziata in Florence. This was the chapel of the Pucci family, from whom this
painting was bought for £3,155 in 1857.

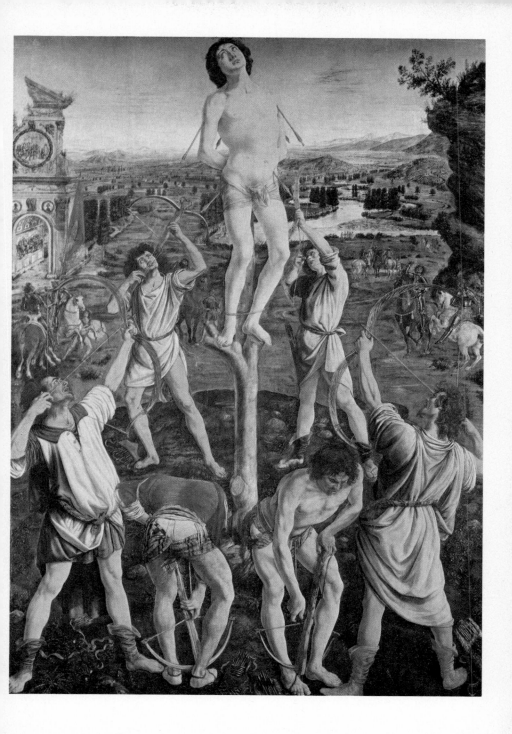

SANDRO BOTTICELLI (c. 1445–1510) *Italian School*
VENUS AND MARS Panel
Catalogue No. 915 Height 0·69 m. $(27\frac{1}{4}'')$
 Width 1·735 m. $(68\frac{1}{4}'')$

Venus reclines like a Roman at a feast, a more than naked foot protruding from her diaphanous gown. The golden border of the gown matches her gilded hair, and it seems that two braids of hair meet in her brooch to make a collar to it and to prove that neither hair nor gown are mortal properties. Smugly triumphant, the Goddess watches, while Mars, defeated in the lists of love, sleeps, the languor of the vanquished instilled in every line. He is deaf to the buzzing of the wasps, even to the blast of the conch that an infant Satyr is blowing full into his ear. In spirited rhythmic unison with the conch-blower, two more little Satyrs steal off with his helmet and his lance. The scene is a grove of myrtle, the plant emblematic of love in antiquity; and through the gap, beyond the enamelled green foreshore, is the green sea out of which Venus had her legendary birth.

The motif of Love's carrying off the weapons of the warrior probably comes from the description of the marriage of Alexander and Roxana by the Greek satirist Lucian. At the court of the Medici in Florence, Botticelli was the favourite illustrator of the idylls of antiquity and their contemporary imitations.

Here the wasps may be a pun on the same Vespucci (since wasp = vespa). The Vespucci family commissioned several pictures from Botticelli. These included decorations enclosed in the richly ornamented panelling of a room; but, though it came from Florence, the early history of *Mars and Venus* is not known. It was acquired there by Alexander Barker and was bought at the Barker sale for £1,050 in 1874.

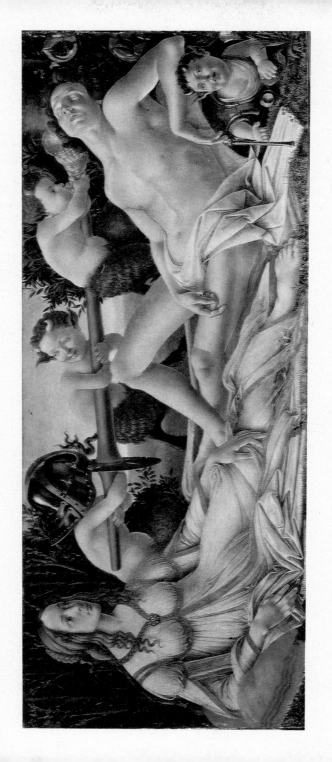

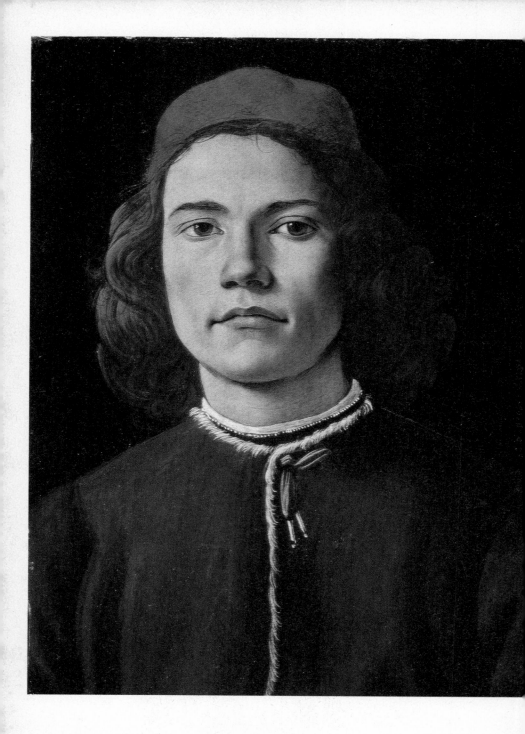

SANDRO BOTTICELLI (*c.* 1445–1510)
PORTRAIT OF A YOUNG MAN Panel
Catalogue No. 626 Height 0·375 m. ($14\frac{3}{4}''$)
Width 0·282 m. ($11\frac{1}{8}''$)

In modern times portraiture has become largely a thing for specialists. The portraitist puts all his skill into getting an immediate likeness and is apt to be content with making a facsimile illusion of the sitter's outer skin. He is in competition with the photographer; but, since the full illusion of form requires colour, he can surpass the photographer without much difficulty even at this mechanical game.

The great portraits of the world, however, are by idealists. The artist whose business is invention may depend also upon appearances; but he goes to nature for what is best in her. He is seeking in form what is basic and permanent, and he modifies it and rearranges it to express his ideas. Consequently he brings to portraiture the power not only to eliminate the momentary and superficial but to idealize what is deep and lasting.

By the second half of the fifteenth century the demand for portraits in Italy came by no means only from princes, and almost every great artist tried his hand at it. The Renaissance meant a revival of man's interest in individual man, and Masaccio had developed his modelling in light and shade largely for the sake of subtleties in characterization. It is no great wonder that this portrait was attributed to Masaccio when it was bought nearly a century ago, and for some time after. Compared with him, Botticelli is technically an old-fashioned painter. Line remained his essential means of expression, so that a picture such as his *Mars and Venus* is like an elaborate coloured drawing beside a picture by Masaccio, or by Giovanni Bellini or Leonardo, who were roughly Botticelli's contemporaries.

But this youth, who is quietly but by no means inexpensively dressed in a fur-lined tunic over a black under-dress, seems to look at us just as he looked at Botticelli. Botticelli's outlines are there, sensuous and expressive as ever; but they are adapted to the still plastic quality of the boy's character, melting into the shadow in a way that suggests that the light was there before the form. Texture and colour, form and light, body and spirit, are all one.

The picture belonged to Lord Northwick by 1837. It was bought for £108 at the Northwick sale in 1859.

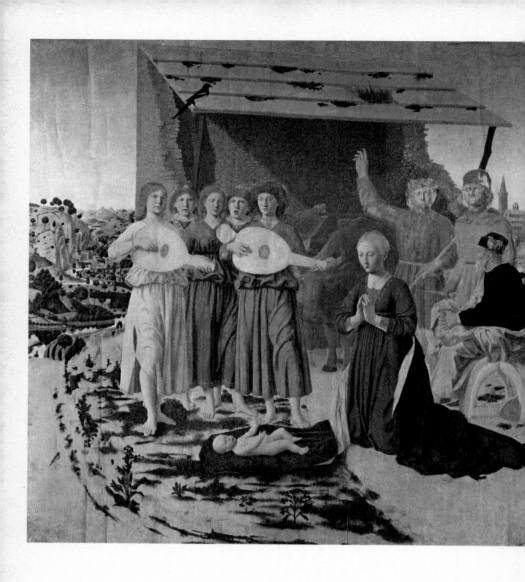

PIERO DELLA FRANCESCA (active 1439–92)　　　　　　*Italian School*
THE NATIVITY　　　　　　　　　　　　　　　　　　　　　Panel
Catalogue No. 908　　　　　　　　　　　　　Height 1·245 m. (49″)
　　　　　　　　　　　　　　　　　　　　　Width 1·23 m. (48¼″)

The theme is the first of all Christmas hymns, sung over the Child by an Angelic choir. One knows that these sturdy beings are Angels not by wings or supernatural beauty, or even by their stolid rapture, but by the way they have taken charge of the scene, imposing the harmony of their music upon its utter naturalness. One cannot hear the sound, but one knows that it is pure as the dry upland air whose stillness is described by the solid reflections in the river winding placidly below. The hymn that the Angels are singing is only a part of the symphony that Piero has painted, harmonizing all nature: God and man and all the visible world of form and light and colour.

Though Sansepolcro, where he was born and mostly lived, is outside Tuscany, Piero at least worked at Florence in his youth. Much of his painting has that intellectual quality which distinguished Florentine art, yet he was also clearly influenced by contemporary Netherlandish painters, with their more empirical approach to the study of nature. So with this picture: the feeling that no part of it could have been otherwise may well be due to an underlying geometrical structure; but the conviction that it also gives of things actually seen could come only from acute observation of nature. This perfect marriage between theory and observation is likely to have come towards the end of Piero's painting career.

Behind the Virgin, St Joseph sits on the saddle of the ass, which brays from the other side of the ox in the ruined shelter. Behind Joseph stand two Shepherds, one of them pointing upwards, presumably to the Star in the East. These figures are sadly ruined, apparently by a violent 'cleaning' done more than a century ago. Indeed the whole picture is rubbed in varying degrees.

Until a little less than a century ago it remained at Sansepolcro with the descendants of Piero's brother Marco. It was bought for £2,415 at the sale of an English collector, Alexander Barker, in 1874.

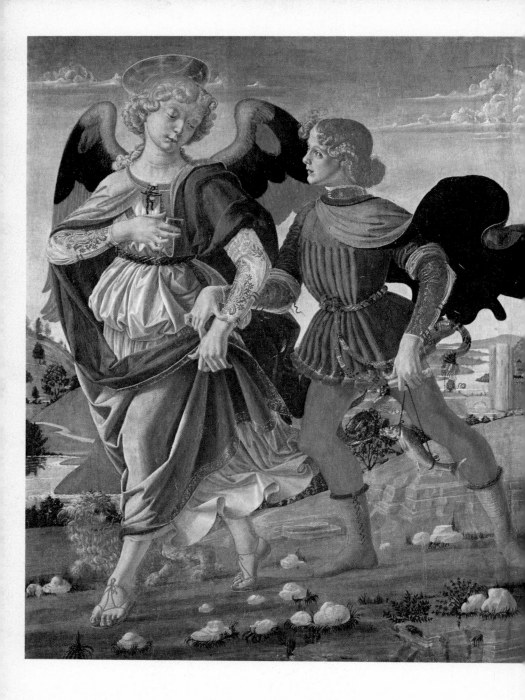

A FOLLOWER OF ANDREA DEL VERROCCHIO *Italian School*
(c. 1435–88)

TOBIAS AND THE ANGEL Panel

Catalogue No. 781 Height 0·84 m. (33″)
Width 0·66 m. (26″)

The scroll in Tobias' left hand is inscribed *Ricord* (o), presumably to show that it is the 'handwriting' which will enable him to reclaim the ten talents of silver which his father Tobit had left with Gabael at Rages in Media. Behind the young man's curly legs and flying cloak winds the Tigris, in which he had caught the fish that is slung from a finger of the same hand. The fish must be shrunken, for it had threatened to devour him: but then in the story they had roasted and eaten it as soon as it was landed. For that matter in the story the Archangel Raphael was travelling incognito as a hired guide. It was only after the happy return to Nineveh, when the miracles had been performed under his instruction, that he was to reveal himself. The little gold box which he holds in his right hand must contain the fish's heart and liver and gall. With the smoke of the heart and liver Tobias in Ecbatane was to exorcize the devils in his future wife Sara which had killed her seven previous husbands; with the gall, when they had brought home the bride and the money, he was to cure Tobit's blindness.

The story of *Tobit* from the Old Testament *Apocrypha* is used in Italian painting usually as it is here, to illustrate the character of Raphael as guardian angel. Just as the fish is a token to identify Tobias, so Tobias, though he has stolen the title of the picture, may be primarily a token to identify St Raphael – as he clearly is in Perugino's *St Raphael*, pendant to the *St Michael* illustrated on p.114.

With Tobias dressed as the dandiest of Florentine dandies, this small altarpiece in honour of St Raphael is surely one of the most light-hearted altarpieces ever painted. As such, it seems thoroughly in the spirit of Verrocchio as we know him from his vigorous and inventive sculpture and church furniture. There are even points of resemblance between these and the solemn figures in his *Baptism* in the Uffizi Gallery. But there are no documented pictures in this light vein or on this small scale.

The picture came from the collection of Conte Angiolo Galli Tassi in Florence. When he died in 1863 he bequeathed it to be sold in aid of Tuscan hospitals. It was bought together with a picture from the studio of Botticelli for £1,000 in 1867.

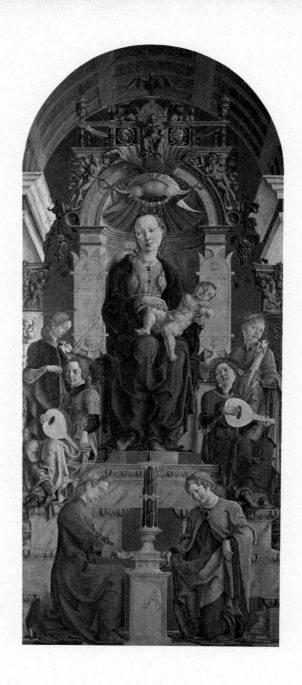

COSIMO TURA (before 1431–95)
THE VIRGIN AND CHILD ENTHRONED
Catalogue No. 772

<div align="right">

Italian School
Panel
Height 2·29 m. (94¼″)
Width 1·02 m. (40″)

</div>

The picture was the centre of an altarpiece originally in S. Giorgio *fuori* at Ferrara.

Ferrara was a tiny State kept lively by the precariousness of the position which its Este tyrants maintained among the ever-greedier powers of Europe. The Este grandeur was expressed in art of every kind. Most of this has disappeared, including the greater part of Tura's life-work; but he grew up among bronzes by Donatello and paintings by van der Weyden and Piero della Francesca. Hence perhaps this combination of a slightly provincial extravaganza of tortuous outlines and arbitrary colour with a solemn and passionate power in forms which are at once earthly and regal.

The altarpiece was damaged in 1709, when Ferrara was caught in the war between Pope and Emperor. In 1855 Eastlake acquired this panel from Federico Frizzoni at Bergamo. It was bought from his widow for £160 in 1867.

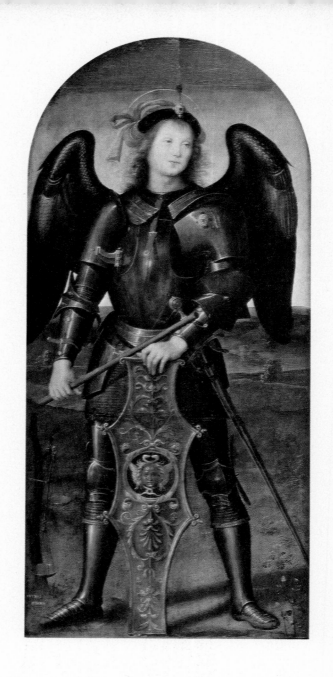

PIETRO PERUGINO (active 1478–1523) *Italian School*
ST MICHAEL Panel
Catalogue No. 288 Height 1·265 m. (49¾″)
 Width 0·58 m. (22¾″)

The altarpiece from which this picture comes seems to have been commissioned from Perugino's workshop in Florence. It is one of the three principal panels, all now in the National Gallery. It is signed on the left: *PETRVS PERVSINV(S) PINXIT*. The pendant to it is *St Raphael* and the centre panel is *The Virgin Adoring the Child*, who is held by an Angel, perhaps the third Archangel, Gabriel. The lunette with *The Eternal Father* is still at the Certosa di Pavia, the monastery founded by a Visconti of Milan and enlarged by the Sforzas.

The altarpiece was commissioned for the church by 1496, but nothing much had been done by May 1499, when Lodovico Sforza was threatening to demand a refund of the advance.

The Carthusians were suppressed in 1782. Two years later the three pictures were taken to the Brera in Milan, then a kind of clearing-house. They were bought for £3,571 from Duke Lodovico Melzi of Milan in 1856.

LEONARDO DA VINCI (1452–1519) *Italian School*
THE VIRGIN OF THE ROCKS Panel
Catalogue No. 1093 Height 1·895 m. (74⅝″)
 Width 1·20 m. (47¼″)

Leonardo was a considerable scientist, pondering the how and the why of everything; he wrote on optics and on painting. But it would never have occurred to him to paint what he saw; the problem was to paint the unknown. Indeed he almost turned his back on the fair sunlight in which his Italian predecessors and contemporaries rejoiced. In this picture at least, he is the first of the *tenebrosi*, the dark ones, the painters of shadow. As to how to paint: 'Relief is the principal aim and soul of painting.' Relief means modelling in the round, the representation of the third dimension. The words are a clue to this picture, for there are few pictures, even of the fifteenth century, in which the idea of form prevails so exclusively. The sky is boundless, cannot be reduced to terms of relief: so it is all but excluded, becomes no more than a foil to the world of Leonardo's creation. It is a world of solid form carved from his dark, scarcely human but still exquisite dreams.

It has been said that the picture is an inferior substitute for another which is all by Leonardo's hand, the version, apparently earlier in style, in the Louvre. It is mysterious certainly that there should be two pictures alike by an artist who painted very few and often did not finish them. But, while the origin of the Paris picture is unknown, the history of the London version is unusually complete.

With two other pictures, by Ambrogio or Evangelista Preda of Milan, from the same elaborate altarpiece, each with an Angel and both now also in the Gallery, it was commissioned for a chapel in S. Francesco Grande in Milan in 1483, when Leonardo had recently come from Florence. We know from a series of documents that only Leonardo was to paint the Madonna panel; that he left Milan without finishing it; that it was still unfinished in 1506; that it was then to be finished in two years and payment to be completed in two annual instalments if Leonardo returned to Milan; that Leonardo did return and received a payment in 1507. The presence of the picture in S. Francesco was recorded frequently by writers from the later sixteenth century. Towards the end of the eighteenth, it was removed to the hospital of S. Caterina alla Ruota, whence it was bought in 1785 by the painter Gavin Hamilton. It was bought for the Gallery from the Earl of Suffolk for £9,000 in 1880.

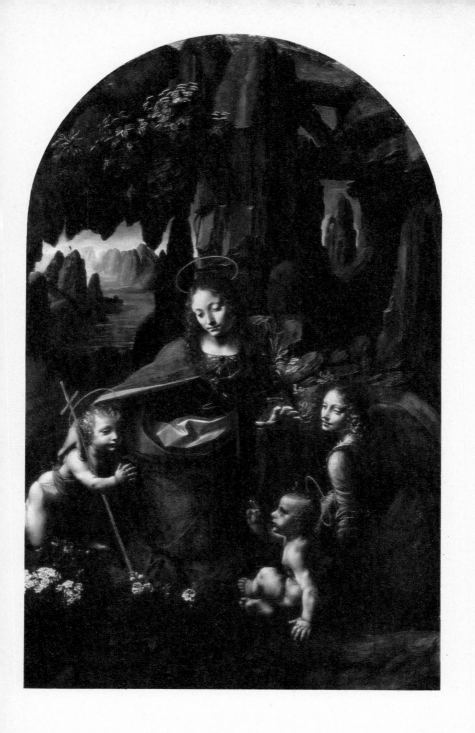

ANTONELLO (active 1456; died 1479)　　　　　　　*Italian School*
PORTRAIT OF A MAN　　　　　　　　　　　　　　　Panel
Catalogue No. 1141　　　　　　　　　　　Height 0·355 m. (14″)
　　　　　　　　　　　　　　　　　　　　Width 0·255 m. (10″)

The modern bronze bust of Antonello in the Town Hall at Messina, which was the chief scene of his activities and probably his birthplace, is based on this portrait. That it is the painter's own likeness is a tradition perhaps as old as the seventeenth century. The panel used to be longer in shape, and according to an inscription in Italian on the back, probably of the eighteenth century, the piece sawn from the bottom used to be inscribed with a statement that the sitter was Antonello himself. Unfortunately, the wording is not recorded. Antonello painted many portraits of this type and usually inscribed them *antonellus messaneus me pinxit* (antonello of messina painted me). This characteristic signature could be mistaken for such a statement. This man, moreover, does not seem to be more than thirty, but the picture almost certainly belongs to the last five years of Antonello's life, which was at least not an exceptionally short one. He is known to have had a pupil at Messina in 1456 and, if he was no more than twenty then – and he may well have been much older – he would have been nearer forty when this picture was painted.

There is no evidence to justify the comparatively modern legend that Antonello visited the Netherlands; but it is easy to believe a statement made less than fifty years after his death that he was the pupil of Colantonio in Naples. Colantonio was a follower of van Eyck and there were pictures by van Eyck in Naples. In earlier pictures Antonello too was a van Eyck imitator. By 1475–76, when he painted in Venice the altarpiece whose remains are in Vienna, he had developed a purer, more classical sense of form, less detailed and linear. This man in the red cap observing us with such calm detachment is so convincing because the descriptive detail of his head, contrasted with the extreme simplicity of his dress, the lifelike colour and the actuality of the lighting, clothe a form as solid and as simple as a sculptor's – and as clear cut.

This could be the supposed self-portrait which was at Ferrara in 1632 in the collection of Robert Canonici. It was bought for £1,040 in 1883 at Genoa, from G. Molfino, whose great-grandfather is said to have written the inscription on the back.

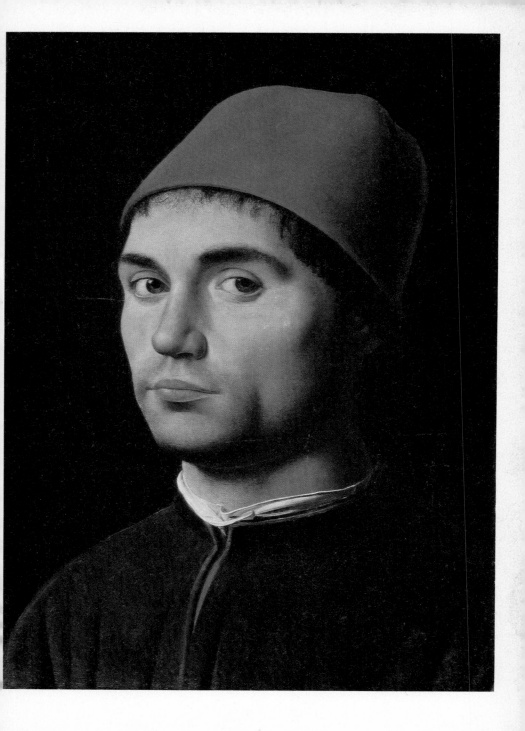

GIOVANNI BELLINI (c. 1430–1516) *Italian School*
THE BLOOD OF THE REDEEMER Panel
Catalogue No. 1233 Height 0·47 m. ($18\frac{1}{2}''$)
 Width 0·34 m. ($13\frac{1}{2}''$)

This manifestation of the *Corpus Domini* is made upon a fine pavement, which ends to
either side at a parapet with a gilded relief. In the relief on the right a man in armour sits
enthroned, holding the wand of Mercury. He appears to be administering an oath to
another armed man who holds his hands upon the tripod between them, in the presence
of a naked witness. To the left there is an altar with a fire, and the man holding a ewer in
his left hand puts out his right over the flames. Behind the altar is a naked man with a
stick, and to the left a Satyr playing a double pipe. One can read part of the dedication
inscribed on the altar: *DIS MANIB | AVR (EL) IVS*.

Roman altars and memorials had not yet been gathered into the museums, and there
was then a lively interest in their reliefs and inscriptions among scholars and artists;
especially in Padua, with its ancient university, where Mantegna reproduced motifs like
these in his early frescoes, and in Mantua, the birthplace of Virgil, where he was establishing himself about this time. Giovanni Bellini was much less pedantic than Mantegna,
who married his sister, or half-sister; but he may well have been better educated in the
classics. His father Jacopo held for long an eminent position as the Venetian painter who
had brought the ideas of Renaissance art to Venice. These reminiscences of pagan religion
are not inserted, therefore, as random decoration, but perhaps as prototypes to the theme
of Christian self-sacrifice.

That this Christ is not more convincing in structure and weight is not due either to the
limited competence of the young Bellini, or to deliberate intention; but rather to his
preoccupation with expressing in every outline, as well as in the colour, the loving tenderness which was his theme. Mysticism is hardly the quality which we associate with the
great school of Venetian painting which he was to found. Yet sensuous imagery was
perhaps only a more worldly expression of that universal love which is the strength of
this and other early pictures by Bellini.

The picture was bought for £472 in 1887.

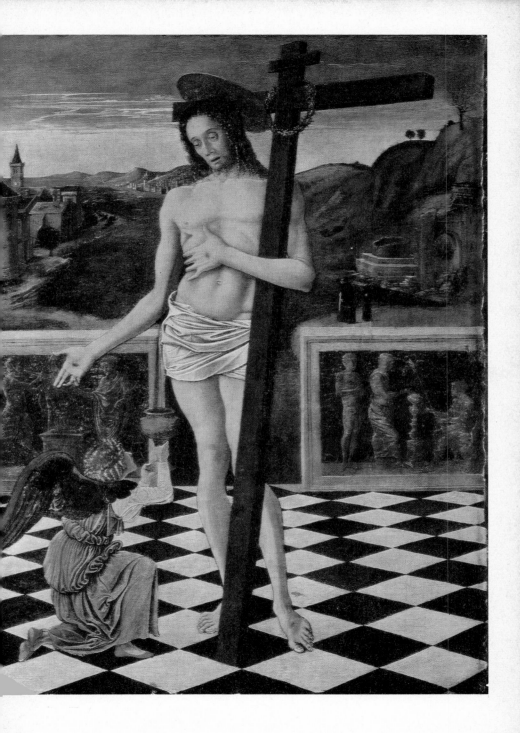

PIERO DI COSIMO (c. 1462–1521?) *Italian School*
A Mythological Subject Panel
Catalogue No. 698 Height 0·65 m. $(25\frac{3}{4}'')$
Width 1·83 m. $(72\frac{1}{4}'')$

In the old catalogues she was called Procris, a wife who was killed accidentally by her husband with a magic spear that could never miss. But this poor nymph in the costly sandals has three wounds; and is mourned not by heroic Cephalus but by a poor shy creature who, for all his goat legs and sensual features, could not even be the father of Botticelli's lusty faunlets; he could be only their silly uncle, not a satyr but a faun. Perhaps the story will turn up one day in some forgotten Italian poem.

Meanwhile a little mystery can only improve a fantasy which is too real to need a name (would they be worth more or less if we could put Latin names to those plants which bow such unbotanical red blossom from either side?). Our sympathy is ensured by all those lines of sorrow flowing downwards towards the careless little flowers carpeting the ground, quickly, as in the two connected arms, or with slow undulation, as in that long descent from his shoulders down to her toes. But it is the space and distance that convince us; and, above all, the light, throwing soft shadows over the sad bodies, beating brightly upon the ivory sands, smoothly mirrored in the sudden blue of the estuary under the uncompromising blue of the sky. One knows this is a magic landscape even by the way the boats ride upon the water, and the pelican, which must have been exotic indeed in the Florence of those days, seems no more weird than those three utterly dog-like dogs upon the shore.

Vasari, who knew several people who had known Piero, tells us that he took indescribable pleasure in 'animals, plants, or other productions out of the common order, such as Nature will sometimes bring forth either by chance or from caprice . . . insomuch that they transported him out of himself'.

The picture belonged to the Guicciardini family at Florence in the early nineteenth century, but its earlier history is unknown. It was bought for £171 from Francesco Lombardi in Florence in 1862.

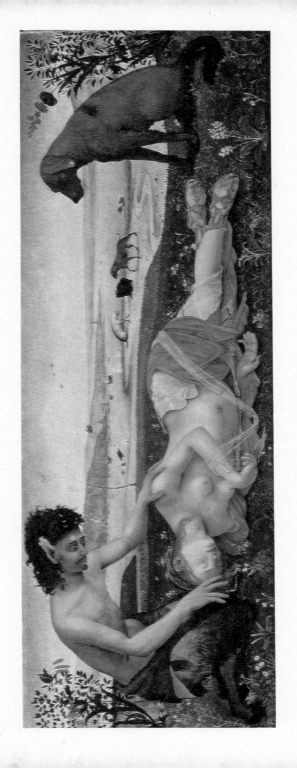

GIOVANNI BATTISTA CIMA (1459/60–1517/18)

Italian School

ST JEROME IN A LANDSCAPE

Panel

Catalogue No. 1120

Height 0·32 m. ($12\frac{5}{8}''$)

Width 0·255 m. (10")

St Jerome has made himself a rude cross of saplings, and beats his naked breast before it. Just as his little 'desert' looks the more sun-baked for the cool rich landscape beyond, so his fervour seems more anguished for the unconsciousness of the two men passing below him. They wear turbans, for this presumably is the East. It would have been unthinkable in the fifteenth century that an artist should merely paint the scene before his eyes; his business was invention. It would have been almost equally unthinkable, however, that experience should not be the source of his invention. So this is also Italy: a smiling part of it between Venice and the foot-hills of the Alps, where Cima's native Conegliano lies.

Giovanni Bellini had painted this picture's grand prototype: the high altarpiece of S. Maria dei Miracoli in Venice, now in the Contini collection in Florence. Bellini had greater powers of construction, of observation, of idealization. By that standard of perfection, Cima, who took from the mature Bellini both the how and the why of his painting, has made a scene which is at the same time less concrete and less ideal. In design and in mood, however, it is wonderfully integrated. St Jerome's grotto encloses him securely with the solid structure of its ageless rock, emphasized by the fleeting reptile population and enriched by the trees and plants that have won themselves a living in it by their organic vigour. Yet his movement leads the eye out of the grotto, first to the domestic hillside across the gorge and then to the sweep of the river beyond, with the cool delight of the green meadows and the hazy mountains above the farther bank.

The picture was bought in Venice in 1770, probably by John Strange. Later it belonged to William Beckford (1760–1844), the famous Romantic, author of travel diaries and the fantastic novel *Vathek*. At the age of nine Beckford inherited a vast fortune, of which he succeeded in spending the greater part. Much of it went in building the huge neo-Gothic Fonthill Abbey, which he filled with books and pictures. Some of the best early pictures in the National Gallery came from his collection before he died. This picture was inherited by his daughter, the Duchess of Hamilton, and acquired for £493 at the Hamilton Palace sale in 1882.

LIBERTAS ❋ ECCLESIASTICA

CARLO CRIVELLI (active 1457–93) *Italian School*
THE ANNUNCIATION, WITH ST EMIDIUS Transferred from panel to canvas
Catalogue No. 739 Height 2·07 m. (81½″)
 Width 1·465 m. (57¾″)

Crivelli painted only religious subjects. But in his hands the religious picture took on the most mundane and amusing look. The carpenter's house has become the most ornate block of a sumptuous palace in the latest style, where ladies and gentlemen, children and monks and servants take their ease in the courts and gardens. For this Feast of the Annuncia-tion the plant-pots and the bird-cages have been put out and the rugs hung over the para-pets, and the peacock hangs his gilded tail from the cornice over the Virgin's room. In the frieze below, the architect has even designed a special aperture so that the Dove can des-cend direct from Heaven. In such surroundings it seems natural for St Emidius, the Patron Saint of Ascoli, to be behaving to the Archangel Gabriel like a courtier to a prince and importuning him with a model of the town.

Perhaps the artist shows his reverence in the fervour of his craftsmanship. In Gothic and Renaissance times it was only a few great artists who did not accept the idea of a picture as an opportunity first to bring together all that was rarest and most refined. Crivelli carries this idea to an extreme.

At the base are inscribed in gold the words *LIBERTAS · ECCLESIASTICA.* Between them are the arms of Pope Innocent VIII and at either end those of Ascoli (on the right) and of its Bishop. On the pilasters of the Virgin's house are: *OPVS · CARO/ LI · CRIVELLI ·/ VENETI* and *1486.* Crivelli was a native of Venice, but he lived and worked most of his life at Ascoli, in the Marches. In 1482 Pope Sixtus IV had granted Ascoli a measure of self-government. The news arrived on the Feast of the Annunciation, and on that day, for many years afterwards, a procession went to the church of the Santissima Annunziata. This picture was painted for the church.

In 1811 it was taken to the Brera Gallery in Milan, which, after the dissolution of the Italian monasteries, became a kind of clearing-house for their pictures. In 1820 it was ceded to Count Auguste Louis-Sivry. By 1847 it belonged to Lord Taunton, who presented it in 1864.

ANDREA MANTEGNA (1430/1–1506)
THE VIRGIN AND CHILD WITH THE MAGDALEN
AND ST JOHN BAPTIST Canvas
Catalogue No. 274 Height 1·36 m. (53¾")
 Width 1·14 m. (45")

St Mary Magdalen, richly dressed and with her luxuriant tresses flowing, holds up the
jar of ointment with which she is to anoint Christ in the house of the Pharisee. St John,
wearing a tunic of camel-hide under his loose mantle, holds in one hand his long cross
and the scroll inscribed with the words of his greeting: (EC) *CE AGN* (VS DEI EC)
CE Q (VI TOLLIT PEC) *CATA M* (VN) *DI* ('Behold the Lamb of God, which
taketh away the sin of the world'). The scroll is also inscribed inside at the top: *Andreas
Mantinia C.P.F.* The *F.* stands presumably for *Fecit*, the *C.P.* probably for *Comes Pala-
tinus*. Mantegna was made a Count Palatine by the Emperor apparently in 1469.

The two Saints, the most popular in Italy, stand in the bright light against a gay
boscage of orange and lemon trees; but neither they, nor the modest young Virgin
between them, nor the already wise and stalwart Child raising his hand in formal blessing,
look either at each other or at us.

Mantegna was treated with respect even by the Gonzagas, to whom he was court
painter at Mantua from the beginning almost of his long, undeviating career. His begin-
nings had been precocious, even in a century which was artistically the most creative
since Greek times. Every other great artist – and most of all Mantegna's brother-in-law
Giovanni Bellini – underwent a considerable evolution. Mantegna soared full-fledged,
not from any studio but from Donatello's bronzes at Padua and the paintings by Uccello
and Filippo Lippi there, perhaps from some paintings by Castagno in Venice. In his
first frescoes at Padua he had already adopted in full the stern classicism which makes
him in one sense the most characteristic painter of the Renaissance. In this canvas of some
forty years later his painting is not different; it is only fuller in form, firmer in outline, more
decorative in colour, broader in conception. It represents Mantegna mature and at his
most serene.

Its original destination is unknown; but it was in Milan, in the Palazzo Andreani
when it was recorded towards the end of the eighteenth century. It had been moved to the
Mellerio Palace before it was bought for £1,126 in 1855.

GIOVANNI BELLINI (c. 1430–1516)　　　　　*Italian School*
St Dominic　　　　　　　　　　　　　　　　*Canvas*
Catalogue No. 1440　　　　　　　　　Height 0·63 m. (24¾″)
　　　　　　　　　　　　　　　　　　　Width 0·495 m. (19½″)

The Saint wears the habit of the Order which he founded. Awkwardly, as if they had been thrust into his hand, he holds two of his emblems: the lily and the book. The lily is for the purity of the Virgin, to whose cult Dominic was devoted. The book – this one bears a label inscribed *Sanct.' Dominic.* – stands for the learning of the Dominicans. It is also a reminder of one of the founder's miracles. In anger at the indifference of the Albigensian heretics, he once threw his book into the fire, only to see it leap out again unscorched.

It was the Albigensians in Languedoc, where he accompanied his Bishop on a mission, who inspired his disgust for heresy and his first preaching mission. Before long the troops of Simon de Montfort had massacred the Albigensians, while Dominic was praying for the victory. He preached unceasingly in several countries before he settled in the principal monastery of his Order, at Bologna. Here he died in 1221.

For this ideal portrait, Bellini apparently got a Dominican contemporary to sit to him. Beneath the little label with the signature *IOANIS BELLINI OP.* is a cruder inscription on the parapet itself: *M. D XV.* and, on either side of this, *IMAGO FRATRIS* and *THEODORI VRBINATIS* (PORTRAIT OF BROTHER THEODORE OF URBINO). It is a reasonable supposition that this secondary inscription was added not very long after the picture had left Bellini by or for someone who wanted there to be a record of the model and the date. There *was* a Fra Teodoro in Venice, and it was in 1514 that he was recorded as one of the inmates of the great Dominican friary there, SS. Giovanni e Paolo. At different times in his life Bellini painted large pictures for the great church of the friary. The two old men may well have been friends.

The painter did not survive more than about a year after the date of his painting. There are signs of his faltering age in the many changes of outline and in the tentativeness of the hand. But in the modelling of the broadly lit head there is no lack of power or, in the countenance, of Bellini's skill in strengthening humanity by his idealism.

The picture was brought to England from France in 1856/7. It was purchased by the Victoria and Albert (then South Kensington) Museum in 1865. It has been lent to the Gallery since 1895.

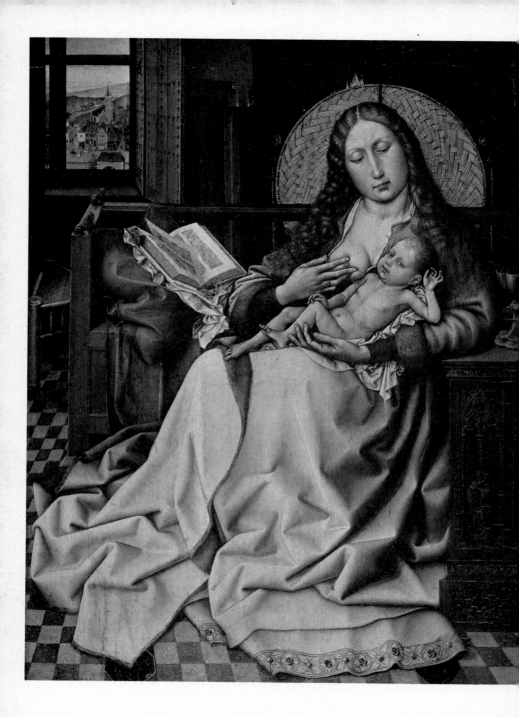

ROBERT CAMPIN (1378/9–1444) *Early Netherlandish School*
THE VIRGIN AND CHILD BEFORE A FIRE-SCREEN Panel
Catalogue No. 2609 Height 0·635 m. (25″)
Width 0·49 m. (19¼″)

The fussy piece of cabinet-making upon which the Virgin is leaning, together with the bolsterish elbow and everything else above and below it, is not original. If one follows it from the top, the join between old and comparatively new is visible in the reproduction, running a little to the right of the Child's left elbow. There is also a narrower horizontal addition, just below the transom of the window.

Campin had difficulties in arranging his composition, with the Virgin sitting on a high stool in front of the settle and the furniture crammed between her back and the window or the fireplace, which are unusually close together in one wall. To unite naturalistically rendered parts within one imaginary whole can be no easier than to conceive unity in more abstract terms from the beginning.

Campin no doubt had to bring in some of these motifs because of the symbolism that he was carrying on from the miniatures of the Middle Ages. Probably, the richly illumi-nated Bible which lies on its voluminous linen cover against the cushion is a reminder of the Annunciation, where such a book almost invariably figures. Certainly, the wicker fire-screen is so placed as to perform the function of a halo.

The substantial practicality of this halo may be taken as a symbol of the picture's character. What had gone before in northern Europe under the dominance of France is well represented by 'The Wilton Diptych' (page 141). The Gothic style in which this was done in tempera and with so much gold was dependent upon linear rhythms and was almost without atmospheric effects. Painting only a generation later in the translucent oil medium, Campin, a completely Netherlandish painter, was bent on achieving tangible solidity and space through the study of light and shade. In Italian painting, which was conquering space at the same time, not empirically by observation, but by the theory of perspective, the halo could remain as part of an idealistic conception. In the Nether-lands it was incompatible with the logic of realism.

There is no certain history of the picture before about 1875, when it seems to have been brought from Italy. It was part of the George Salting Bequest to the Gallery in 1910.

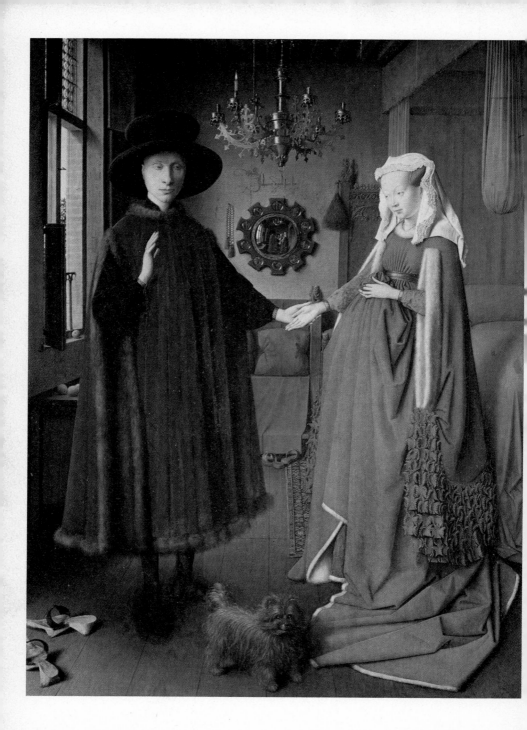

JAN VAN EYCK (active 1422, died 1441) *Early Netherlandish School*
THE MARRIAGE OF GIOVANNI (?) ARNOLFINI
AND GIOVANNA CENAMI (?) Panel
Catalogue No. 186 Height 0·818 m. (32¼″)
 Width 0·597 m. (23½″)

Facing the door of the bedroom, holding her hand in his, he raises his right hand as if in oath. In the convex mirror behind is a clear reflection of the room, showing two persons standing in its open door. One of these is presumably van Eyck, for over the mirror the wall is elaborately inscribed: *Johannes de eyck fuit hic.* / . *1434.* (Jan van Eyck was here. 1434.)

Obviously a wedding picture, it may well represent the marriage itself. The single candle burning in the chandelier could be a nuptial symbol; even the little dog could represent Fidelity. The room is full of testimonies to the girl's piety: a rosary hung beside the mirror, the frame of the mirror with ten roundels painted with scenes from Christ's Passion, the post of the high-backed chair carved with St Margaret.

The picture was inventoried in 1516 – when it belonged to Margaret of Austria, Regent of the Netherlands – as *Hernoul le Sin avec sa femme dedens une chambre*, and in 1523–24 with the correction *Arnoult Fin*. This must stand for Arnolfini, a merchant family from Lucca in Italy, of which there were several representatives in Flanders. Since van Eyck worked mostly at Bruges, this man is likely to be the Arnolfini then most prominent in that town. This was Giovanni di Arrigo Arnolfini (d. 1472), who married Giovanna Cenami.

The picture was inherited from Regent Margaret by her great-niece Mary of Hungary. When Mary retired to Spain in 1556 she took it with her, and, when she died in 1558, it passed into the Spanish Royal collections.

It seems a far cry from van Eyck's picture to the great Spanish masterpiece of two centuries later, Velazquez's *Las Meninas*: but the mirror at the back of each is more than a trick that the two have in common, more than a way of uniting in each the painter and his sitters, or both, with the spectator. In each the keenest observer of his century has made us feel that this world we glimpse is complete and more significant than our own.

It is not known how the picture returned to Flanders. It is stated to have been bought in Brussels after Waterloo by James Hay, who sold it to the Gallery for £630 in 1842.

ROGIER VAN DER WEYDEN (c. 1399–1464) *Netherlandish School*
Pietà Wood
Catalogue No. 6265 Height 0·355 m. (14″)
 Width 0·45 m. (17¾″)

On the left of the Virgin supporting the dead Christ at the foot of the Cross St Jerome is half kneeling in his cardinal's robes. His lion is seen descending the path behind him. On the other side, standing probably, behind the knoll is a Dominican Saint, no doubt St Dominic himself, reading from a great illuminated book. One hand on Christ's head, St Jerome encourages with the other the layman who commissioned the little picture, clad in a splendid black velvet coat lined with fur.

In a variety of forms this is a favourite subject with van der Weyden and his followers. His earliest *Pietà* is evidently the little vertical panel in the Capilla Real at Granada, where SS. John and Joseph of Arimathea mourn with the Virgin. There, though there is a landscape behind, the figures are compressed in a vertical design and within an elaborately sculptured Gothic arch.

The National Gallery picture is plainly a more advanced composition. The abolition of the architecture enhances the unity with the landscape, and the horizontal structure allows a larger number of figures to dispose themselves in it more naturally. This is a tiny picture, quite possibly intended as a travelling altarpiece; yet it can be enlarged to almost any size without losing its grandeur or intensity. Even the layman is a comparatively slight figure and the rest are worn with suffering or grief, with austerity or age; but all are firm beyond the ordinary and impose themselves completely upon the scene. Together they almost fill the picture space; and yet this is one of the first *plein air* landscape paintings, with the figures enveloped in the clear light of day. The tranquillity of the light and the strength of the vast distance relieve the poignancy and make the tragedy eternal.

The National Gallery picture seems to be the prototype of many versions in the production of which van der Weyden's hand is to be recognized in varying degrees. It made its first recorded appearance in 1902, at an exhibition in London. Acquired in 1956, it was the first to come to the Gallery under the terms of the Finance Act of that year. It was ceded by the Earl of Powis in lieu of estate duty.

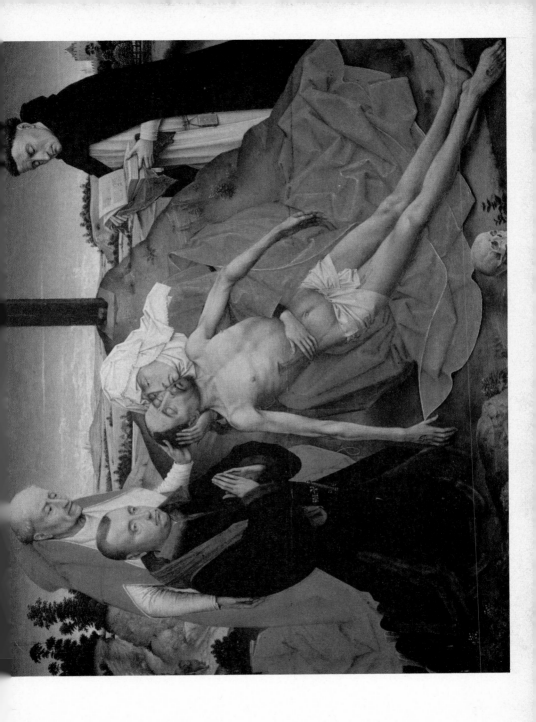

ROGIER VAN DER WEYDEN (c. 1399–1464) *Early Netherlandish School*
PORTRAIT OF A LADY Panel
Catalogue No. 1433 Height 0·365 m. (14¼″)
 Width 0·27 m. (10½″)

Her plump hands are folded to show her rings, and so her married status; but her eyes look down, demure and almost expressionless. Van der Weyden's male sitters may have more fire than this in their eye; but all are very different from van Eyck's, who more often than not return one's own look with interest. This difference between the two painters is characteristic. All van der Weyden's pictures have this impersonal, aristocratic quality.

The earliest, probably, show the influence of van Eyck; but this soon gives way to that of Campin, to whom he was apprenticed at a quite mature age in Tournai. He settled soon after at Brussels, perhaps because van Eyck, nearly a generation older and by then well established, was based on Bruges. Considering this propinquity of time and place, and the newness of the school to which they belonged, two great painters could hardly be more different in their vision. Van Eyck's solid forms are enveloped in a cube of light and shade which gives to each person and each thing its individual existence, while holding it static in a sculptured whole so real that the means of expression are forgotten. Van der Weyden's figures are dependent upon a clearer, more rarified light, for colour and tone and outline so refined that nature seems to become in the end a material irrelevance.

The sense of light here is dimmed to some extent by the overpainting of the blue back-ground and the deadening of the colour with old varnish; but the forms were always less full and rounded than in the very similar portrait in Washington. In the London picture the design has become almost 'abstract', and one wonders less at the charm of the girl, more at the breadth and unity of the austere design. If the head of the lady in London is less solid, the hands are more so. They have become an introductory pyramid, and there is no distraction, only the lines of the gown opening upward, between this and the firm pyramid of the head and its dress; where the stiff translucent linen and the pale glowing flesh are wonderfully combined.

The picture is first recorded in Paris in 1876, when it was in the sale of Mme Blanc, mother-in-law of the Belgian painter Alfred Stevens. It was bequeathed to the Gallery in 1895 by Mrs Lyne Stephens.

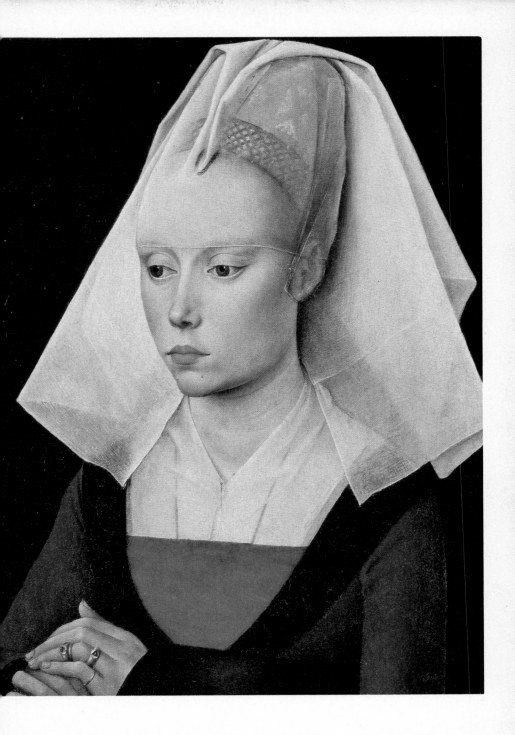

FRENCH SCHOOL (*c.* 1395)
RICHARD II PRESENTED TO THE VIRGIN AND CHILD BY HIS PATRON SAINTS
('THE WILTON DIPTYCH') Two panels
Catalogue No. 4451 Width 0·29 m. (11½″) each
 Height 0·46 m. (18″) each

Behind King Richard, urging him towards the group in the other panel, stand his
Patron Saints: Edmund, last King of East Anglia, Edward the Confessor and John the
Baptist. Richard holds out his hands as if to receive the standard from the other panel.
In this the Christ Child holds out his hands as if to take the standard for him from the
nearest of the eleven Angels – all wearing the French collar and the English badge.

There are no documents concerning the origin of the diptych, which is claimed for
both French and English schools. It is recorded first in the collection of King Charles I.
It belonged to the Earls of Pembroke at Wilton House from early in the eighteenth cen-
tury until it was acquired at the price of £90,000 in 1929.

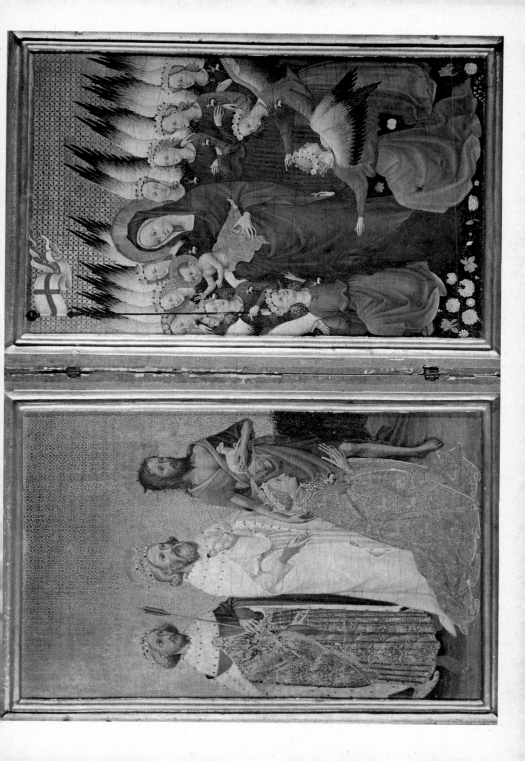

HANS MEMLINC (active 1465; died 1494)
SS. JOHN THE BAPTIST AND LAWRENCE
Catalogue No. 747

Early Netherlandish School
Two panels
Height 0·57 m. (22½″) each
Width 0·17 m. (6¾″) each

A young and smooth St John points to the *Agnus Dei* on his left arm. St Lawrence, an elegantly dressed boy deacon, as he always is, holds a model of the gridiron upon which he was grilled before his execution, in the middle of the third century. He had refused to give up the treasure of the Church entrusted to him by Pope Sixtus II before Sixtus was martyred. He had already distributed it among the poor.

On the reverse of each panel is a dark landscape, suggesting late dusk or early dawn, in which cranes in various attitudes are prominent. On a tree in one of them hangs an unidentified coat of arms. The figure of St John appears also in the *Donne Triptych* by Memlinc, also in the Gallery; but this smaller figure is the more brilliant.

The panels were evidently the wings of a small altarpiece, covering the centre panel – now lost – when they were closed and probably forming, when open, a continuous scene with the central painting. The centre might, however, have been a carving.

In essence, everything is as it might have been in an altarpiece by van der Weyden or Bouts. But all passion is spent. Everything is smooth and simplified in a soft evening light. Perhaps it was because he came from Germany that Memlinc was able to accept and assimilate, without any wish to alter it, the Netherlandish style, rationalizing, rounding, polishing until he had produced, as soon as he was mature, a classical epitome upon which he would make only minor variations for the rest of his life.

He had settled early at Bruges. It is no wonder that, when his peaceful career there had come to a close, he should have been described by a fellow citizen of the still prosperous but already somnolent town as reputed to have been in his time the most accomplished and excellent painter of the whole Christian world.

The pictures were bought in Paris together with thirty others for £9,205 in 1865.

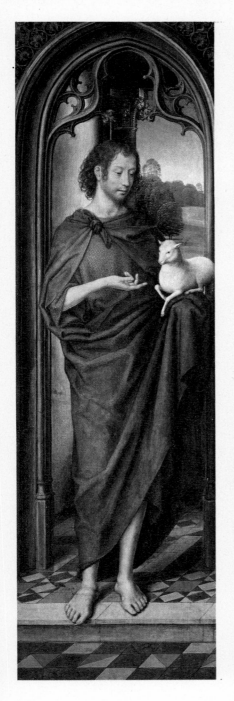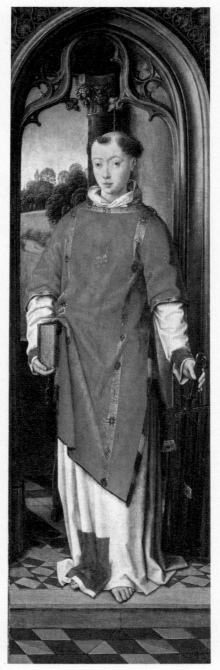

DIERIC BOUTS (living *c.* 1448, died 1475)　　　*Early Netherlandish School*
THE ENTOMBMENT　　　　　　　　　　　　　　　　　　　　Cotton
Catalogue No. 664　　　　　　　　　　　　Height 0·90 m. (35½″)
　　　　　　　　　　　　　　　　　　　　　Width 0·74 m. (29¼″)

It is probably Joseph of Arimathea who lowers the thin body by the shoulders and Nico-demus who holds the shrouded feet. Behind the tomb the Virgin, holding one arm in both her hands, is supported by St John. Jerusalem is behind us. At least, no cross or building is to be seen, on the rock to the left or among the gentle hills beyond. The bereavement of these men and women is enhanced by the slow pace of the placid river and the emptiness of the road winding through fields beside it into a distance softly blurred by little trees.

Bouts was not one of the great inventors. He never drew with the power of a van Eyck or the refinement of a van der Weyden; but he combined their ideas usually in a rich atmo-sphere of his own obtained with colour either in resplendent masses, as in his *Virgin and Child* in the Gallery or subtly fused as in his *Portrait of a Man*, dated 1462.

This is probably a comparatively early work, painted perhaps before he settled in Lou-vain. Later, unless the picture was for a special purpose, he would hardly have chosen these materials with their rather dry effect. The portable pictures of the fifteenth century and earlier are normally upon panel; but in most countries there is a small minority painted upon textile of some kind. The fourteenth-century *grisaille* painting in the Louvre, known as the *Parement de Narbonne*, is upon silk; the rest are generally assumed to be on linen or canvas. Some, of course, at least in the latter part of the fifteenth century, are painted with an oil medium; until in Venice in the sixteenth, oil on canvas began to be the most usual technique. Curiously enough, in the Netherlands, where oil first became the normal medium upon panel, its use upon canvas was slow to establish itself. Some kind of watercolour was generally used.

The support of this picture is shown by analysis to be cotton, the medium to be glue. Strips of less faded paint along the top and left edge, once covered by a smaller frame, show that the green fields were originally bluer, and the sky quite blue.

The picture is said to have come from the Foscari collection, presumably in Venice, to Vienna and to have been bought there by a Guicciardi, presumably Conte Diego, who was an envoy to the Congress of 1814–15. It was bought from the Guicciardi family in Milan for £121 in 1860.

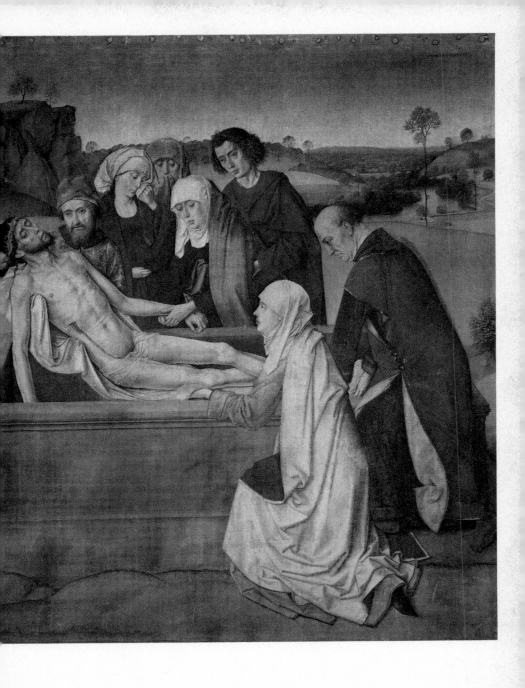

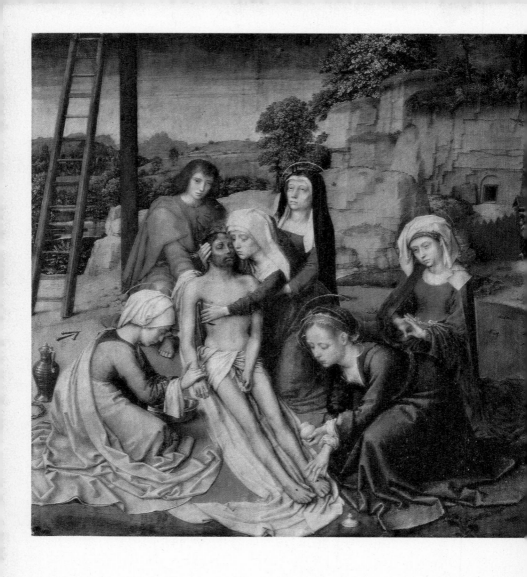

GERARD DAVID (active 1484; died 1523)
THE DEPOSITION
Catalogue No. 1078

Early Netherlandish School
Panel
Height 0·63 m. (24¾″)
Width 0·62 m. (24½″)

St John is still supporting the body from behind, while the Virgin presses the cold cheek to her own. Probably it is her mother, St Anne, who kneels protectively behind her. Normally not more than four women are associated with the Crucifixion and its aftermath, all of them named Mary. Of the other three, Mary Magdalen is easily identified as the trim and modish girl with a dainty veil over the broad fillet of gold and jewels which holds her brushed-back hair. The other two should be Mary the wife of Cleophas, mother of James the Less, and Mary Salome, mother of the Apostles James and John. Mary Salome was according to tradition one of the midwives of the Virgin; so it may well be she who is bathing Christ's wrist with water from a gold basin. At the base of the great rock to the right the tomb has been prepared by Joseph of Arimathea and Nicodemus, who are coming through the gate in front.

David, too, spent much of his life in Bruges, and was influenced at first by Memlinc. Here the pale colouring and the elegant little Magdalen show him influenced by the preciousness of Quinten Massys.

The Deposition has a pendant, *The Adoration of the Kings*. The two were bequeathed by Mrs Joseph H. Green in 1880.

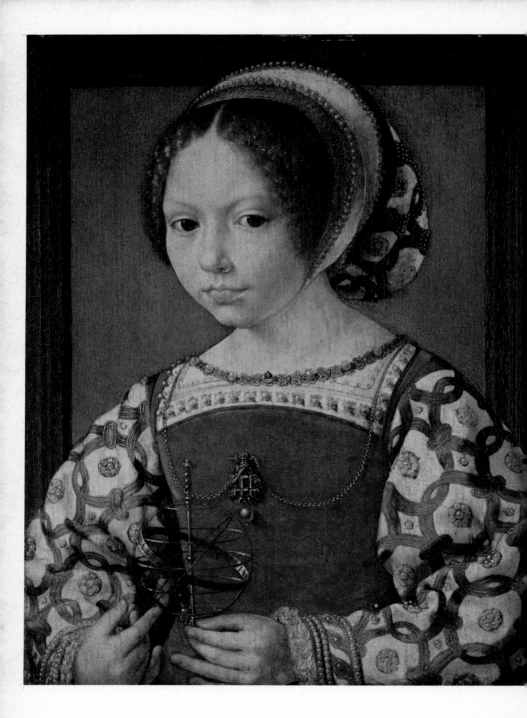

MABUSE (Jan Gossaert, active 1503, died *c.* 1533?) *Early Netherlandish School*
A LITTLE GIRL (JACQUELINE DE BOURGOGNE?) Panel
Catalogue No. 2211 Height 0·38 m. (15″)
 Width 0·29 m. (11⅜″)

She is a very rich little girl, her sumptuous cap and dress embroidered with heavy gold thread and sewn all over with numberless pearls. There is a triple rope of pearls at each wrist, and she has two gold chains, one richly designed and jewelled, the other attached to a brooch-pendant ending in a pearl of largest size. She is holding an armillary sphere inscribed with a great many letters.

That she is Jacqueline de Bourgogne there is no documentary evidence beyond a statement printed in 1882, when the portrait was first exhibited in England. But her dress is compatible with the wealth and importance of Jacqueline's father Adolphe de Bour-gogne, scion of the ruling family of the Netherlands and himself Lord of Beveren and Veere and Admiral of Zeeland; while it needs no stretch of the imagination to see a strong likeness in her face to that of Adolphe's wife, Anne de Bergues, of whom there are two well-authenticated portraits by Mabuse in the United States. They were married in 1509. Jacqueline was their youngest child. The date of her birth is not recorded; but, if she had been born about 1515, that would accord well with the mode of the costume in the portrait. Adolphe was Mabuse's patron in Middelburg, and according to Carel van Mander – the later and very limited Vasari of the Netherlandish painters – Mabuse painted Jacqueline's mother and brother as the Virgin and Child.

Though the costume is so elaborate, the design of the picture is unusually simple for Mabuse, who was apt to indulge in complex and over-refined effects. In the great picture of his early years, *The Adoration of the Kings* in the National Gallery, the methods and ideas of van der Goes and David are elaborated into an astonishing technical *tour de force*. After a visit to Italy, where he is recorded in Rome, he used his Netherlandish technical dexterity to develop an exaggeratedly Italian style, with rounded, overpolished forms artificially lit in the manner of the Leonardesque painters of Milan. His forms re-mained robust and solid; but not so the emotions which they express. The prodigality with which he lavished his refinements of technique and ornamentation upon the trite and frivolous makes him the perfect example of decadence.

The picture was bought for £2,300 in 1908.

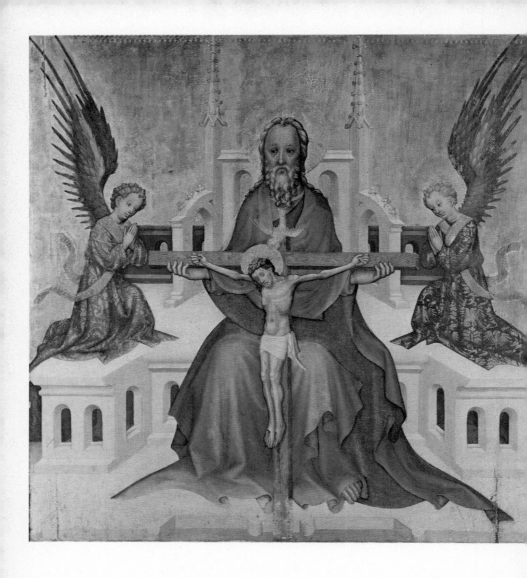

AUSTRIAN SCHOOL (early fifteenth century)
THE TRINITY WITH CHRIST CRUCIFIED Panel
Catalogue No. 3662 Height 1·18 m. ($46\frac{1}{2}''$)
 Width 1·15 m. ($45\frac{1}{4}''$)

Seated on a Throne of Mercy, God the Father supports the Cross with Christ Crucified, and the Holy Spirit descends from one to the other. The Holy Spirit is visualized already as a dove, in connection with the Baptism, in the Gospel of St John, 1, 32: 'And John bare record, saying, I saw the Spirit descending from heaven like a dove, and it abode upon him.' The Passion is naturally associated with the Trinity, and this presentation of the subject is usual in the art of the fourteenth, fifteenth and sixteenth centuries.

The picture itself seems unusual in the National Gallery, in company with the panels of Campin and of Masaccio; for, though it was painted very few years before either, that conquest of reality, of which they were pioneers, quickly became the prolific impulse in European painting. Yet, when they were painted, the pictures of this unknown Austrian artist may well in most countries have seemed less extraordinary than theirs. The Gothic style, in which the throne is designed, was still the architectural style of all Europe, and draperies concealing the body were to flow like this, ample, languid and gracefully linear, in the work of many painters, even in Italy.

The Holy Trinity was the centre of a triptych of which the wings are now in the chapel of the Schloss Rastenberg belonging to Count Phillip Thurn. One wing represents *The Virgin and Child,* the other *St Stephen.* The centre panel was bought for the Gallery for £4,750 in 1922.

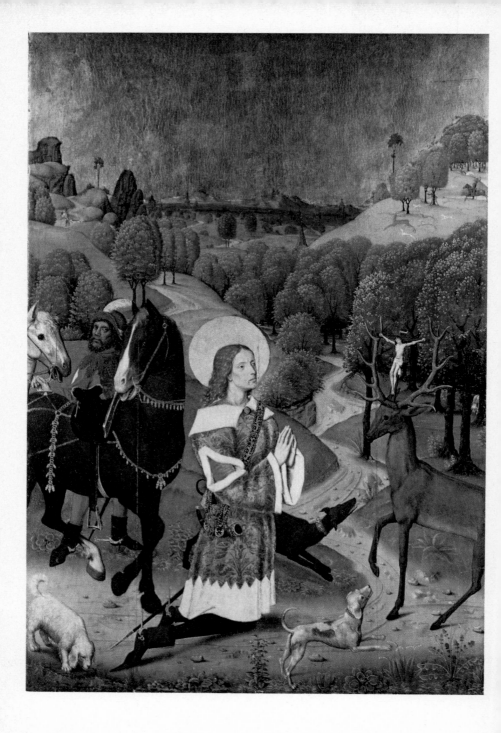

THE MASTER OF THE LIFE OF THE VIRGIN

German School

(later fifteenth century)

THE CONVERSION OF ST HUBERT

Catalogue No. 252

Panel

Height 1·238 m. (48¾″)
Width 0·83 m. (32¾″)

On the hill to the left is a falconer with two dogs. To the right the horn is sounding and the hounds are close on the stag, with huntsmen riding behind. In the road which runs between the hills towards the city, through what should be the Forest of Ardennes, the courtly St Hubert is kneeling before the apparition of the Crucifix between the horns of a stag.

St Hubert was hunting in Holy Week. That was the main objection of the stag, and though Hubert gave up hunting and went into the Church, he became the patron saint of the chase. He was also the patron of dogs, of which there is a variety in the picture. He became the first Bishop of Liège, where he died in 727.

Originally, on the back of this panel was another painting with *SS. Augustine, Ludger (?), Hubert and Gereon (?)*; but the panel was divided and the two paintings framed separately before they were acquired. There is a companion pair of pictures in the National Gallery with *The Mass of St Hubert* (page 283) and *SS. Jerome, Bernard (?), Giles and Benedict (?)*, originally also on one panel but now transferred to canvas.

The four pictures came from the former Benedictine Abbey of Werden, near Düssel, dorf, and were attributed until recently to 'The Master of Werden' on account of their strong character and the fine quality of the execution, particularly in *The Conversion of St Hubert*. All the pictures which show connections with these, however, have an equally strong relationship with the work of 'The Master of the Life of the Virgin', named after a series of eight panels from Cologne of which one is in the National Gallery (No. 706, *The Presentation in the Temple*). This master seems to have worked mostly in Cologne from about 1460, the probable commencement date of *The Life of the Virgin* series. The pictures from Werden were painted probably about 1485–90, by which time the master may well have developed a considerable studio practice. Painted a quarter of a century later, *The Conversion of St Hubert* still has a gold background. But it is now only a sky above a landscape of infinite distance. The depth and spaciousness are suggested not only by the skilful linear design but by a careful study of the light.

By 1847 the paintings were in the Kruger collection at Minden. In 1854 this large collection was bought *en bloc* by the Chancellor of the Exchequer.

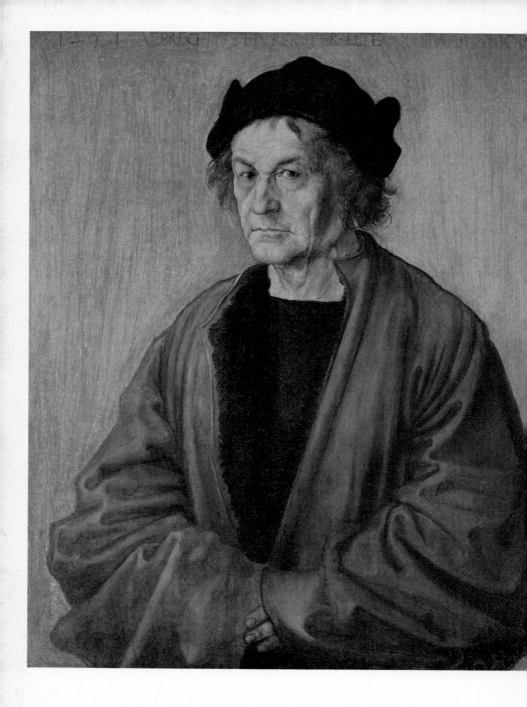

ALBRECHT DÜRER (1471–1528)　　　　　　*German School*
THE PAINTER'S FATHER　　　　　　　　　　　Panel
Catalogue No. 1938　　　　　　　　Height 0·51 m. $(20\frac{1}{16}'')$
　　　　　　　　　　　　　　　　　Width 0·397 m. $(15\frac{7}{8}'')$

The painter's father, also Albrecht Dürer, was born in Hungary in 1427. In 1455 he settled in Nuremberg, then a free city of the Empire, the home of the sculptor Veit Stoss and a great centre for the crafts. There he became a distinguished goldsmith. He and his wife Barbara, whom he married in 1467, had eighteen children, of whom Albrecht the younger was the third. He began as a goldsmith in his father's workshop, but he was apprenticed to the painter Wolgemut while still a boy. He had already in 1490 painted the portrait of his father in the Uffizi Gallery.

The inscription along the top of the National Gallery picture · *1497 ALBRECHT · THVRER · DER · ELTER · ALT · 70 · JOR* · may perhaps not be by Dürer himself; but it is contemporary, and there is no reason to doubt its statement of facts. The picture itself is mostly in good condition; and there is little reason to doubt its authenticity as the original of at least five versions. It is probably therefore the picture which was presented by the city of Nuremberg to King Charles I in 1636 and sold with the greater part of his collection in 1650.

Precocious as he was, and though he had already paid his first visit to Italy two years before, this does not represent Dürer's mature style as a painter. He was famous as an engraver at an early age, and there are the limitations of the engraver's vision in the rather niggling treatment of the face, the hard and restless outlines and the application of the colour as to a design that has already been completed in black and white. Compared with the works of the Venetian and Netherlandish painters whom Dürer was to study later the form is papery and thin.

Nevertheless it was only at rare moments, when he was strongly under their influence, that Dürer became a painter of their quality. Vigorous and intelligent as he was, and determined to be a great man in the new style of the Renaissance, he was consistently at his best as an engraver. The fact that this picture is unambitious in the method of its painting and in the manner in which the sitter is presented is much to its advantage. Dürer did not wish to flatter either his father or himself, and the result was one of the most sincere and sympathetic of his works.

It was bought from the Marquis of Northampton in 1904.

ALTDORFER (before 1480–1538) *German School*
LANDSCAPE WITH A FOOTBRIDGE Canvas
Catalogue No. 6320 Height 0·420 m. (16½″)
 Width 0·355 m. (14″)

This is generally believed by writers on German painting to be the earlier of two such landscapes which Altdorfer painted in oils. These are the first two pure landscape pictures known. Landscape of course had taken an increasingly important part in the subject matter of painting in the Netherlands and in Italy since quite early in the fifteenth century. An interest in nature is a basic characteristic of the Renaissance, and aerial perspective became inevitably a part of the fifteenth century painter's study of light. Such a picture as *The Nativity* by Piero della Francesca is wholly convincing as a landscape. The Venetian painters, who were more beholden to Piero, probably, than to any other mainland precursor, were eager students of landscape, and the great German writer Max J. Friedländer wrote that no one could deny to Giorgione the distinction of being the first landscape painter.

Nevertheless Giorgione was only carrying further the idea of landscape inherited from Giovanni Bellini, in which the mood of nature establishes and supports the mood of the human beings whose history is the subject of the picture. In the *Landscape with a Footbridge* the interest is in the mood of the artist himself, who has set up his easel – or more probably, to be exact, his drawing-board in a corner of nature in order to record his reactions. No comparable picture was to be painted again in Europe until the seventeenth century.

The *Landscape with a Footbridge* was bought from the collection of Dr Jacques Koerfer at Berne in 1961.

HANS HOLBEIN THE YOUNGER (1497/8–1543) *German School*
JEAN DE DINTEVILLE AND GEORGES DE SELVE ('THE AMBASSADORS')
Catalogue No. 1314 Panel
Height 2·07 m. $(81\frac{1}{2}'')$
Width 2·095 m. $(82\frac{1}{2}'')$

Jean de Dinteville (1504–55) is on the left, wearing the gold chain with the Order of Saint Michel. His age is chased on the gold sheath of his dagger: *ÆT · SVÆ/29*. Ambassador to England, he went there five times on diplomatic missions. Whilst there in 1533, he was visited by Georges de Selve (1508/9–41). De Selve was Ambassador at different times to the Emperor, Venice and the Pope. The book under his elbow is inscribed with his age: *ÆTAT / IS SVÆ · 25*. The picture is inscribed to the left on the floor: *IOANNES / HOLBEIN / PINGEBAT / 1533*.

The ambassadors stand on a pavement copied with slight variations from one in West‑minster Abbey. Part levitated from it between them is a skull, viewed as if in a distorting mirror. This apparition, though trying, is no more mystifying than the choice of some of the many complicated objects on the simple buffet covered by a 'Turkey' carpet.

Those on the top are astronomical or chronometrical instruments. On the shelf below is a terrestrial globe, the work of Schöner at Nuremberg, 1523. Holbein has added to it several names, including *POLISY*, de Dinteville's domain. The book in front of the globe is Apian's *Eyn newe unnd wolgegründte underweysung aller Kauffmanss Rechnung,* printed in 1527. The wide‑open book is a hymn‑book in which can be read the first verse of Luther's rendering of the *Veni Creator Spiritus* and the beginning of his 'Ten Command‑ments'. Why two Catholic French diplomats, of whom one, de Selve, was a bishop, should want to be painted with a German Protestant hymn‑book, or even a German arithmetic book, is unexplained.

Holbein had returned to England the year before. This demonstration of his powers may well have been the first step towards the position he was soon to occupy as Court Painter to Henry VIII.

The picture was taken to Polisy. Brought to Paris in 1653 by de Dinteville's great‑great‑nephew the Marquis de Cessac, it was in a sale there in 1787. It soon became the property of the Earls of Radnor at Longford Castle. With the help of several benefactors it was bought from the Earl of Radnor in 1890. For this and two less valuable pictures the price was £55,000.

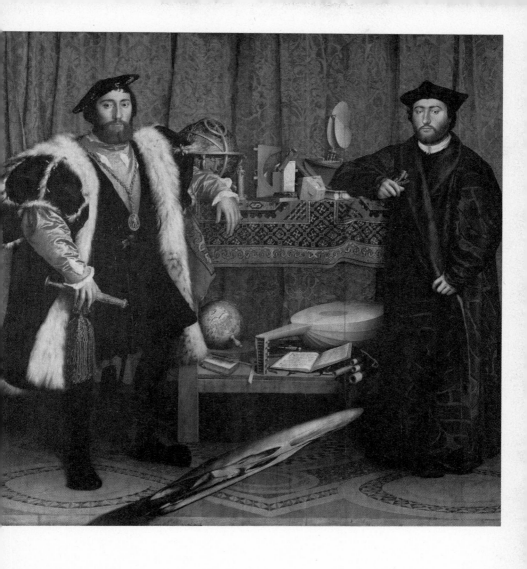

HANS BALDUNG (c. 1484–1545) German School
PORTRAIT OF A MAN Panel
Catalogue No. 245 Height 0·593 m. (23⅝″)
 Width 0·49 m. (19¼″)

The date is inscribed in gold at the top · *1514*. The picture owes its position at the end of this group to convenience of arrangement rather than chronology; it was painted some twenty years before *The Ambassadors,* and Baldung was a generation older than Holbein. Holbein was yet to paint a number of portraits on the same principle, with the figure in silhouette against a blue background. In this greatest period of portraiture, from the middle of the fifteenth to the middle of the sixteenth century, it was a type of portrait much favoured throughout Europe, but especially in the North by Netherlandish, French and German painters.

The date shows that this is a comparatively early work, and indeed the powerful colour and the complex manner of painting, as in the texture of hair and fur, for instance, so elaborately delineated, show that it was painted under the strong influence of Baldung's friend Albrecht Dürer. He was not long, however, in becoming a fashionable painter. His portrait of the Margrave Christopher of Baden, now at Munich, was painted the following year. He painted for many years for the House of Baden-Durlach.

He was born at Schwäbisch-Gmünd; but in 1509 he was a citizen of Strasbourg, where he died. A prosperous river-port, Strasbourg was always an important point of juncture between East-West and North-South currents. Southern Germany, of which Alsace was then part, was even richer in painters than was France.

Baldung painted religious subjects – the National Gallery has a *Pietà* from his hand – and many allegorical nudes. From these he found it hard to exclude the figure of Death. This ageing sitter in the rich fur coat and laden with gold chains may well be brooding upon such a theme.

The picture was bought for £145 in 1854.

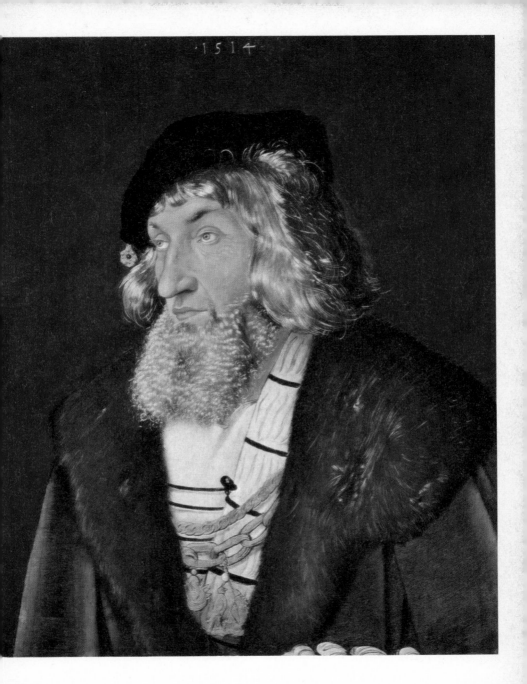

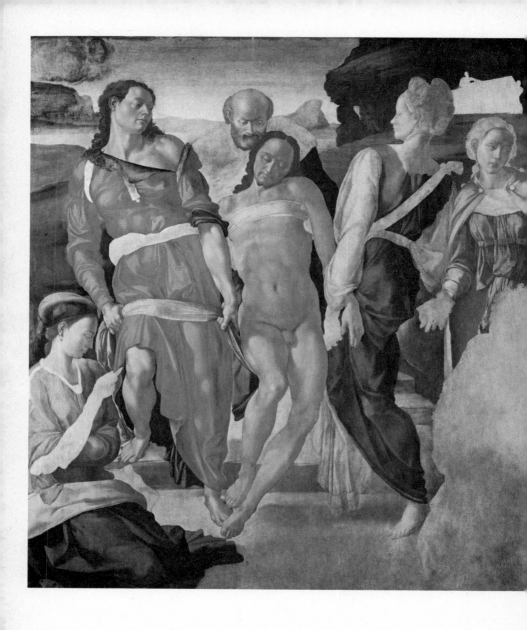

MICHELANGELO (1475–1564)
THE ENTOMBMENT (unfinished)
Catalogue No. 790

Florentine School
Panel
Height 1·61 m. (63⅔")
Width 1·49 m. (59")

The unpainted space in the distant rock was evidently to have become the sepulchre, with two men making it ready. Towards it, up the steps, Joseph of Arimathea and the young St John are carrying the dead Christ, helped by one of the Holy Women. The Mary who can be most easily identified is the Virgin, although she is represented only by that other space, left empty as grief itself.

Though the degree of finish varies, the picture is possibly not quite completed in any part. In addition it has been rubbed and knocked about, and is covered by an old varnish, yellow and rather opaque. There is only one panel picture by Michelangelo which is both finished and universally accepted: *The Holy Family* of the Uffizi. In this, which is wonderfully preserved, everything is brought to a very high finish, the forms elaborately rounded and polished and set in a hard light, an atmosphere clear to the horizon. Probably in *The Entombment* Michelangelo intended much the same effect, though he may well have painted it a few years later. Perhaps he had only got so far with the picture when he was called to Rome in 1508 to paint the Sistine Chapel ceiling.

There have been many doubts as to whether Michelangelo was the author at all. But surely the setting of *The Entombment* alone reveals a great artist: one who allows no mundane distraction from his figures yet knows both how to enclose them in grandeur and how to suggest a noble infinity beyond. The quality of the landscape explains the light, which even now, through the mist of the picture's condition, plays in and out with infinite delicacy among the rounded intricacies of the forms. These have a strength which does not seem to be given by their elaborate outlines but to grow from the power within; but they have an extreme refinement, perfectly matched by that of the colours, which are not colours that one can see elsewhere. The figures are set close and square; but the rhythm which binds them together is mobile as the rhythm of music and draws us, as music can, into a mood of exaltation far above ourselves.

The picture was bought in Rome by a Scottish painter, Robert Macpherson. It was he who sold it to the Gallery for £2,000 in 1868.

RAPHAEL (1483–1520) *Umbrian School*
St Catherine of Alexandria Panel
Catalogue No. 168 Height 0·715 m. (28$\frac{3}{17}$")
Width 0·557 m. (21$\frac{3}{4}$")

St Catherine's wheel, which was shattered when they tried to tear her to pieces, is whole and set with studs not knives; and she has none of her other usual attributes; the crown, the book, the ring or the sword. Their absence is due not to carelessness, or even perhaps to the official scepticism about the Catherine legend, but to Raphael's determination upon soft delight and smooth continuity of form.

Within a very few years, in Rome, he was to go further than Leonardo in achieving unity of design, carrying a single rhythmic movement through a variety of figures across the width of a frescoed wall, and into its imaginary depth. Here, almost before he was independent of Perugino, the unity is achieved already in a single figure. The torture-wheel is changed into a snug support at the base of an obelisk, and Raphael has turned the obelisk into a tapering column of classical womanhood, then chased and gilded the resulting spiral of suave and shining grace. Wherever one looks one finds the contour moving round, the voluptuous outline mounting up. Those chaste but shapely solids of thighs and trunk and arms are relieved by the ripple of the yellow mantle-lining looped across the loins, that almost severe line of the features by the shimmer of the blonde hair before it disappears in the mauve scarf behind.

Behind, the landscape lies vague with mist and flat. But vertical is cunningly married to horizontal by that wedge of rock close to the foreground and the green banks behind. The dandelion puff and the few frail irrelevant flowers in front, the complex of feathery trees and buildings melted into the distance are all foils to the apparent simplicity.

The picture must have been painted during Raphael's last year or so in Florence, 1507–8, when he was ready for the call to Rome. In the seventeenth and eighteenth centuries it was in Rome, in the Borghese collection. It was brought to England with many other pictures by Alexander Day, an English artist and dealer resident in Rome, who exhibited them in London in 1801. Later it belonged to the famous millionaire, romantic traveller and writer, William Beckford. It was bought from him with two less valuable Italian pictures for £4,350 in 1839.

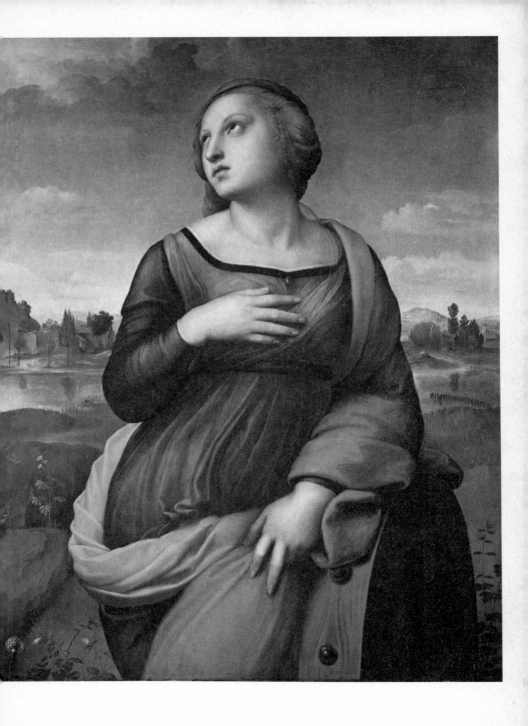

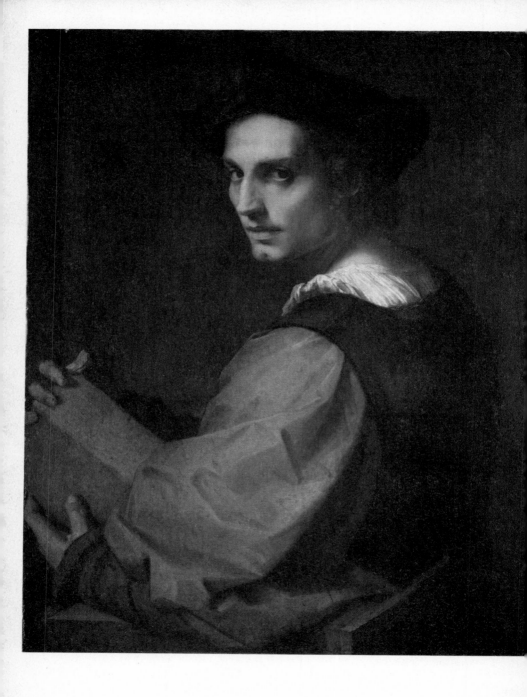

ANDREA DEL SARTO (1486–1530) *Florentine School*
PORTRAIT OF A YOUNG MAN Fine linen
Catalogue No. 690 Height 0·72 m. $(28\frac{1}{2}'')$
Width 0·57 m. $(22\frac{1}{2}'')$

He is seated in an arm-chair, and what he holds between his hands is almost certainly not a block of stone, as has been surmised, but an open book, with the text either never inscribed or erased in the course of time. He should be a scholar or a minor poet, with his mild eye and delicately cut features, his quiet and easy but not unfashionable dress. But then Giorgione, when he died in 1510, had inaugurated an age of dreamy portraiture which made all men look like poets.

Of all the Florentines of the 'High Renaissance' Andrea came nearest to the Venetians in the sensuous texture of his painting and the richness and emotive quality of the atmosphere which he thus created.

This must have been painted not long after Giorgione's death. There is less flesh and blood to the man, less fire to his soul than in the Venetian portraits that probably influenced the painting of this one. But there is an intellectual distinction which is characteristically Florentine, and which is well supported by the quality of the design: a realization of form in space more elaborately worked out and more scrupulously defined than was usual in Venetian portraits.

On the wall behind is inscribed to the left Andrea del Sarto's characteristic monogram.

The picture was bought for £270 in 1862 from the heirs of Cavaliere Niccolò Puccini of Pistoia, near Florence.

CORREGGIO (1489?–1534) *School of Parma*
THE MADONNA OF THE BASKET Panel
Catalogue No. 23 Height 0·33 m. ($13\frac{1}{4}''$)
 Width 0·25 m. ($9\frac{7}{8}''$)

In the soft evening light the Virgin is trying to put His jacket over the shirt of the little
Boy struggling in her lap. Behind, outside their cottage built in the ruins of some great
building, St Joseph is working at his bench.

This is a tiny picture, for a boudoir. Yet there is nothing small but its dimensions; even
its gaiety is courageous. It is not only that, at least in a *Madonna* picture, such joyful freedom
of movement was a novelty in itself; but that such an unselfconscious, whole-hearted
absorption in the hour could not have been expressed except by forms conceived in large
terms to fill and dominate the picture space.

When all is so soft and pretty, it is surprising how solid are the forms, how much depth
there is from front to back, for the light to play in. When the movement in and out is so
vivacious and complex, it is surprising how simple and grand is the whole effect.

Correggio was born and died at Correggio near Parma, the capital in which he founded
a school of painting. There are reminiscences in this little picture of Bellini's tenderness
and Raphael's classicism and, above all, of Leonardo's unity; but more obvious are the
anticipations of the next century, of Rubens with his flexibility of movement and his con-
tinuity of rhythm.

It was a famous picture, for there are at least a dozen copies. Probably it belonged after
Correggio's death to the painter Girolamo da Capri. Certainly it belonged to Philip IV
of Spain. It was still in the Spanish Royal collection in 1789. In 1813 it came to England,
without finding a buyer. Taken to Paris, it was later, in 1825, bought at the sale of M.
Lapeyrière by a dealer who sold it immediately to the newly founded Gallery for £3,800.

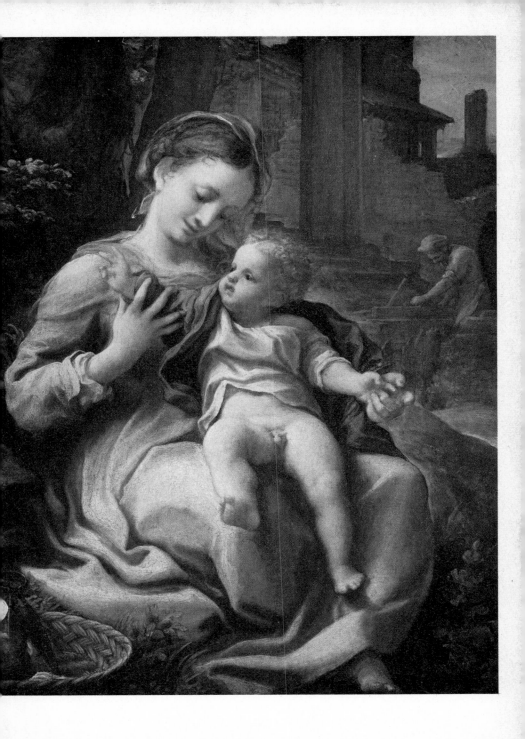

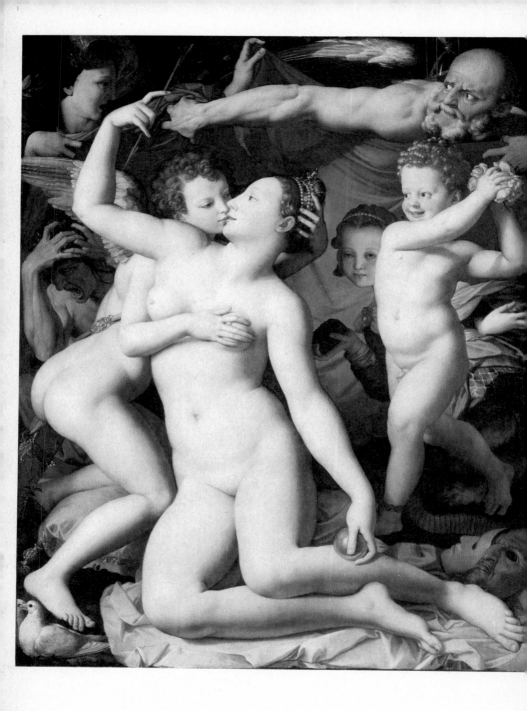

ANGELO BRONZINO (1503–72)
AN ALLEGORY OF TIME AND LOVE
Catalogue No. 651

Florentine School
Panel
Height 1·46 m. (57½")
Width 1·16 m. (45¾")

Venus, attired in a tiara of pearls, is seated on a satin cushion; and Cupid kneels upon it, clad only in the jewelled strap of his gold-mounted emerald quiver. She has taken his arrow, and in her other hand holds a golden apple. From behind her a jolly little boy, clad in an anklet of golden bells and no doubt representing Pleasure, is about to shower the couple with a double handful of roses. But behind him is the image of Deceit. That pretty little girl looking one straight in the eyes wears a green dress only to conceal imperfectly her griffon's body, with clawed feet and scaly tail. Her hands seem to be reversed. The left on her right arm offers honey in the comb, the right on her left arm holds up her tail to show a vicious and well-loaded sting. To her perhaps belong the two masks in front, one female, young and suave, the other male, old and saturnine. On the other side, with face contorted like a tragic mask, Jealousy tears her hair. This elaborate group representing Luxury and its drawbacks is there to be revealed by Time and Truth, who are exchanging steely looks behind. Truth, an unattractive lady, has revealed herself by putting up her veil over her hair. She and Father Time, his hour-glass on his winged shoulder, have drawn from over the lascivious group the bright blue drapery now forming a foil and a background to the enamelled brilliance of their flesh. So compressed and intellectual an allegory, so far removed from nature even in its eroticism, is typical of the Florentine 'Mannerists' of the mid-sixteenth century, of whom Bronzino was the archetype.

Cosimo I, the first Grand Duke of Florence, who presumably commissioned this picture, gave it to the King of France, probably François I (d. 1547). It was in England from the middle of the eighteenth century, but was bought from a Paris dealer with thirty other pictures for £9,205 in 1860.

GIORGIONE (1477–1510) *Venetian School*
THE ADORATION OF THE MAGI Panel
Catalogue No. 1160 Height 0·29 m. (11¾")
 Width 0·81 m. (32")

Giorgione lived so short a time and evolved so far and so fast that there is no picture of his, unless it is the *Concert Champêtre* in the Louvre, his most mature picture, which does not seem transitional. But the evolution of style is especially obvious in this *Adoration* because of the two worlds that he has brought together in it.

There is a contrast that is deliberate: on one side the Holy Family, tranquilly seated with the ox and the ass, simple of form but the more majestic in their solidity, the great folds of their voluminous draperies glowing with colour among the warm shadows; on the other, at a reverent distance enhanced by the verticals of the plain brick piers behind, the royal train mundane and restless with variety of colour; the grooms at the end standing carelessly by their horses in the full blaze of evening light.

And there is a contrast that is incidental: between the Holy Family painted by this pupil of the pious Bellini (though even Bellini did not paint figures quite so Masaccio-like in their solidity, and no one but Giorgione would have used that blazing yellow of St Joseph's mantle) and the others painted in a new manner, increasingly more worldly from left to right, spontaneous in pose and in the choice of colour.

This is a tiny picture, youthful and naïve in much of its expression. But in one figure at least there is a full taste of the visual poetry which was to make Venice famous in the sixteenth century.

The picture was in England in 1822, when it was in the collection of P. J. Miles at Leigh Court near Bristol. It was bought at the sale of Sir William Miles at Leigh Court in 1884.

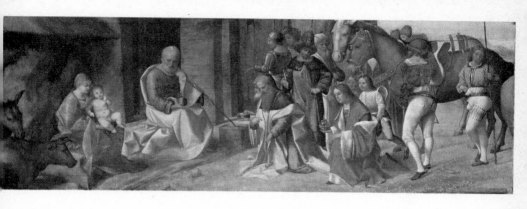

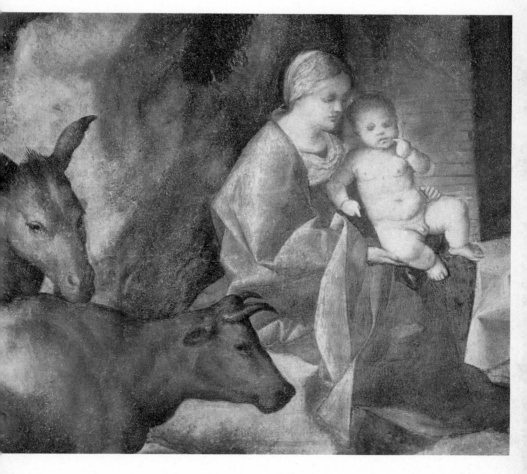

TITIAN (1478–1576)
THE VENDRAMIN FAMILY
Catalogue No. 4452

<div align="right">

Venetian School
Canvas
Height 2·06 m. (81″)
Width 3·01 m. (118½″)

</div>

Long before this picture was painted, the reliquary with a crucifix containing fragments of the True Cross, which belonged to the Scuola di S. Giovanni Evangelista in Venice, was being carried in procession when it was allowed to fall into a canal. The Guardiano of the Scuola dived in and brought it up. He was Andrea Vendramin; and the reliquary came to have a special value for the family, bringing their ships safely home and working one spectacular miracle.

Here it is seen between lighted candles on an altar in the open, and Gabriele Vendramin, head of the great patrician family, half kneels below. Round him are gathered the males of his family, the elders in their robes of State. Behind Gabriele stands his brother Andrea, whose sons form the rest of the group.

The erstwhile imitator of Giorgione has become the most original of all painters. He had followed Giorgione in abandoning formal design for the sake of spontaneity; but even this he had done without excess of system. Formal idealism, passionate expression, realistic observation are mingled in each of his pictures in different proportions; because each picture is above all the record of a new sensuous experience. A full development of the senses was one of the products of his city's beauty; while her form of government and trading empire made the Venetian unique as a judge of men. Titian became one of the greatest of portrait painters. His pictures are such a storehouse of experience, the brush that created them was so flexible an instrument of expression, that he inspired all Europe and altered the way of painting.

Van Dyck, the owner of many pictures by Titian, was the owner of this one. It was bought from his executors by the Earl of Northumberland. The Duke of Northumberland sold it to the Gallery for £122,000 in 1929.

TITIAN (1478–1576) *Venetian School*
PORTRAIT OF A MAN Canvas
Catalogue No. 1944 Height 0·812 m. (32″)
 Width 0·663 m. (26″)

The calm of this well-established disdainful presence must not make us forget the novelty of the picture. The portraits in this book by Baldovinetti and van der Weyden, Botticelli and Antonello show how quickly during the fifteenth century portraiture attained in Italy and Flanders a searching revelation of the portrayed. Nevertheless the great majority of fifteenth-century portraits were on a scale well below that of life, and a sitter who is only half life-size is, however magnificent, only half as imposing as he might be.

It was the Venetians, with their unique statecraft and knowledge of the world, who first in modern times portrayed the full measure of a man, physical and spiritual, on the scale of life, and his full displacement of the atmosphere. The perfect portrait of the Head of the State, Giovanni Bellini's *Doge Leonardo Loredan* in the National Gallery, was painted about 1502. This is still a little less than life-size; but it was not long before Giorgione was endowing private sitters, large as life, with another kind of grandeur, more personal, more poetical in its ideal. It was a time when much thought was given to the perfection of individual man as a member of a leisured society; and Giorgione, whose uniquely sensitive brush and burning intensity of colour were perfect instruments for romantic characterization, inaugurated a golden age of portraiture.

His ideas and personality dominate this picture signed with the initials carved on the parapet: .T. .V., for *Ticiano Vecellio*, and it cannot have been painted long after Giorgione's death in 1510. Titian had the same ardour for making visual poetry out of material things like this mountain of lavender silk. He was a harder and a less sensitive artist; so that the comparatively tough and sensual characterization may not be all due to the sitter.

The earlier of Rembrandt's two self-portraits in the Gallery is influenced by this picture, which was owned in Amsterdam by a Flemish merchant who moved there about 1630 from Venice. In 1641 it appeared in the sale of Alfonso Lopez. From 1824 to 1904 it belonged to the Earls of Darnley at Cobham Hall, Kent. It was acquired in that year for £30,000.

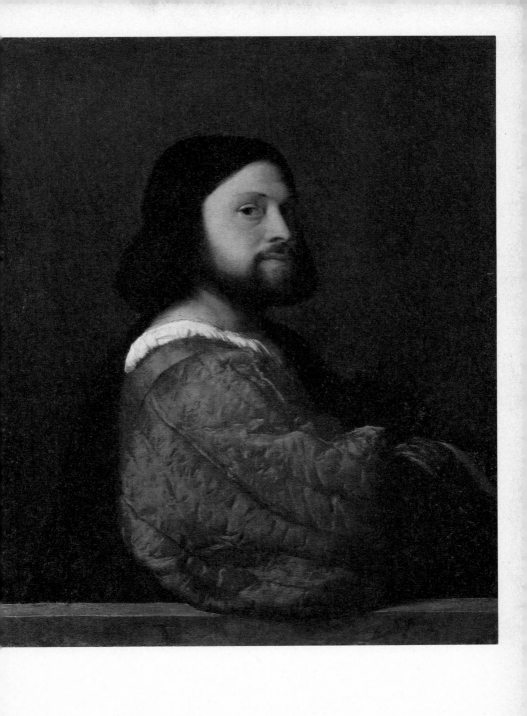

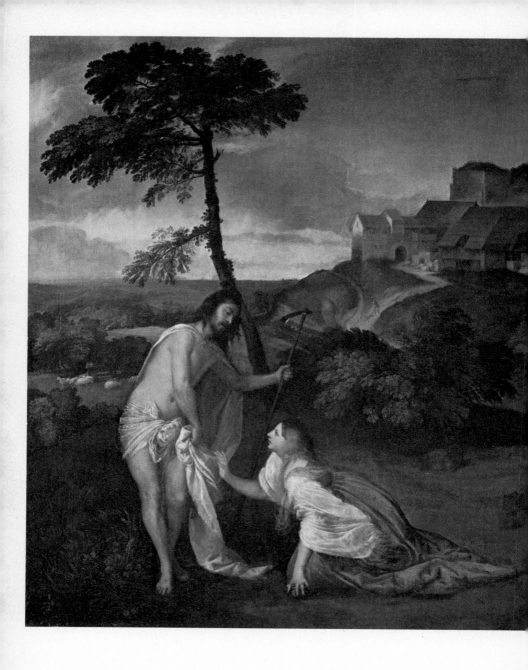

TITIAN (1478–1576) *Venetian School*
'NOLI ME TANGERE' Canvas
Catalogue No. 270 Height 1·09 m. (42¾″)
 Width 0·91 m. (35¾″)

The first to see Christ after the Resurrection was St Mary Magdalen: 'She, supposing him
to be the gardener, saith unto him, Sir, if thou have borne him hence, tell me where
thou hast laid him, and I will take him away. Jesus saith unto her, Mary. She turned
herself, and saith unto him, Rabboni; which is to say, Master. Jesus saith unto her,
Touch me not *(Noli me tangere)*; for I am not yet ascended to my Father' (St John, xx,
15–17).

The shroud still hangs from Christ's shoulders, to be withdrawn by his right hand from
her touch. In his left he holds the gardener's hoe.

At one stage in the painting Christ wore the gardener's hat, as he does in other represen-
tations. The X-rays which reveal this fact give no support, however, to the theory advo-
cated by many that the picture was begun by Giorgione. There is a connection of another
kind, for the group of buildings was to be seen also in Giorgione's *Reclining Venus* in
Dresden. According to the diary of Marcantonio Michiel, the landscape in that picture
was painted by Titian.

The *Reclining Venus* was a picture in which landscape and figure could be considered
separately; but that is not so here. Indeed it is hard to think of any painting in which the
interdependence of man and nature is more beautifully expressed. The moving relation-
ship between the two figures, established by the chain of limbs and the magic of the space
between them, is carried on into the forms of the landscape; and the suggestion in the
New Testament story of an eternal sympathy, which is to come after the passionate anti-
climax of the moment, is echoed in a view of nature which is both homely and warm to
humanity and yet capable in its vastness of an infinity of moods.

The picture was in a well-known collection at Verona, that of the brothers Muselli.
Before the end of the century it had been bought by the Marquis de Seignelay, French
Minister of Marine, who was the owner also of Tintoretto's *Origin of the Milky Way*. By
1727 it was in the great collection of the Duc d'Orléans at the Palais-Royal. The Italian
pictures from the Orléans collection were brought to London after the Revolution and
this picture became the property of Arthur Champernowne. At his sale in 1820 it was
bought for Samuel Rogers, ex-banker, poet and later a Trustee of the Gallery. He be-
queathed this picture in 1856.

JACOPO TINTORETTO (1518–94) *Venetian School*
THE ORIGIN OF THE MILKY WAY Canvas
Catalogue No. 1313 Height 1·48 m. (58¼″)
 Width 1·65 m. (65″)

The bed-curtain is hung over a cloud, for the scene of this commotion is the bedroom of
Hera on Olympus. Zeus, her husband, has had an affair with Alcmene, the grand-
daughter of Perseus, and the result has been the birth of little Heracles. Alcmene being
mortal, Zeus wants immortality for their child, and has a scheme. While he presides in
proxy, in the form of his eagle with a thunderbolt in its claws, his messenger Hermes puts
the infant to the breast of his sleeping wife. Hera, however, averse to the child, awakens
and jumps out of bed; and the immortal milk is spilt in the heavens. It becomes the Milky
Way.

The picture has lost a lower part which told the rest of the story: how drops of milk
reached the earth, causing flowers to grow. The composition as a whole is recorded in a
copy in oils, in an early drawing in the Accademia in Venice and another, in the Berlin
Print-Room, by Jacob Höfnagel.

Höfnagel was Court Painter (1608–12) to the Emperor Rudolf II, for whom Tintoretto
had painted such a picture, which hung in the early seventeenth century in the Imperial
Palace in Prague.

The commission was something of a rarity for Tintoretto. Unlike Titian, whose pictures
were sent all over Europe, he painted almost exclusively for the Government buildings,
the churches and guild-halls of his native city. He was born and lived his entire life in
Venice. His ambition was mainly to get enough wall-space for his canvases; and his
painting, though it was always in oils and rarely without a certain richness of effect, was a
kind of reinforced draughtsmanship; at least when compared with the ever-evolving sen-
suous effects of Titian. By far the greater part of his pictures had religious subjects. This
was perhaps the most sensuous that he painted. Here the glow of the rising sun and the
sparkle of the new-born stars pick out countless delightful roundnesses, and are reflected
from many surfaces rich in texture and in colour.

Like Titian's 'Noli me tangere', this picture belonged to the Marquis de Seignelay
(d. 1690) and to the Ducs d'Orléans. The Italian pictures from the Orléans collection
began to be sold in England in 1792 through Michael Bryan. He bought this one for
himself. Later it belonged to the Earl of Darnley. It was bought from another Earl of
Darnley in 1890. This picture and the next cost £5,000.

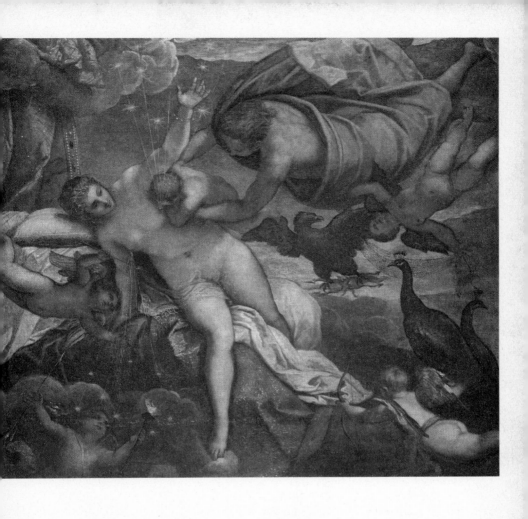

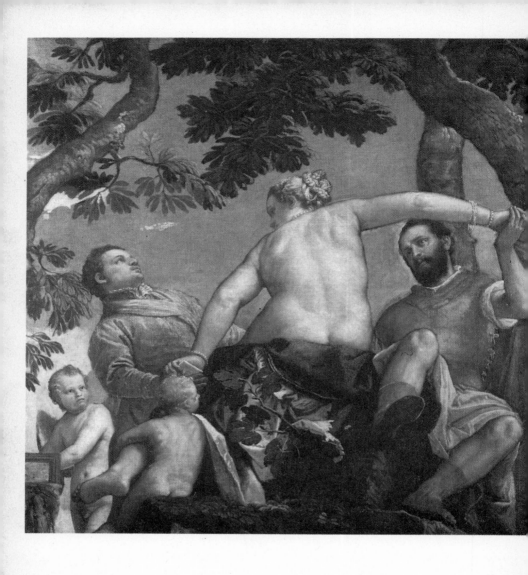

PAOLO VERONESE (1528–88)
ALLEGORY OF LOVE, I
Catalogue No. 1318

Venetian School
Canvas
Height 1·89 m. (74¾")
Width 1·89 m. (74¾")

This is one of a set of four allegories.

Though Bronzino was barely a generation older than Veronese his *Allegory of Time and Love* still smacks in subject of medieval dialectics, and in design of the complexities of the fifteenth century. The revival of Antiquity had consciously inspired all the painting of the Renaissance; but to look in it for that 'calm greatness and noble simplicity' which Winckelmann in the eighteenth century recognized as the great characteristic of Greek and Roman art, is to find it only in the later works of Leonardo, of Michelangelo and of Raphael. In these the whole composition begins to be bound into a single unit of design. In Venice Tintoretto developed their architectonic composition in depth.

Veronese was the heir to all this. Coming to Venice from Verona with its grandiose Roman remains, he added a sense of proportion authentically Roman. Before him no one would have designed quite like this, almost in one great sweep – with a subtle contra-position of the two subsidiary males to give variety and the third dimension. He was no pedantic revivalist. The Olympus where his sweet rational mind took up its dwelling was roofed with the Venetian sky, which is always reflected in the cool, pure clarity of his colours.

Like Tintoretto's *Origin of the Milky Way* these four pictures were painted probably for the Emperor Rudolf II, and certainly hung in the Imperial Palace in Prague. Taken by the Swedes in the sack of Prague in 1648, they came to belong to Queen Christina of Sweden, who abdicated and retired with her great collection to Rome. In the next century they too belonged to the Dukes of Orléans, and were brought before the end of it to England. In the nineteenth they belonged to the Earls of Darnley. In 1890/1 one of them was presented to the National Gallery by the then Earl; the others, including this, were purchased from him.

CANALETTO (1697–1768) *Italian School*
THE STONEMASON'S YARD Canvas
Catalogue No. 127 Height 1·238 m. $(48\tfrac{3}{4}'')$
 Width 1·629 m. $(64\tfrac{1}{8}'')$

The modern title, *Venice: Campo S. Vidal and S. Maria della Carità*, is correctly based on the topography of the scene, which shows the Campo in the foreground separated from the Carità buildings by the Grand Canal. It is very different today. The mason's yard, with its huts, has long been cleared away, together with the house on the left, and the Grand Canal is now spanned by a substantial wooden bridge. On the other side, the campanile of S. Maria della Carità has not been there since 1744, when it collapsed, and the old Scuola della Carità adjoining the church to the right was rebuilt not many years later to include a heavy classical façade in white stone. This is now the entrance to the Accademia. Church and Scuola were suppressed in 1807 and the buildings were handed over to the Accademia di Belle Arti, with its art school and picture gallery.

The picture is more topographical therefore than it now seems in comparison with the very large number of neat and tidy architectural views with which Canaletto recorded the appearance of Venice for the delight of the contemporary tourist and posterity. A comparatively early work, it shows already his acute perception of the character of buildings and the science and deftness with which he could reconstruct them and enhance their meaning by his rendering of light and colour. But here all the delicious details and domesticities belong to a second exploration of the picture. Innumerable re-explorations are necessary for a full appreciation of a scene which proffers first of all the grandeur of nature herself. The Venetian sky is made more brilliant by its own reflection from the sea, and noble masses of warm sun and cool shade overlie the thousands of lively little contests between light and dark.

By the time he painted this picture Canaletto's work was already finding its way to England, and it was not long before almost the whole of his output was for the English market. He paid at least three visits to England, on the first occasion remaining more than four years. The early history of this picture is not known, however. By 1808 it belonged to Sir George Beaumont. In 1823 he had deposited it at the British Museum for the future National Gallery, founded the next year. It came here in 1828.

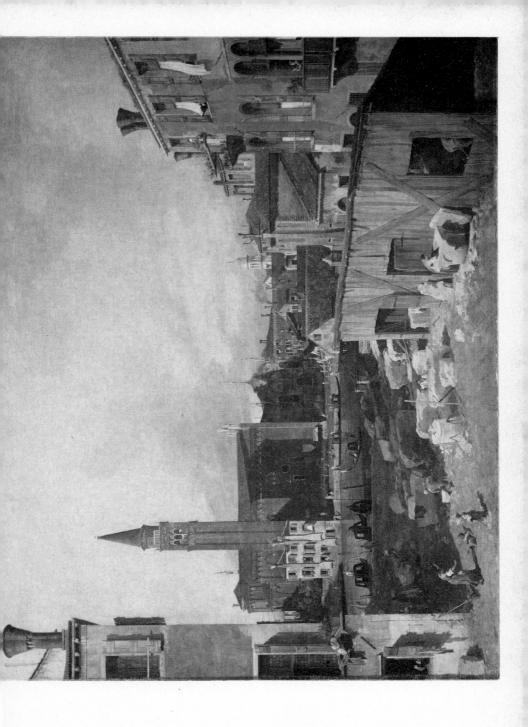

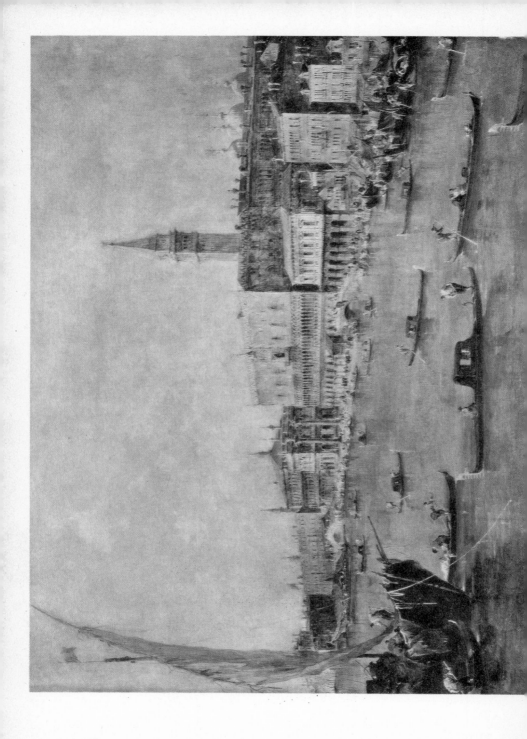

FRANCESCO GUARDI (1712–93) *Italian School*
THE DOGE'S PALACE, VENICE Canvas
Catalogue No. 2099 Height 0·581 m. $(22\frac{7}{8}'')$
Width 0·764 m. $(30\frac{1}{10}'')$

This is the grand view of Venice, taken from a boat. The Doge's Palace, the forepart of rose marble and then still unrestored, is in the centre. It extends across the picture to the right, with the cupolas of St Mark's rising above it. Adjoining it on this side is the prison. On the other are the two ancient columns at the end of the Piazzetta, which leads into the Piazza S. Marco, the centre of all. The tall Campanile, rebuilt since then, stands in the Piazza. Behind the columns is the Library, and next to it the Mint.

When this picture was painted the Republic of Venice was still one of the sovereign States of Europe. She had lost the great commercial empire which had brought her wealth and power; but she was still the owner of a fertile piece of Italy. What is more, she had in Giambattista Tiepolo the consummate artist of the century in Europe, the last man who could paint to the scale of great architecture.

Guardi began life in a family workshop as a painter of altarpieces and decorative pictures in pale but individual imitation of Tiepolo, who had married his sister. Later, he turned to landscape. Though Venice, with her lagoons and canals, her piazzas and courtyards, is rarely absent, what matters most in his scenes is the total effect of light and colour. The picturesque elegance of his compositions, the fastidious touch with which he makes the scene sparkle in a light veiled by gentle cloud are remnants of a tradition in which the taste has lingered after the force has gone. Yet his paramount interest in the atmosphere is something new. The light of Venice was soon to endear her to the new landscape painters from the North. First Bonington and Turner, then Whistler and Monet and Renoir came to find that her last painter had anticipated a part of their ideas.

The picture has a pendant, *Sta Maria della Salute*. The two were bequeathed by the Misses Cohen in 1906.

HIERONYMUS BOSCH (active 1480/1–1516) *Early Netherlandish School*
CHRIST MOCKED Panel
Catalogue No. 4744 Height 0·735 m. (29")
 Width 0·59 m. (23¼")

The old man on the left, with the star and crescent on his head-dress, pats the patiently folded hands in mock comforting and in anticipation of the cruelties of the younger men: the tearing off of Christ's own garment to substitute the mockery of the purple robe, the crushing on of the plaited crown of thorns, the spitting and the buffeting. But these actions are suspended, as if the curtain were about to go up and we were presented first with the *dramatis personae*, a contrast between mean characters itching to humiliate and a humility which is also compelling.

Bosch is famous for spacious and delicate landscape settings in which he sets a crowd of little phantasmagorical figures to all sorts of tricks. His few compositions with a larger scale and no landscape are almost all of this subject or one that is closely allied.

This is probably an early example. It shows already, however, how independent he was of his Netherlandish contemporaries. David and Mabuse were both younger men, and the picture has been detached from the chronology in which it belongs. Bosch in his own day belonged to no school. Looking back with the perspective of history, we see that his great pupil was Pieter Bruegel, who was almost three generations younger.

There is a beauty in the handling of the paint in all great pictures, for the creative quality of the artist's mind reaches into the very means of creation. But Bosch is perhaps the first northern painter who seems deliberately to knead form and light and colour into a texture of paint which is in itself a beauty and a means of expression. His method of painting freely on panel with a thin medium was adopted by Bruegel and became the essence of one of the characteristic techniques of Rubens.

The *Christ Mocked* was in England by 1882, though it was bought for 300,000 lire in 1934 in Rome.

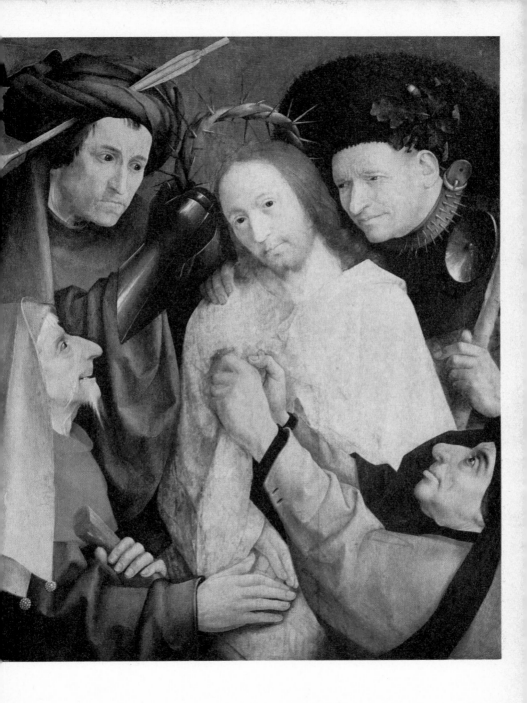

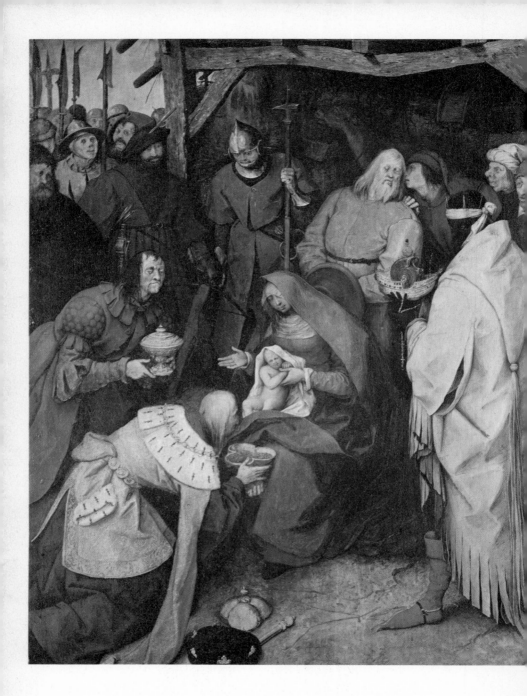

PIETER BRUEGEL THE ELDER *Early Netherlandish School*
(active 1551; died 1569)
THE ADORATION OF THE KINGS Panel
Catalogue No. 3556 Height 1·11 m. $(43\frac{3}{4}'')$
 Width 0·835 m. $(32\frac{3}{4}'')$

As is customary, Caspar, the old king, kneels to make the first offering, his sceptre under the royal hat upon the ground, with the lid of the chalice that he is offering. Melchior holds another gold cup behind him and on the right Balthazar, the black king, holds a more exotic offering in the form of a gold nef with a nautilus shell bizarrely mounted. Behind the Virgin's shoulder St Joseph holds a big round straw hat. Perhaps the man whispering in his ear is a shepherd, telling of the Annunciation to the Shepherds which is frequently added to the Adoration; but his two companions are not very shep-herd-like. The retinue of the Kings are mostly rough soldiers much like those infesting the Netherlands under Spanish occupation, whose depredations Bruegel chronicled in other pictures.

In the bottom right corner is inscribed: *BRVEGEL M. D. LXÍÍÍÍ.* The picture thus comes into the second half of his short painting activity, as it is recorded by such inscrip-tions from 1557. He had become Master at Antwerp in 1551; but he seems to have journeyed to Italy and even to Sicily in 1552–3 and to have begun his subsequent career as draughtsman and engraver.

There is something of the engraver-illustrator in the fine-drawn lines and thin edges of this picture; but these describe true forms which have weight and bulk under their descriptive detail. The Child emerged from his cocoon of drapery becomes the climax by His plain classical solidity as much as by His central position and the ingenious arrangement of all the lines to lead to Him.

In Bruegel's painting the single influence that counts is that of the lonely Bosch. Bruegel painted more broadly and with less sensuous delight. He was concerned less with fantasy and more with nature and with those who lived close to the soil. But the technique is essentially Bosch's, shared by the two men because it would express something that they had in common: a sense of humour and pathos, a belief in the wisdom of ancient proverbs and the earthy knowledge of the peasant.

The *Adoration* is said to have been in Vienna at the end of the last century. It was bought for £15,000 in 1920.

PETER PAUL RUBENS (1577–1640) *Flemish School*
THE JUDGMENT OF PARIS Panel
Catalogue No. 194 Height 1·44 m. (57″)
 Width 1·90 m. (75″)

Paris keeps his sheep on Mount Ida, and thither Hermes has led the three goddesses for the prize-giving. As the apple is awarded to Aphrodite in the centre, Eris, personification of discord, appears in the sky, and Hera's peacock screams at Paris' dog. Athene seems not yet to have taken in her defeat; but the Medusa-head shield is a warning that she can be dangerous.

Rubens was completely the heir of the Italian Renaissance. During eight years in Italy he never ceased to study the painters and sculptors of the full Renaissance and of an Antiquity in whose heroic virtues he was a passionate believer. He was a collector of antique gems, and was learned in the classics. Yet, if he surpassed the Italians in one thing only, this was the ability to throw himself with an enjoyment even less self-conscious than Titian's still deeper into the earthy paganism of mythology. Everything here is in terms that were real to him: the familiar pastures, the plump, fairfleshed women of Flanders, with his young wife in the centre. In these last ten years the Baroque rhythm is given to his forms so spontaneously that we are aware of nothing but the ease with which these have come together in the composition. The art is in the sheer, harmonious enjoyment, in the richness and tangibility of all the forms, in the range of light and colour, in the vitality of the textures.

The panel is all of one piece except for a six-inch addition to the right side. In this case however Rubens was repeating a smaller and more complicated picture in Dresden.

The picture belonged to Cardinal Richelieu, a great admirer of Rubens' art. Later, 1729–95, it was in the collection of the Dukes of Orléans. When this collection was brought to England, *The Judgment* was bought by Lord Kinnaird. It was acquired for £4,200 at the sale of John Penrice in 1844.

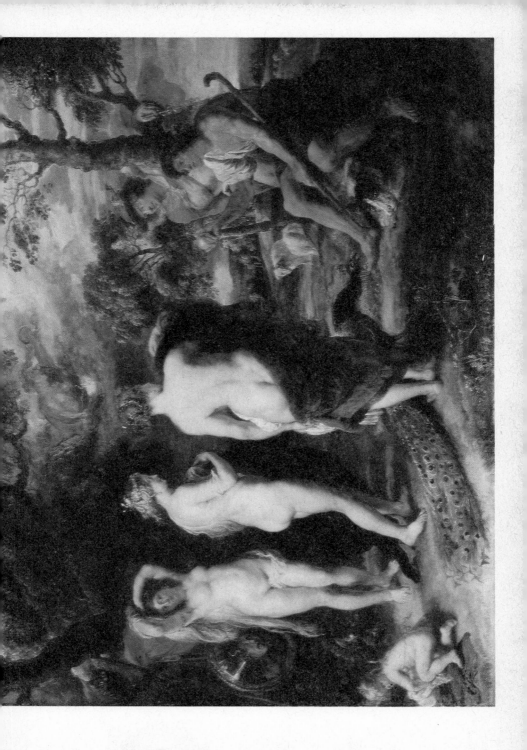

PETER PAUL RUBENS (1577–1640) Flemish School
'Le Chapeau de Paille' Panel
Catalogue No. 852 Height 0·79 m. (31″)
Width 0·545 m. (21½″)

The lady is not, of course, wearing a straw hat. The simplest of several explanations of the time-hallowed title is that *paille* is a corruption for *poil*; the most attractive that the word corrupted was *poesle*, old French for *baldachin* and the painter's nickname for the hat.

Tradition had it that the sitter was Helena Fourment, the artist's second wife. Helena was the beauty of Antwerp; but this is not at all like her at the time of their wedding in 1630, when she was sixteen. The picture cannot have been painted much later than that; but the modern belief that the sitter is Susanna Fourment, Helena's eldest sister, born in 1599, has led to dating it too early. It must have been painted about the time of his marriage. Helena had more than one sister.

When his pictures were to be painted by assistants Rubens made careful sketches and everything was planned. The pictures that he painted himself he seems to have started usually with only a vague idea as to how they would end. Here he has had to add a piece three inches wide down the right side and another, more than six inches wide, along the bottom. Even the addition at the bottom, which includes part of the right hand, is less carefully painted. On the side he has hurriedly invented this dark storm-cloud which detracts a little from the brilliance of the whole.

Nevertheless, this portrait is unique in the seventeenth century for the effect of full daylight in the open air and for the brilliance and subtlety of tone with which the painter has met the challenge of the sun. Jacob Burckhardt, author of *The Civilization of the Renaissance in Italy*, called this in a letter of 1879 'Rubens' wonder picture'.

Brought to England in 1822, it was bought by Robert Peel, the future Prime Minister. Peel's great collection was bought *en bloc* from his eldest son in 1871.

PETER PAUL RUBENS (1577–1640) *Flemish School*
LE CHÂTEAU DE STEEN Panel
Catalogue No. 66 Height 1·34 m. (53")
Width 2·36 m. (93")

The greatest portraits have not been painted by men who specialized in portraiture. The power to abstract and idealize, which is necessary to great portraiture, comes best with the practice of the imagination; and power of form, which is the first essential, grows out of the study of the human figure in space. One can say much the same of landscapes. The great landscape is something more than a single view of a natural scene, and yet one must feel able to set foot in it and travel to the horizon confident of firm ground.

Rubens' earliest landscapes had been imaginary scenes with some legend of Antiquity as their theme; but he had painted pastoral landscapes occasionally for a dozen years or so when in 1635 he bought the domain of Steen, between Vilvorde and Mechlin. Here, as in the portraits of his wife and children, he threw aside all classical pretexts and again painted pure landscape for the sheer joy that he felt in Nature: in her abundance, in the variety and unison of her form and light and colour.

The Château de Steen is to be seen here to the left in the shade of the trees, its windows flashing back the light of the newly risen sun, reflected also in a thousand glistening sur' faces across the fields. The house is still there, but to the pedestrian eye the fields are flat and shapeless. Their lord's enthusiasm, together with his long practice in historical painting, has endowed their forms with rhythmical undulations that are swelled and coloured by the blaze of light.

There are some strange anomalies of proportion, due perhaps to the composition of a largely imaginary scene from studies of different parts. The panel itself is composed in the most unorthodox manner, having begun with a piece of wood about three feet wide in the centre, to which sixteen pieces have been added round. Certainly the first intention was not a painting of this size. *The Rainbow Landscape* of the Wallace Collection was probably painted later as a pendant; they were together in the Balbi Palace at Genoa. They were brought to England in 1802, and *Le Château de Steen* was bought in the following year by Lady Beaumont for her husband, Sir George Beaumont, who presented his collection in 1826.

ANTHONY VAN DYCK (1599–1641)
CORNELIUS VAN DER GEEST
Catalogue No. 52

Flemish School
Panel
Height 0·375 m. $(14\frac{3}{4}'')$
Width 0·32 m. $(12\frac{1}{2}'')$

Van der Geest was a collector of pictures in Antwerp. A painting by W. van Haecht records his proudest moment, when he was showing his gallery to the Regents. He is best known to posterity by the engraving of Paul Pontius in the *Iconographie*, a large series of portraits of distinguished men by various engravers, all after drawings by van Dyck. The drawing for van der Geest, now at Stockholm, is later than this picture; but it is so like that it was probably adapted from it.

For all his steady look in the concentrated light, van der Geest's face does not tell us a great deal; but few of van Dyck's faces do that. Later, as he quickly learned to endow his sitters with a prodigious glamour, they acquired an hauteur of even greater coolness. This picture shows what a capacity for striking an impressive likeness he had from the first. It must have been painted before his first brief visit to England in 1620.

He had been an independent painter at sixteen; but after a few years he had to enter the factory of Rubens. The great man treated him generously, and he was mentioned in the contracts for many important pictures as their chief executant; but a great career was to be made only abroad; first in Genoa, then in London. Here he settled in 1632, to become painter to King Charles and his court. In England he developed an easy style which had great influence upon the English painters of the next century. The Gallery has a great equestrian portrait of Charles I; but its size defies reproduction.

The *van der Geest* was brought to England in 1796 enlarged by a later hand to show a good deal of body. In this form it came to the Gallery with the Angerstein collection in 1824. It was restored to its present dimensions in 1948.

CARAVAGGIO (1573–1610) *Italian School*
THE SUPPER AT EMMAUS Canvas
Catalogue No. 172 Height 1·39 m. (55″)
 Width 1·95 m. (77½″)

'And it came to pass, as he sat at meat with them, he took bread, and blessed it, and brake, and gave to them.

'And their eyes were opened, and they knew him; and he vanished out of their sight.

'And they said one to another, Did not our heart burn within us, while he talked with us by the way, and while he opened to us the scriptures?'

St Luke (XXIV, 30–2) tells us of a gentle scene, of a companionship quietly enjoyed and becomes a poignant revelation. Caravaggio gives us an explosion.

Michelangelo Merisi da Caravaggio finished his apprenticeship in Milan in the month of Veronese's death; and in Rome had painted several pictures before Tintoretto died. Yet in this anthology of reproductions his picture would have looked strangely incongruous with theirs. It comes more naturally after those of his contemporary Rubens, who admired his work in Rome, and before that of Velazquez, who was influenced by it in his early days at Seville. Not that there is much affinity with the late works of those artists, mellowed by the maturity of their authors and by their communing with Titian. Caravaggio, who mellowed little in his short life, was even more out of sympathy with the poetic rhythms of Venetian colour than he was with those of Raphaelesque and contemporary Roman form.

Already in Lombardy and the Veneto, however, painters like Savoldo and the Bassani had introduced *genre* into religious scenes. Such a lighting effect as this, with light coming from a single source and throwing black shadows, had been used not only by these northerners but at intervals through two centuries of Italian painting. What was fundamentally shocking when the picture was new is what is shocking now: the violence in the projection of the forms, reflecting a lack of internal harmony which within a few years made Caravaggio, after many unseemly episodes, a fugitive from justice in Naples and Malta.

This picture was painted probably about 1598, for Marchese Ciriaco Mattei; and then acquired by Cardinal Scipione Borghese. It remained in the Borghese collection in Rome until 1798. It was given to the Gallery by Lord Vernon in 1839.

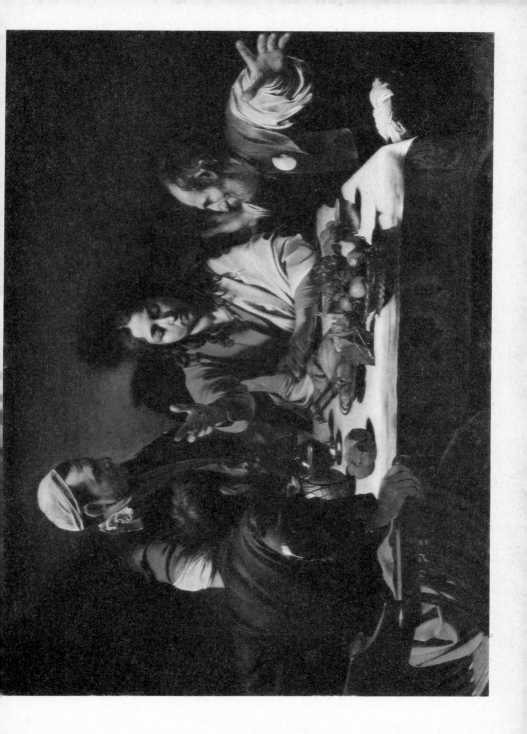

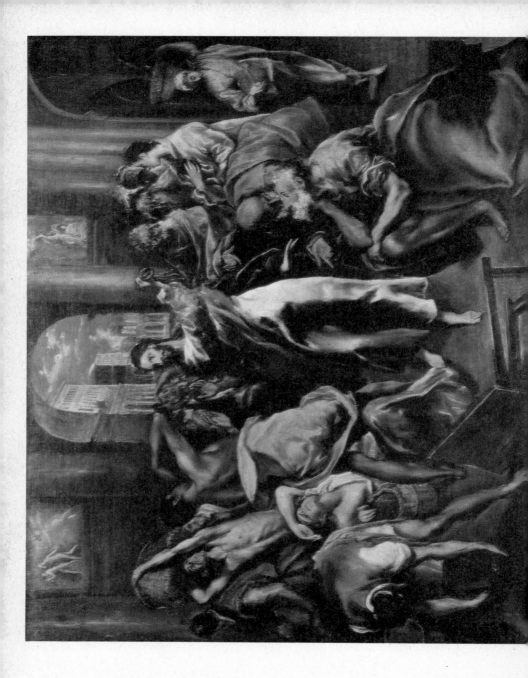

CHRIST DRIVING THE TRADERS FROM THE TEMPLE Canvas

Catalogue No. 1457 Height 1·063 m. (41⅞″)

Width 1·297 m. (51⅛″)

'And Jesus went into the temple of God, and cast out all them that sold and bought in the temple, and overthrew the tables of the money changers, and the seats of them that sold doves. And said unto them, It is written, My house shall be called the house of prayer: but ye have made it a den of thieves' (Matthew, XXI, 12–13).

Christ dominates by the wide eye flashing righteous anger and the contemptuous backhanded swing of the scourge, by the brilliance of the red robe, which is alone in the colour pattern of the picture, and the upright stance in the very centre. This uprightness is repeated in the columns of the architecture behind, between which are two carved reliefs, one of an earlier expulsion, *The Expulsion from the Garden of Eden*, and the other of *The Sacrifice of Isaac*, the Old Testament prototype of the Crucifixion. But the movement of all the other figures is in strong contrast. It is roughly parallel with one or other of the two diagonals which would join the four corners of the picture, crossing in the figure of Christ; and this both holds the composition together and makes the impression of disruption, of Christ's centrifugal force.

Through the arch at the back is a reminiscence of the sky of Venice and the palaces of the Grand Canal lit by its reflections from the water. When he painted this picture El Greco was well established at Toledo; but it is a refinement upon a composition which he had painted at least twice before, probably before he had left Italy. Indeed the pose of almost every figure in it can be traced back to an origin in some well-known picture of the Italian High Renaissance, by Titian or Tintoretto, by Raphael or, above all, Michelangelo.

Toledo, the religious capital of Spain, was the nerve-centre of the Counter-Reformation. There the devotional ecstasy of Loyola and his followers found perfect expression in El Greco's dramatic emotionalism. In other pictures he had already gone further from the Italian tradition with its insistence upon solid form and architectonic composition, levitating his figures from the ground into a flickering light between earth and heaven.

The picture was bought at Christie's in 1877, probably by Sir J. C. Robinson, who presented it to the Gallery in 1895.

DIEGO VELAZQUEZ (1599–1660) Spanish School
THE TOILET OF VENUS ('THE ROKEBY VENUS') Canvas
Catalogue No. 2057 Height 1·225 m. $(48\frac{1}{4}'')$
 Width 1·77 m. $(69\frac{3}{4}'')$

In the Spain of Velazquez's day the female nude was a subject virtually proscribed, even though the artists were modelling themselves upon the Italians of the late Renaissance. Velazquez painted probably at least four other nudes; but he owed this freedom to his visits to Italy and to the protection of King Philip IV.

When this picture was in his studio in the royal palace, it may well have looked insipid in contrast with the series of full-bodied Venuses that Titian had painted for Philip's grandfather. These were one of Velazquez's responsibilities, and, as he passed maturity, he assimilated more and more of the Venetian way of painting. But he was Titian's opposite. Without either his passion or his poetry, he was endowed instead with extra-ordinary objectivity of observation and cool perfection of taste. This rare combination gave him power not only to eliminate all that was not essential to the dignity of his subject and to the harmony of his effect but to compose as if seeing and designing were the same thing, as if unity could be achieved by the eye alone.

In *The Toilet of Venus* his talent for elimination may have left too little in the subject for us to admire. But there is real structure in the sweep of the outlines, and the breadth of the dignified conception is balanced by a precise quality 'probably the picture's greatest distinction: subtle changes of tone and colour which register the almost imper-ceptible changes in the angles of the surfaces and consequently in their reflection of the light.

In 1651 the picture belonged to Don Gaspar Méndez de Haro, Marqués del Carpio and de Heliche, who may well therefore have commissioned it. It passed in 1687 to his daughter, who married the tenth Duke of Alba. It remained in the Alba collection until after 1802 and was sold by order of King Charles IV to the Queen's favourite Godoy, Principe de la Paz. It came to England in 1813 and was sold not long after to J. B. S. Morritt of Rokeby Hall, Yorkshire. Sold by H. E. Morritt to Thos. Agnew and Son, it was bought and presented to the Gallery by the National Art Collections Fund in 1906.

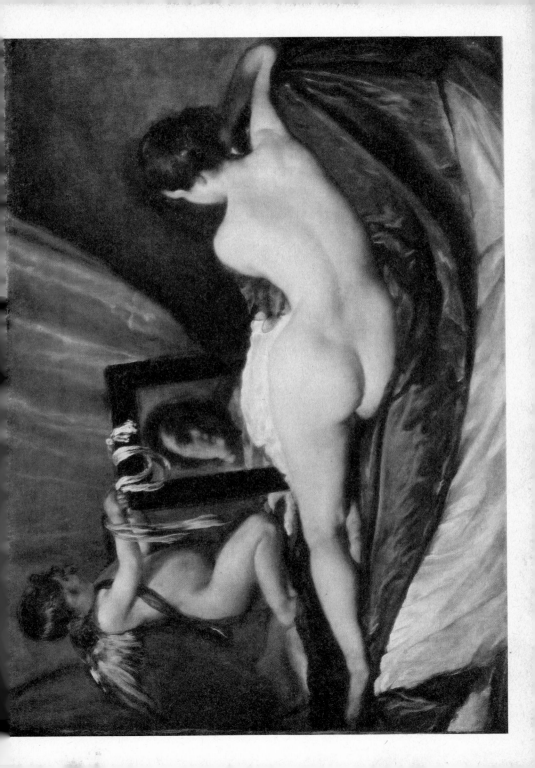

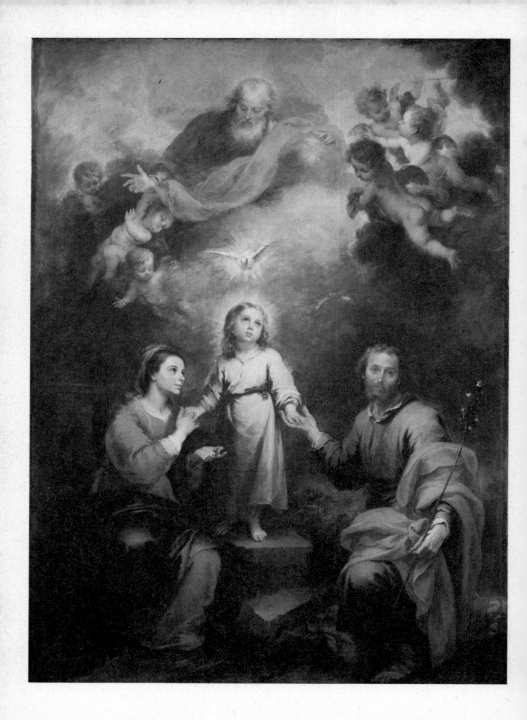

BARTOLOMÉ ESTEBAN MURILLO (1617–82) *Spanish School*
THE TWO TRINITIES Canvas
Catalogue No. 13 Height 2·93 m. $(115\frac{1}{4}'')$
Width *c.* 2·07 m. (*c.* $81\frac{1}{2}''$)

On earth the earthly counterpart of the triple Godhead, the Holy Family. While the Virgin sits, St Joseph kneels holding the wand whose flowering singled him out from the other suitors as Mary's future husband. The Child stands on the block of masonry which forms the Virgin's seat, and so is elevated above his parents into the clouds which bear the Eternal Father and his assistant Cherubim. So, in the sky, the Holy Ghost descends from Father to Son.

There is a picture of the same subject in the National Gallery, *The Nativity with God the Father and the Holy Ghost* by the Venetian Giovanni Battista Pittoni (1687–1767), but the Eternal Father and the Holy Ghost had been painted over in that picture long before the Gallery acquired it in 1958. In fact the theme, which does not seem to have occurred before the end of the sixteenth century, was never a popular one.

Yet Murillo has been inspired by it to one of his grandest pictures, rich in colour and atmosphere, graceful in the flowing continuity of the design and not without spatial construction. With his habitual sweetness of face and gesture there is real tenderness in the well drawn hands.

Murillo passed his whole life in Seville, which was much the most prosperous city in Spain. He began there, as Velazquez and Zurbarán had done, in the tough realistic style which was native; but after a visit to the royal collection in Madrid, with its pictures by Titian and Rubens and van Dyck, he adopted the soft sfumato which made him one of the most popular of painters, first in southern Spain and then, after he was dead, throughout all Europe.

Traditionally said to have been painted for the Pedroso family, this great altarpiece at least belonged to the Marques del Pedroso in Cadiz by 1708. Brought to England from Seville about 1810, it was bought for the Gallery for £7,350 in 1837.

FRANCISCO GOYA (1746–1828) *Spanish School*
PORTRAIT OF THE DUKE OF WELLINGTON Canvas
Catalogue No. 6322 Height 0·603 m. $(23\frac{3}{4}'')$
 Width 0·515 m. $(20\frac{1}{4}'')$

Goya had already been painter to the Spanish Bourbon kings Charles III and Charles IV, and to Ferdinand VII. When Ferdinand fled before the victory of the Peninsular War, the future Duke of Wellington became the most powerful man in the world of the painter, who saw him not only when he entered Madrid in 1812 as Earl of Wellington and the fiery leader of a liberating army, but in 1814, when he returned as the formal Representative of the British Government. He had been appointed Ambassador to Paris after Napoleon's first banishment.

Goya made in all five portraits of him. The large, wild equestrian portrait now in the Wellington Museum at Apsley House appears to be hastily executed, and X-radiography shows that the head and figure of Wellington were superimposed over those of an earlier and less fortunate sitter. Yet that is the portrait first mentioned in contemporary records. Three weeks after he entered Madrid it was stated in the *Diario de Madrid* to be ready for exhibition in the Academia de San Fernando; and Goya in an undated letter records a discussion with 'His Excellency Señor Willington' about hanging it. A half-length portrait on canvas is in the National Gallery, Washington, D.C., and there are two drawings, one in pencil in the Hamburg Kunsthalle, another in red chalk in the British Museum Print Room.

The latter may possibly be the first likeness which Goya took; but both the observations made during the recent cleaning and infra-red photography have shown clearly that the National Gallery portrait was the model for the rest. It must have been painted first in 1812, perhaps as a sketch for the equestrian portrait, and has remained a vivid record of a man-to-man encounter between two powerful personalities. But it was greatly enriched and made rather more formal in 1814, when the orders and decorations meanwhile received by the great man had to be added. He was very particular in matters of dress.

The picture is believed to have been given by Wellington to his sister-in-law, the Marchioness Wellesley, and bequeathed to her sister, the Duchess of Leeds. It was sold by auction for the late Duke of Leeds in 1961 and bought by Mr Charles Wrightsman, who graciously offered to cede it to the National Gallery at the auction price. The purchase was made possible by the generosity of the Wolfson Foundation. The picture was stolen from the Gallery less than three weeks later, but was recovered in 1965.

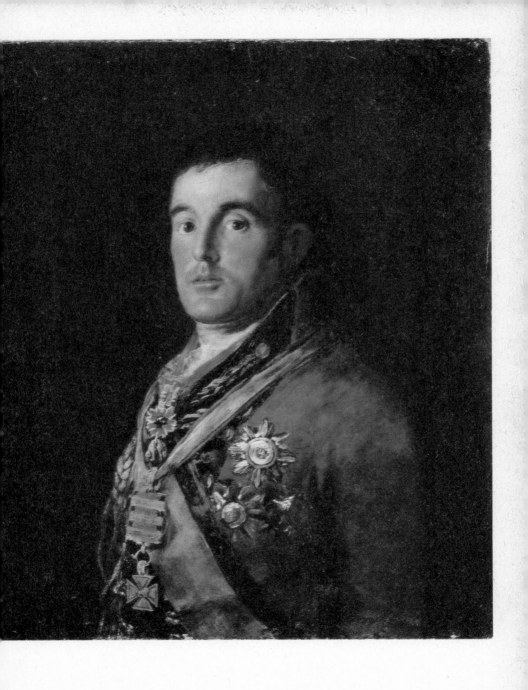

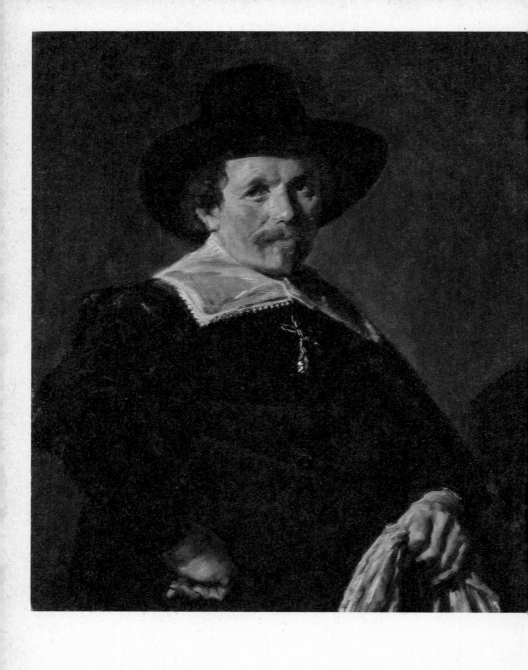

FRANS HALS (c. 1580?–1666) *Dutch School*
PORTRAIT OF A MAN HOLDING GLOVES Canvas
Catalogue No. 2528 Height 0·785 m. (30⅞″)
Width 0·673 m. (26½″)

More likely than not, this substantial, sun-tanned man, dressed in his dignified best and holding the gloves of respectability, was a citizen of Haarlem. It was there, though he was born in Antwerp, that Hals painted all, or nearly all, his pictures. He must have painted a high proportion of his fellow-citizens, as well as many men and women from other towns. He painted the great Descartes, though the original has disappeared. He is thought to have been visited by Rubens and van Dyck. It is something of a puzzle therefore that he was rarely out of debt and that, in his last few years, when sitters had become shy, he was receiving relief from the town.

Part of the explanation lies in the economics of Dutch painting. The United Provinces, with their Protestant majority, had succeeded in separating themselves from Flanders and in throwing off the yoke of Spain. This new-found freedom and the commercial prosperity which was part cause and part effect resulted in a great surge of feeling for the country in all its aspects. It found expression above all in painting. So phenomenal were the number of painters and the quantity of their pictures that these had to be sold for the most part at modest prices; and few of the painters who are famous today made an easy living.

Hals had two younger brothers who were painters. He was one of the first painters of the new regime. His earliest portraits are reminiscent of the mid sixteenth-century portraitist Anthonis Mor, who died as painter to the Spanish Court at Brussels. But he soon developed a more dashing style, applying his paint directly in opaque colour which achieved its effect in one layer – *alla prima* – instead of in transparent layers over a monochrome foundation. This rapid method enabled him to achieve likenesses less profound but more spontaneous than those of his predecessors.

A Man Holding Gloves belongs to the middle of his career, to about 1640. It was part of the great Salting Bequest of 1910.

REMBRANDT VAN RIJN (1606–69)　　　　　　　　　*Dutch School*
THE WOMAN TAKEN IN ADULTERY　　　　　　　　　Panel
Catalogue No. 45　　　　　　　　　　　　　　　Height 0·838 m. (33″)
　　　　　　　　　　　　　　　　　　　　　　Width 0·654 m. (25¾″)

In one respect Rembrandt might be called the great descendant of Caravaggio: he too habitually excluded the sunlight and called up his figures from deep shadow for the drama of the effect. But, especially by the time of this picture, the effect could hardly be more different, for it evokes all the sympathy that we possess. Though the psychological difference may be fundamental, it is far from the only one. Rembrandt saw the physical world in another way. Caravaggio, who seems to have suffered from agoraphobia, made the darkness close in upon his figures. Rembrandt's shadows are an infinity of space, from which more is for ever emerging as long as one cares to look.

Here the hugeness of the temple, with its vaults invisible above, and the vasts of darkness across which the light falls with such tenderness upon the small kneeling figure in white, calls by contrast for pity on its loneliness and emphasizes the humanity of the theme:

'And early in the morning he came again into the temple, and all the people came into him; and he sat down and taught them. And the scribes and Pharisees brought unto him a woman taken in adultery; and when they had set her in the midst, They say unto him, Master, this woman was taken in adultery, in the very act. Now Moses in the law commanded us, that such should be stoned: but what sayest thou? This they said, tempting him, that they might have to accuse him. But Jesus stooped down, and with his finger wrote on the ground, as though he heard them not. So when they continued asking him, he lifted up himself, and said unto them, He that is without sin among you, let him first cast a stone at her' (St John, VIII, 2–7).

The story is depicted with wonderful completeness. Behind, the ordinary crowd is winding up further flights of steps towards the throne of the High Priest, who in a blaze of barbaric gold is administering another form of justice.

This picture is signed and dated *Rembrandt · f · 1644*. In 1657 such a picture headed the inventory of an Amsterdam dealer recently deceased; but it was sold in 1803 by the Six family. It came to the Gallery with the Angerstein collection in 1824.

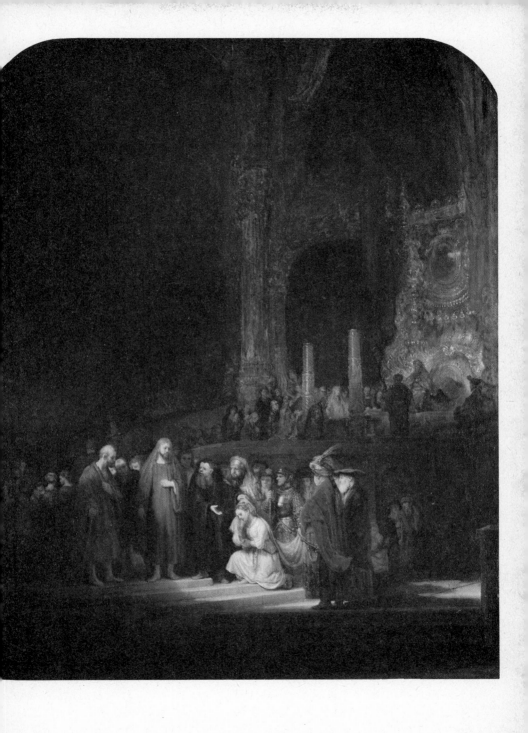

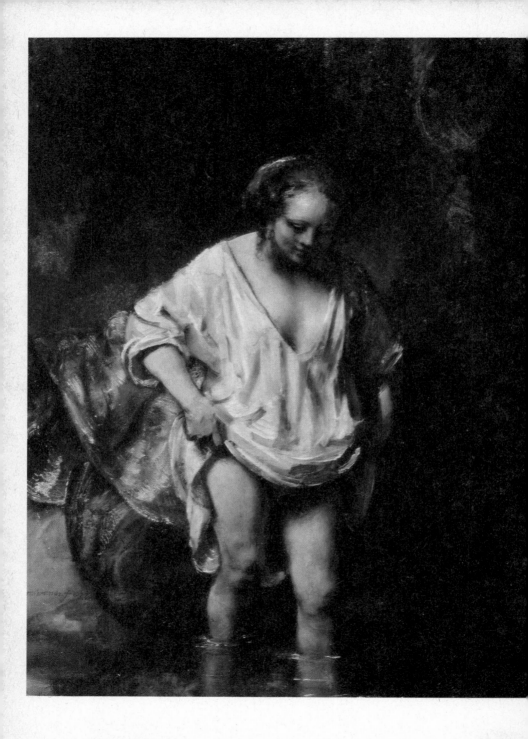

REMBRANDT VAN RIJN (1606–69) *Dutch School*
A Woman bathing in a Stream
(Hendrickje Stoffels?) Panel
Catalogue No. 54 Height 0·618 m. (24$\frac{5}{16}$″)
 Width 0·470 m. (18$\frac{1}{2}$″)

This picture is inscribed on the left: *Rembrandt · f · 1655*, which shows that the painter had little doubt of his significance to posterity. He is unlikely when he painted it to have expected a sale for such a picture, for it belonged to a virtually new type both in the theme and in the manner of its handling. In effect he was making the claim that the artist was free to paint whatever he chose and to paint it as he liked.

He also claimed to live as he liked. The model is much like Hendrickje Stoffels, at least as she has been identified in many pictures. With Hendrickje, after the death of his wife Saskia, Rembrandt lived from about 1649 until her death before 1664. In any case, in spite of an official reproval from Hendrickje's church, they were never married.

The technique is bold as that of Hals, but much more complex. There was a first painting in monochrome and there are glazes over a lighter ground in many of the shadows. Between these and the opaque fat dabs in many of the highlights there is a wide range of degrees in transparency. The handling, considering the small scale of the picture, is even more free, the result quite as fresh and lively as in any of Hals' portraits; while utterly tranquil and intensely intimate. The drama is in the completely unselfconscious absorption of this girl, who is enjoying the coolness of the water and worrying only about where next to put her foot. What makes so small a human drama so significant is the profundity of the sense of form. There is a close identity in our experience between depth of emotion and the third dimension.

Rembrandt in his earlier years had made both movement and continuity out of the Baroque rhythms of Rubens, whom he began by emulating in more than one respect. As he developed his powers, movement became less and less important to him; it was enough for his figures to breathe, and feel, and think. The idea of tranquil contemplation is not easily compatible with linear rhythms. So this figure is hacked out of the dark block of shadow with abrupt strokes.

The picture was bought in 1829 at the sale of Lord Gwydyr by the Rev. William Holwell Carr; it came to the Gallery two years later with the Holwell Carr Bequest.

REMBRANDT VAN RIJN (1606–69) *Dutch School*
PORTRAIT OF THE PAINTER IN OLD AGE Canvas
Catalogue No. 221 Height 0·860 m. $(33\frac{7}{8}'')$
 Width 0·705 m. $(27\frac{3}{4}'')$

When the story concerned the fate of an individual, Rembrandt was the greatest of all story painters. It was inevitable perhaps that almost from the first he should realize that the most moving of all human stories is written in the human face.

It was only for about a decade, after he had moved from his native Leiden to Amsterdam in 1631, that he seriously attempted to be a fashionable portrait-painter, and this was a phase in his career more important perhaps for others than for himself. It enabled him to buy a big house and set up a great school of painting which had its repercussions through almost the whole field of Dutch art. Meanwhile his personal evolution continued, not only in subject pictures but in portraits of his immediate relations and above all of himself. From his earliest years he painted himself at frequent intervals, irregularly but so often that to make the total he must have painted on the average nearly two self-portraits a year.

The motive inevitably seems to vary from time to time and from portrait to portrait. There is often fancy dress which seems to imply the wish to create and study a particular effect; in the early years one can diagnose sometimes admiration, sometimes self-pity. All through there is, equally inevitable, a certain defiance of the world: 'Here I am.'

Yet, above all, there is the constant twofold object: to create form, and to make a particular form which should chronicle the workings of time and of the emotions which have come swirled along its stream upon that rugged plebeian face. 'Here I am: flaccid, wrinkled, with bulbous nose and few teeth, no more than sixty and rather tremulous. Yet here I am, the Dutchman who has never been to Italy, the greatest living master of form.'

The picture was bought for £430 at the sale of Viscount Midleton in 1851.

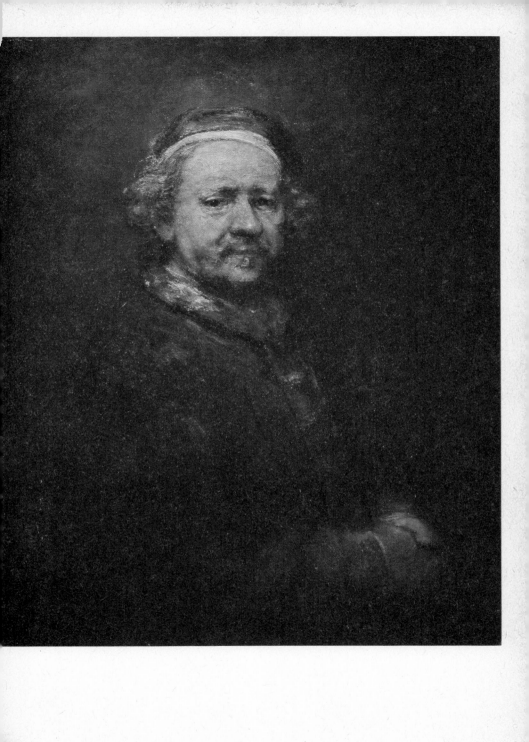

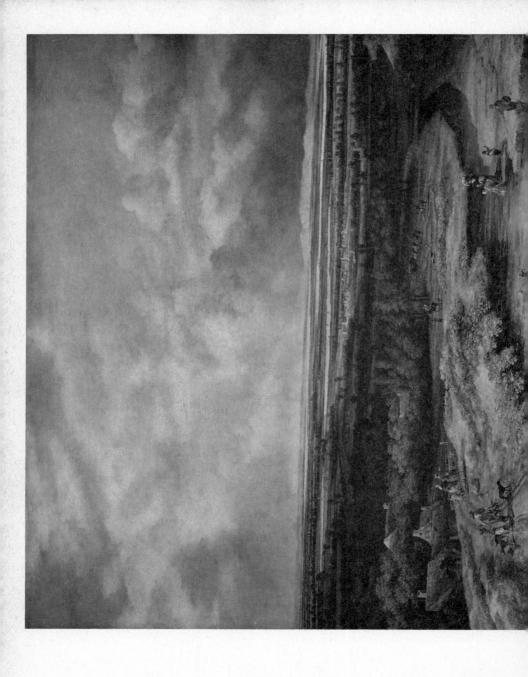

PHILIPS KONINCK (1619–1688) *Dutch School*
AN EXTENSIVE LANDSCAPE WITH A HAWKING PARTY Canvas
Catalogue No. 836 Height 1·325 m. (52¼″)
 Width 1·605 m. (63⅛″)

In the foreground on the right fishing and washing are going on, as always, among the ducks in the backwater. On the left a hawking party is advancing along the road, the falconer in front. He is followed by ladies and gentlemen on horseback and farther back, round the bend of the road, a coach and six has just emerged out of the passing shadow into the light.

Yet for all their clarity and distinctness – and in spite of the fact that they may well have been put in for Koninck by another artist – these toy men and animals and birds are no distraction from the grandeur of the wide wet scene. Indeed they are there to testify to nature's might, to the infinity of this panorama, so various and noble and yet a playground for the light and shadow as the clouds sweep across the sky.

Koninck, however, though he was much less prolific than many of the specialists, tried his hand at many themes; for he was almost without doubt the pupil of Rembrandt, whose ideas are dominant in his art. He attempted scenes from the Bible and from Classical mythology without very much success. Portraits he painted at intervals throughout his life; but these too show little sign of the grandeur or of the accomplishment of his best landscapes. Rembrandt's landscape paintings are few, almost monochrome and quite imaginary; the idea of reproducing nature on wood or canvas had no appeal for him. But in the country he made a great many rapid pen sketches, some of farms and cottages, some of trees, and some with only a road and a dyke and a few bushes which evoke in our minds images of something infinitely greater, of the whole flat countryside of Holland, and its weather. It may well have been from these inspired hints of Rembrandt's rather than from the wild romantic landscapes in almost monochrome of Hercules Seghers that Philips Koninck developed the great prose poem of his panoramas. All his few great landscapes are of this type.

The picture was part of the great collection of Sir Robert Peel, bought from the Prime Minister's son in 1871.

JACOB VAN RUISDAEL (1628/9–82) *Dutch School*
AN EXTENSIVE LANDSCAPE WITH RUINS Canvas
Catalogue No. 2561 Height 0·340 m. ($13\frac{3}{8}''$)
Width *c.* 0·40 m. (*c.* $15\frac{3}{4}''$)

A majority of the Dutch painters became specialists in one theme or another, in portraits or landscape, genre or still-life; and in all these subjects and many others there were specialists again: romantic landscape or the Dutch scene, high life or low life, kitchen things or flowers. The total effect was as if all the minor men had combined to produce an exhaustive memorial of their country's beauty in all its aspects, and of their own devout love.

Ruisdael, who was born and died at Haarlem but spent more than twenty years probably in Amsterdam, was a pure landscapist. His landscapes range over the whole Dutch scene, viewed sometimes intimately from low down at close quarters, sometimes from a height in sweeping grandeur. He is one of the most accurate observers of nature and the greatest of all authorities on cloudy skies; but this does not hinder his consummate skill in gathering this great scene into one. The picture is signed: *JvR* (in monogram).

It came with the Salting Bequest in 1910.

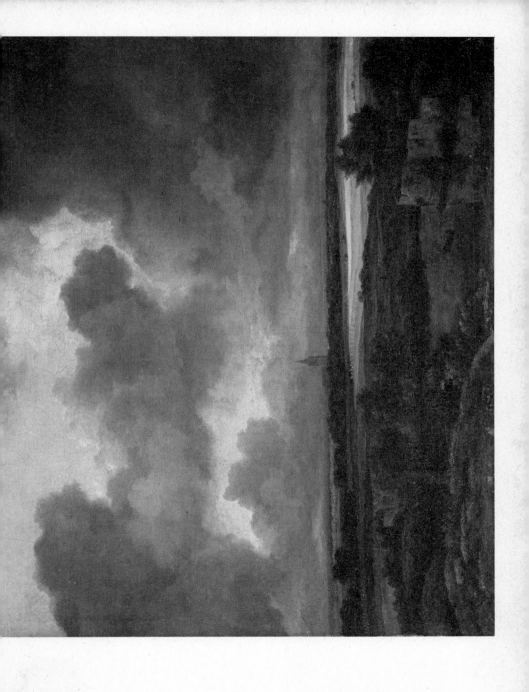

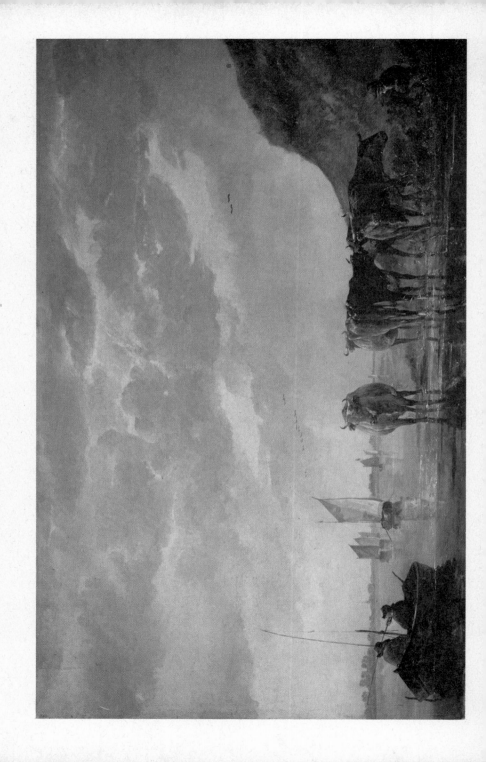

AELBERT CUYP (1620–91) *Dutch School*
A Herdsman with Five Cows by a River Panel
Catalogue No. 823 Height 0·454 m. ($17\frac{7}{8}''$)
 Width 0·740 m. ($29\frac{1}{8}''$)

Cows in a landscape were not an entirely novel subject when Cuyp started painting. As in so many things, Rubens, the great inventor, had been beforehand. In the idyll of his *Polder Landscape* at Munich, of 1620–25, the cows more than the milkmaids are the heroines. Grouping themselves at a variety of angles, they add their curly backs to the system of undulations in meadows and rivulet and in the tall trees through which the sun sends a final burst of gold as it goes down. Here too by the Meuse it is sunset; but only a greenish gold tinges the cold grey northern light, and the cows standing stolidly in the estuary mud make another straight horizon with their backs. The homely bulges in their sides and the sides of the sailing barges form the only curves. Cuyp also painted romantic landscapes with a warm nostalgic light on distant hills. He has chosen this apparently prosaic subject deliberately out of his sincerity about nature and for the problems of form and composition presented by the watery landscape round his own city of Dordrecht.

This is a new kind of picture in that there is no narrative and no nostalgia. There is no appeal to the emotions in its subject but through the recognition of what is there; and there might have seemed to be very little there to a man who was born and died with such a landscape at his back door. Yet this wide uninteresting space has been reconstructed with a skill born of continuous observation and patient practice, and in the process of recon-struction has been endowed with a precious quality not possessed by the original: unity of form. Cuyp has developed an almost magical power of illusion. How utterly intangible is the light upon the sails! Yet he never allows the illusion to be so great that nature can escape again from his control. The sails are also paint; and the whole picture is built up in touches of paint of which each seems to be both a plane in the scene before us and a facet of a sculptured structure, in three dimensions but no wider than the picture-frame.

The picture is signed *A · cuyp ·* . It was bought with the Peel collection in 1871.

JAN VERMEER (1632–75) *Dutch School*
A Young Woman standing at a Virginal Canvas
Catalogue No. 1383 Height 0·517 m. (20⅜″)
 Width 0·452 m. (17¹³⁄₁₆″)

Her touch is scarcely that of a musician; she has been made to stand at the instrument as the centre of a composition. Perhaps she co-operated rather ill; for the composition is not a complete success. One may accept the positions of the instrument and the chair as dictated by the painter's wishes rather than by the needs of the room; but the collection of heavy rectangles formed by these and the frames seems rather meaningless, and, though none of the ruled lines is quite as awkward as the nearly straight lines of her arms, the black edges of the virginal's lid look as if they were drawn upon the wall.

The wide range of cool tones from white to black and the elegant accompanying scheme of blues and golds are exquisite; but Vermeer made many compositions more successful than this. However, its limitations perhaps illustrate the better the difficulties of the task he set himself.

His ambition to belong to the Italian tradition is made obvious by the themes of his two large early pictures in Edinburgh and The Hague: *Christ in the House of Mary and Martha* and *The Toilet of Diana*. But he may never have been out of Holland, and certainly resided always at Delft. He soon settled down therefore to apply classical principles of form and design to the household scene around him and, above all, to his own way of seeing things, which was essentially Dutch. He may have been a Catholic; but at this distance of time his pictures seem a perfectly Calvinistic interpretation of the classical principle of unity.

If the end of a composition is emotional expression, the effect is likely to be heightened by a degree of incompleteness in the design, by the suggestion of facts not more than half stated or even merely implied. To make a unity perfect and completely visible out of cold facts reflecting the light of every day is a technical problem of another order. It is no wonder that Vermeer was not always equally successful or that his pictures are few.

This one is signed on the virginal: *I(V?)Meer* (IV?M in monogram). It can be traced at intervals since 1714, when it was sold at Amsterdam. It was bought for £2,400 for the Gallery in 1892.

JAN STEEN (1625/6–79)
SKITTLE PLAYERS OUTSIDE AN INN
Catalogue No. 2560

<div align="right">

Dutch School
Panel
Height 0·335 m. ($13\frac{3}{16}''$)
Width 0·270 m. ($10\frac{5}{8}''$)

</div>

The sign shows that this scene is set in the garden of 'The Swan'. A jug hangs under the sign, and the woman sitting on the ground in front of it is drinking dark beer out of a tall glass. A beer-pot is on the barrel table between this couple and the man with a pipe, and another is in the hand of the youth who stands watching the skittles to the right. Steen seems to have composed quite spontaneously, going straight to work with his brush with-out preparatory drawings. Yet something more than instinct must have been at the root of a composition which is equally satisfying for its unity and its diversity, its finish and its spontaneity. Each man and woman and boy is utterly absorbed, but each leads to another in the organization of the space; and then the old buildings, by the tilt of their roofs and the weather embodied in their surfaces, make the transition from solid ground and firmly planted figures to the airy wonderland in the trees. There the leaves are vibrating in the light, and bring us to the realization that, most of all, it is the young spring evening which makes everything so alive and various by its motley of light and shadow.

Steen was not often quite so spontaneous. This is one of his earlier pictures, and he went on to more elaborate and selfconscious things. The genre of the majority of his pictures is slightly theatrical, but, since he was exceptionally prolific, he bequeathed us a remarkable picture of Dutch life. He was apt to spoil its natural zest a little with a superficial moral or the quotation of an ancient saw. It was he who first said 'every picture tells a story'; but, though he is at his best when there is no story but only life, he never forgot that he was painting a picture. He was a keen observer of form and light and colour and the manu-facturer of delicious and varied effects in his handling of paint.

He painted for a time at Leiden, his birthplace, and it was there that he died; but he lived, meantime, in several places, including The Hague and Haarlem.

This picture can be traced from the early eighteenth century. In the late eighteenth and early nineteenth centuries it was in France, where it belonged at one time to Talleyrand. It came to the Gallery with the Salting Bequest in 1910.

Panel
Height 0·737 m. (29″)
Width 0·646 m. ($25\frac{7}{16}$″)

The left side of the room is a glow of light, diversified by the interval of wall and by the shuttering of half the farther window, to make a dark mirror of its panes. The fine gentle-man looks anxious as the lady of the house holds up his glass of wine to the light, to enjoy, before it disappears down his throat, the liquid radiance that it contains.

One should turn back from de Hoogh's picture to Vermeer's to appreciate the diversity within the little world of Dutch painting exemplified by the widely different vision of these two men, who were often in Delft at the same time. De Hoogh was born at Rotterdam, spent the later part of his life in Amsterdam and was often at Leiden and The Hague; but he married at Delft in 1654, and had been painting there some time before. This was as soon as or sooner than Vermeer. The question of who started first is of little significance, however. The degree of similarity only emphasizes the divergence of their themes.

While de Hoogh's personalities are engaged in their relation with each other, there is usually a suggestion of the world of light and space and more humanity beyond. This is a rare instance of an interior of his in which no door can be seen; but the sense of infinity already suggested by the softness and variety of the light is furthered by the considerable part of the large room left to the imagination and by the figure of the servant advancing carefully with a pan from the kitchen across the checkered floor.

Giorgione is recorded by Vasari to have had a turning-point in his career at which he decided to paint straight from nature. One can see that de Hoogh belonged to the warm and impulsive Venetian tradition, while Vermeer has made himself a member of the colder, academic school of Rome. Vermeer's lonely girl, closed in a measured space on every side, is there to reflect back the light for ever from her porcelain surfaces. De Hoogh's party of people belongs to a warmer world of life and death. There is infinity in its range of tones, and these ephemeral persons are one with it by the unity which he has established between light and colour and form. Signed on the left: *PDH*, this panel was bought with the Peel collection in 1871.

MEIJNDERT HOBBEMA (1638–1709) *Dutch School*
THE AVENUE, MIDDELHARNIS Canvas
Catalogue No. 830 Height 1·035 m. (40¾″)
Width 1·41 m. (55½″)

Inscribed *M: Hobbema / f 1689*, this is the last great Dutch landscape. All the other Dutch painters whose work is reproduced in this book were dead when it was painted. There were others still alive, less great but well enough known today; but most of these had already produced their best. The fire of invention had died out, much more suddenly and inexplicably than it had burned into a blaze.

With its flatness and emptiness, its rectangles and its great expanse of sky, *The Avenue, Middelharnis* sums up our idea of the Low Countries quietly but with extraordinary boldness. Middelharnis is still not much more than a village; but the avenue is not there today. That it ever was there cannot be taken for granted. Hobbema and his Dutch contemporaries only made drawings in the open air, and the pictures which they painted in their studios were at the most very free adaptations of what they had sketched.

If this picture does represent a view which existed in the Dutch countryside – as it is hard to believe that it does not – that by no means makes it a typical Dutch landscape painting. But it is perhaps a rather prophetic picture in more important respects than that.

Born in Amsterdam, where he also died, Hobbema was strongly influenced at first by the painting of Ruisdael, and his most characteristic subjects seem to be taken from the sandy woodlands in the neighbourhood of Haarlem. Unlike Ruisdael, he was a student of trees rather than of the sky, and it is his sympathy with the slender lopped trees of the avenue that makes the central charm of this picture. There is nothing, however, in his own previous work or in all Dutch landscape to prepare us for the magnificent and austere geometry of the design, which seems even more modern today than the other unusual feature, the diffusion of the light.

The picture was bought with the Peel collection in 1871.

The sculptured god has been decorated for his festival, and presides with stony laughter over the rites. Half dance, half riot, the festival is a scholarly compromise between earthiness and culture, convention and crude fun. It is only grape-juice that one of the two *putti* is collecting from the maenad in his porcelain cup. No one believes that her sister on the ground is in serious danger from the satyr who has got her down; or that what brains he has are really to be spilled by the gold vase poised in the hand of her rescuer. Her arm in turn is restrained by another nymph, who links the three strugglers with the other three, still intent upon their ritual dance.

These, with their clean outlines and their classic convention of red men and white girls, are like a group from some imagined frieze by a painter from ancient Attica. Yet how real is the Golden Age! The beauty of the reflected light on the shadowed facets of these bodies gives them authenticity, and the vine-leaves which hang, as they do in Virgil, from the trees above their heads, move calmly in the clean air from the Arcadian mountains beyond.

Poussin came to Rome, both spiritually and physically, via Venice; for Titian and Veronese inspired his earlier work in Rome. Titian's Bacchanals had already been brought there from Ferrara, to give colour and intensity to his reactions.

Rome in the seventeenth century was a gathering place for artists from all over Europe. Encouraged by the Pope, the Academy of St Luke had set itself to build up a purer idea of the Classical based on the study of Raphael and the Antique.

By the time Poussin arrived, however, the Academy was more stale and tired than before. It needed fresh blood from the north of Europe to revive the imagined spirit of Antiquity yet again and produce one more vital phase of the Renaissance.

The picture was bought for the Gallery for £9,000 in 1826.

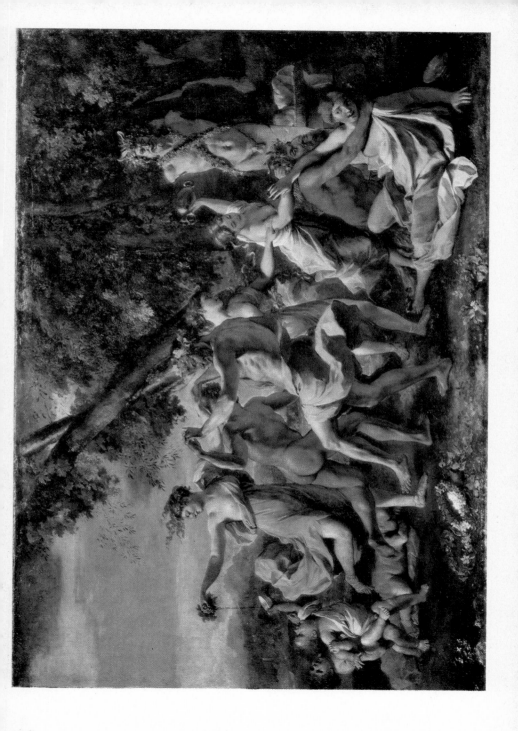

CLAUDE LORRAIN (1600–82) French School
LANDSCAPE: CEPHALUS AND PROCRIS REUNITED BY DIANA Canvas
Catalogue No. 2 Height 1·02 m. (40″)
 Width 1·32 m. (52″)

Poussin in an early picture at the National Gallery, *Cephalus and Aurora*, had told of
Cephalus' dalliance with the goddess of the dawn. When this characteristic Greek hero
returned to his faithful wife Procris, he played so base a trick upon her that she fled to the
mountains, and the protection of Diana. Cephalus went in pursuit. Now, by the drink-
ing-pool among the long shadows from the bright, low sun, Diana stands between them
as their hands are about to touch. She is pointing to one of the two magic presents which
she has given Procris, the dog Laelaps; the other present, a spear, is held by the boy
behind. Neither of these was ever to miss its quarry. Alas, Procris was to turn them over to
Cephalus. It was a pure accident; but before long Cephalus was to kill the unlucky
Procris with the spear.

The picture is inscribed *C G L* (in monogram). *I· V· ROMA* [E?]·/*1645*. Claude
Gellée, Le Lorrain, had come to Rome over thirty years before as a mere boy. There was a
large Roman colony of northern artists, many of whom already specialized in romantic
'classical' landscape. Most of them are forgotten now, with the notable exception of the
German Elsheimer. He had died in 1610; but he bequeathed to Claude in his tiny
moonlit landscapes a dream which the Frenchman was to expand and illuminate by the
full light of the sun.

From the rest Claude may be said to have inherited some elements of a superficial,
largely decorative tradition. In his canvases it became transformed out of recognition by
the glowing realism of his poetry. Probably Rubens alone has painted ideal landscapes
as firmly constructed and as brilliantly lit; but his were strongest and most brilliant,
perhaps most poetical, when they were most naturalistic. Claude rarely, if ever, painted a
'pure' landscape. His scenes are stories from the Bible or from classical mythology. He
belongs to the Renaissance, as much as Poussin, who arrived to find him established in
Rome. Wonderfully different in their conception of a picture, they provide part and
counterpart in a joint reconstruction of the Golden Age.

As part of the Angerstein collection purchased in 1824, this is one of the Gallery's
foundation pictures.

ANTOINE WATTEAU (1684–1721)
'La Gamme d'Amour'
Catalogue No. 2897

French School
Canvas
Height 0·51 m. (20″)
Width 0·60 m. (23½″)

Was there ever a picture more French? Yet Valenciennes, where Watteau was born, had only recently been chopped from Flanders by Louis XIV. When Watteau arrived in Paris he was called *peintre flamand*, and the title lingered for years after his death. It referred less to birth, however, than to painting. His father in painting was Steen, who introduced this subject; his grandfather Rubens, who had painted a more earthy panorama from which Steen and Watteau each cut themselves a portion.

Thus, just as in Rome a Norman had painted the first truly Roman picture, so in Paris it needed a Fleming to show the French themselves in paint. The Académie Royale and Watteau were counterparts. Founded in 1648, the Académie had spent much time and temper in argument. Made a member some seventy years later, Watteau won the first of the victories for the spontaneous and the life-begotten over intellectual theory and official pomp.

Not that this is a picture of French life; the men at least are in theatrical dress. But it is ultimately in order that in a period of stiff manners and costume they may express the more freely the lyricism of the theme.

The picture was bequeathed by Sir Julius Wernher in 1912.

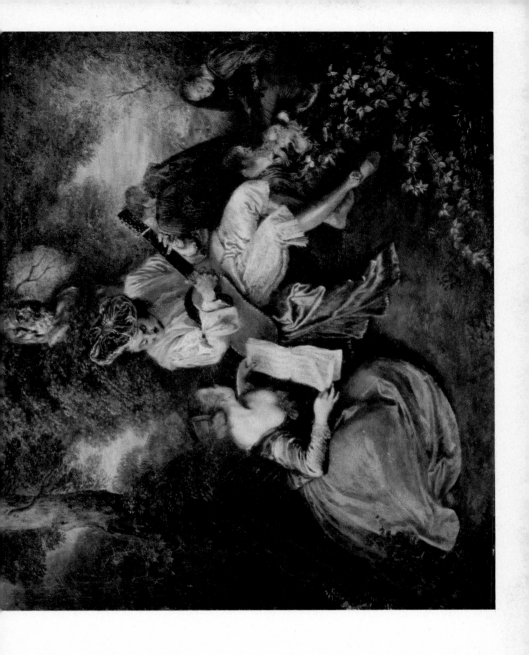

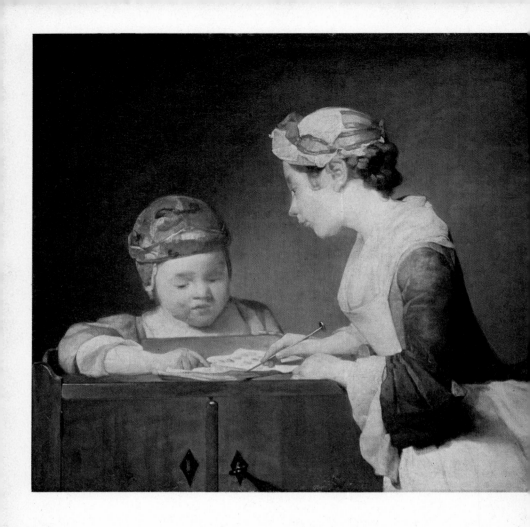

JEAN-BAPTISTE-SIMÉON CHARDIN (1699–1779)　　　*French School*
THE YOUNG SCHOOLMISTRESS　　　　　　　　　　　　Canvas
Catalogue No. 4077　　　　　　　　　　　Height 0·615 m. (24½″)
　　　　　　　　　　　　　　　　　　　　Width 0·665 m. (26¼″)

*Si cet aimable enfant rend bien d'une maitresse
L'air sérieux, le dehors imposant . . .*

The first lines of the verse which accompanied the engraving of the picture imply that the lesson is in deportment. No dalliance here, nor scintillation; only duty and solicitude. The theme, the point at which subject and treatment meet in one, is concentration.

Chardin is more deeply French than Watteau. The delicacy, the slightness are only apparent. They are themselves the result of iron self-discipline, of which one becomes aware if one takes one's eye for a walk up the steep ascent of that corseted and buckram'd back, over the hair and cap and round the precipitous complexities of head and neck. It is a tremendous walk, upon a piece of sculpture of which the profile is at no point an edge; there is always a signpost pointing another way, to the third dimension.

Perhaps the extinction of the Dutch genius before the end of the previous century was due to the hegemony of France and the incompatibility of Dutch and French ideas. If so, the Dutch had their revenge, first in Watteau, then in Chardin, also a member of the Académie; for in his work the idea triumphs completely that what matters is not the nobility of the subject, but the nobility of that very different thing, the theme.

Not that this could be mistaken for a Dutch painting; it represents rather a union between Dutch spontaneity and the best in the theory of the Académie: the importance of unity. This composition has a sculptural strength and coherence rarely attained in Dutch genre painting. It comes from the more powerful assertion of the unity of form and colour within the trinity of form, colour and light.

The picture is signed: *Chardin*. It was acquired with the John Webb Bequest in 1925.

JEAN-AUGUSTE-DOMINIQUE INGRES (1780–1867) *French School*
MADAME MOITESSIER SEATED Canvas
Catalogue No. 4821 Height 1·20 m. $(47\frac{1}{4}'')$
Width 0·92 m. $(36\frac{1}{4}'')$

The picture has two inscriptions on the right: at the top *Mͨ INÈS MOITESSIER | NÉE DE FOUCAULD* and half-way down *J. Ingres 1856 | Æt LXXVI*.

The portrait was begun in 1844–5 and was still unfinished in 1847. The sitter's little daughter Catherine was then in the picture, at her mother's knee. The drawing for the original composition is at Montauban. Ingres seems to have lost interest in this and other pictures before the death of his first wife in July 1849 which so shattered his world that he gave up painting for months. When he took up the brush again in 1851, it was for a new portrait of Madame Moitessier standing, now in Washington, which he finished without delay. He returned to the seated portrait next year, only to abandon it again in March 1853. The finished picture left his studio only in January 1857. By then it had undergone considerable change. Little Catherine had disappeared and her mother had, naturally, changed her dress.

The seated pose of Madame Moitessier is derived from the Roman painting called *Herakles and Telephus* from Herculaneum at Naples of which Ingres bequeathed a copy to Montauban. The great mirror behind her, on the other hand, represents one of the technical triumphs of the modern age. Extending almost the whole width of the background, it reflects itself twice, and Madame Moitessier in profile. Ingres used such a device several times in order to elaborate his compositions.

Founded, like the Empire in which it first flourished, on classical models, his style was a dogmatic statement of form, rounded and rubbed and polished, until there was no trace remaining in the execution of man's handiwork or of his feeling. He has made of Madame Moitessier a massive and fleshy monument to a series of authoritarian regimes.

The picture was bought from the descendants of the sitter for £14,646 in 1936.

The picture is signed *Euge Delacroix*. According to Moreau's book on Delacroix, pub-lished ten years after the artist's death, part of the landscape is by Paul Huet, who had been a fellow-pupil of Delacroix in the studio of Guérin.

If one compares this portrait with similar works by Lawrence, who may well have influenced it, it looks singularly unprofessional. No doubt that was why it was rejected in 1827 for the Salon, in which Ingres had triumphed three years before. Delacroix made alterations over several years; but the picture seems to have retained both its deficiencies and its freshness. The Salon jury may have been justified in their rejection by the profes-sional standards of portraiture; but it was the pictures of Ingres that were to be rejected, before his triumphant career was finished, by a new generation of painters who made Delacroix their hero.

Delacroix had every wish to be a hero, but none consciously to be a rebel. He might not have liked even to be called Romantic; for he insisted that his design was based on logical principles, as well as on careful preparatory studies. The violence, the sadism even, that are the theme of many of his pictures have been explained by the theory that he was the bastard son of Talleyrand and by the extraordinary number of nearly fatal accidents that attended his bringing up. This may be true; but they are also the reaction to the iron chains of a classicism preached for two centuries in France, which would have come to an end before if it had not been for the overwhelming personality of Ingres.

Schwiter was a younger colleague, a painter of portraits and landscape whom Dela-croix evidently found sympathetic. This picture is without the grand agitation that his restlessness and rebellion sometimes called forth. But the absence of these qualities enables us to appreciate the generosity of the risks that he has taken and of the great realm of colour which he has once more opened up.

The picture was sold in 1890, soon after the sitter's death. It was bought at the sale of Degas in Paris in 1918.

GUSTAVE COURBET (1819–77) *French School*
STILL-LIFE: APPLES AND POMEGRANATE Canvas
Catalogue No. 5983 Height 0·445 m. (17½″)
 Width 0·61 m. (24″)

This is the first still-life in the book, though it is a subject that the Dutch had made universally popular. While its painters were able to tempt the bourgeois purchasers by their skill in *trompe l'oeil*, they could also satisfy at close quarters their own sense of the poetry to be found in the endless play of light, in the subtle relationship of light and form.

Dutch still-life, however, was largely the work of specialists; and, as with portraiture and with landscape, the greatest still-life painting is not by specialists. It was Chardin in the eighteenth century perhaps who first made still-life great, divesting it of ostentatious cleverness and making of simple kitchen stuff a noble unity of form and light and colour.

Courbet, who, like almost every other great leader of the nineteenth century, proclaimed himself a realist, had visited Belgium and Holland. Yet he took as his prototype not the still-life painting of the Dutch but that of Chardin. Thus, while this is one of the least original of his pictures, it is one in which his grasp of form is at its strongest. One is not entirely convinced about the other side of this mound of indigestibles, and the indigestibility is due to textures which are characteristically coarse; but these fruits are nevertheless solid and tangible, and glowing with a colour which is an integral part of their form.

The picture is signed *G. Courbet*, and dated 71. This was a sad year for the artist; the date identifies the painting as one of a group which he did during some months of imprisonment.

He became a member of the Commune, and was elected in a free assembly President of the Federation of Artists. Rashly, when the column in the Place Vendôme, monument to monarchy and Bonapartism, was toppled to the ground, he made his great bulk conspicuous upon a balcony. Hence his incarceration, after he had been arrested by the army from Versailles. The new government presented him, not illogically, with the bill for restoring the column, and in 1873 he had to fly from France. He died in exile, at La Tour-de-Peilz, near Vevey, in Switzerland.

The picture was bought for £3,800 in 1951.

PIERRE-AUGUSTE RENOIR (1841–1919) *French School*
LES PARAPLUIES Canvas
Catalogue No. 3268 Height 1·80 m. (71″)
 Width 1·15 m. (45¼″)

The young girl in the centre cannot be opening her umbrella; she must be shutting it.
She is by nature confident that the rain could not spoil things for long. Nor does the
weather cause much anxiety to the smart little family this side of her, warmly but gaily
dressed for a day in spring. The rich painting of their fine plumage, done with so much
delight in all its variety of soft colour and texture, is in contrast with the rest: the unadorned
dress of the midinette, with her severe bandbox, the uniform colour and uncompromising
curves of the umbrellas, chopping up the space and cutting off much of the light.

Perhaps so much severity was not originally intended; the picture shows clear signs in
the painting of having been produced in two stages. There were always perhaps umbrellas
in the right part, which is probably the earlier; but in the left, perhaps painted three or
four years later, there is no relief to the plainer manner of the execution. It has been sug-
gested that Renoir went on his travels in between. In 1881, perhaps after beginning on
Les Parapluies, he spent some weeks with Cézanne at L'Estaque, where he caught pneu-
monia. Then in 1881–82, he paid two visits to Algiers and spent a considerable time in
Italy and Sicily. Though it is mostly the trees here that are reminiscent of Cézanne's way
of painting, it may well have been his ideas which led Renoir to this unique essay in
formal composition. While the little family is painted richly, instinctively, without pre-
dilection for particular shapes, the rest of the picture is constructed, closely but not too
logically, in an alternation of concave and convex forms. The smooth manner of the
painting seems to belong to the period after his return from Italy, when a brief flirtation
with the 'classical' led him to apply his paint less sensuously.

It was equally unusual with Renoir either to construct concisely in hard shapes or to
suggest that it was raining. No artist has ever given us a more consistent picture of the
joyfulness of living. He had an unashamed belief in pleasing subjects, and was convinced
that pictures were meant to please, that painting was for the pleasure of the artist.

The picture is the prize of the large Bequest of Sir Hugh Lane, 1917.

CAMILLE PISSARRO (1830–1903) *French School*
VIEW FROM LOUVECIENNES Canvas
Catalogue No. 3265 Height 0·525 m. $(20\frac{3}{4}'')$
 Width 0·82 m. $(32\frac{1}{4}'')$

The white horse pulling the high market-cart up the hill, the peasant woman walking down, the other two quiet country figures are characteristic presences in Pissaro's pictures. He was essentially a landscape painter; the sky is half the scene, and the light is more than half the picture; but it was usually a domestic landscape that he painted, with the people who work in it often playing a part.

Pissarro was one of the founders of Impressionism; but there was also in many of his pictures a tectonic quality which was to have some influence on Cézanne.

The aqueduct on the opposite hill is that of Marly; the village to the right is Voisins. It is a humdrum suburban scene today.

View from Louveciennes was painted about 1870, perhaps just before the blow was struck which destroyed most of the work of Pissarro's first fifteen years. He was living in the village when war broke out, and it was not long before his studio was looted by the Prussians.

This is one of thirty-nine pictures of the nineteenth and twentieth centuries bequeathed by the picture-dealer Sir Hugh Lane (1875–1915). He would have given these to Dublin had the city agreed to build a modern museum; but in 1903 he transferred them to the National Gallery in London. When the Trustees proved unwilling to exhibit more than fifteen, the idea was discussed of removing them to the Tate Gallery, where a modern foreign annexe was eventually built.

After Lane had gone down with the torpedoed *Lusitania* a Will was found bequeathing the pictures to the National Gallery, with a subsequent codicil leaving them to Dublin. The signature to the codicil was unwitnessed and the pictures belong legally to the National Gallery. A perpetual controversy as to what was really Lane's final intention was brought to an end, it is hoped, in November 1959 by an agreement between the National Gallery Trustees and the Commissioners of Public Works in Dublin that for four successive periods of five years first one and then the other half of the pictures should be lent for exhibition in Dublin.

EDGAR DEGAS (1834–1917)
COMBING THE HAIR (unfinished)
Catalogue No. 4865

French School
Canvas
Height 1·14 m. (45″)
Width 1·46 m. (57½″)

Degas rarely used such blazing colour in an oil-painting, reserving it usually for the pastels to which he devoted himself increasingly towards the end of his career. But this scene is like one of the pastels of his later years, with its diagonal design and the rhythmical chain of movement in and out of the picture space. It is far from finished; but it is consequently an illuminating record of how Degas went to work. He used a technique nearer to that of the 'old masters' than most of his contemporaries, painting less *alla prima*, and building up from a considerable substructure with a number of layers of thin and more transparent paint.

Though there were other great French figure-draughtsmen of the later nineteenth century, he was the only one who studied movement and anatomy with the persistence of an Italian of the Renaissance. Following in the footsteps of Ingres, he went to Rome, spending four years in Italy, where he made drawings after a variety of painters. Like several painters of the later Renaissance, he made wax models of the figures for his pictures, and often drew these naked before he painted them clothed. He made use of photography, especially in order to catch movements too quick to be followed by the eye.

He began with essays in classical subjects; but the classicism is not very convincing, and there soon followed romantic subjects towards which he must have been led by Delacroix. By 1866 however, he was painting scenes from the racecourse, and, soon after, he began his long series of scenes from the life of ballet-dancers, on the stage and in the practising rooms.

Thus he had quickly followed Manet in taking his subjects from contemporary life; but, while his vision was more traditional in that he put drawing and movement first and modelled usually with decided effects of light and shade, his composition might be said to be more modern. In his search for unselfconsciousness of action, he often cut through bodies and objects with the edges of his canvas, in order to present scenes as the camera does, sliced from a larger field of vision, from a continuous view of life.

After the death of the artist, this picture belonged to the painter Henri Matisse. It was bought from his son Pierre Matisse for $20,000 in 1937.

CLAUDE MONET (1840–1926)
VÉTHEUIL: SUNSHINE AND SNOW
Catalogue No. 3262

French School
Canvas
Height 0·595 m. (23½″)
Width 0·81 m. (31¾″)

The picture is inscribed *Claude Monet 1881*. Monet had moved to Vétheuil, on the Seine below Mantes, in 1878, and lived there until 1882, when he made the final move to Giverny. He always lived close to the Seine. It was at Vétheuil that he painted the majority of the snow scenes.

The Impressionists, of whom he was the accepted leader, saw the key to the problem of representing nature in a picture as the study of light. The Dutch of the seventeenth century, the only great school of painters who had previously found a sufficient theme for their art in landscape and the scene of daily life, had made a similar discovery. But there was a fundamental difference of outlook characteristic of the two nations. The Dutch, in order to study the relation of light and form, had often limited colour severely. The French Impressionists insisted that form would come of itself if only the colour-values of nature were correctly stated. They claimed that their vision in colour was supported by optical science.

It was on the snow that Monet could find the colours of light and shade at their purest. The result of his observations here is a blaze of colour and light more sensuous perhaps in intention and effect than he realized. Cézanne, who solved the problem of reconstructing form more fully than any other painter of the nineteenth century, did so in terms which depended for much of their beauty upon Monet's discoveries, as he acknowledged in stating that he wanted to make of Impressionism an art as enduring as that of the museums. The Impressionists' theories led them into weaknesses of pictorial construction and could not for long satisfy men with a rounder vision of life, like Renoir. But Monet may be said to have cleaned up the world's vision of nature and heightened its colour sense for many generations. His devouring passion not only for light-and-colour but for sensuous painting effects lies at the root of much of the best modern painting.

This picture was also part of the Lane Bequest of 1917.

ÉDOUARD MANET (1832–83)　　　　　　　　　　　*French School*
La Musique aux Tuileries　　　　　　　　　　　　　　*Canvas*
Catalogue No. 3260　　　　　　　　　　　Height 0·76 m. (30″)
　　　　　　　　　　　　　　　　　　　　Width 1·18 m. (46½″)

The picture is inscribed: *éd Manet 1862*. In those days the Tuileries Palace was still standing. Napoleon III held his Court there, and twice a week, when the band played, Parisian society gathered in the gardens.

This crowd contains many people from Manet's circle, and others whom he knew perhaps only by sight. He himself is on the extreme left. To the right of him is the monocled Comte Albert de Balleroy, with whom he had shared a studio; he appears in Fantin Latour's portraitgroup, *Hommage à Delacroix*. Seated behind them is Zacharie Astruc, whose portrait Manet is painting in Fantin's *Hommage à Manet*. Fantin himself appears, farther back and more to the right, in full face before the tree. Next to him, a little in front, in profile against the tree, is the poet Baudelaire, talking to the bearded writer Théophile Gautier. To the right of the centre, the tall figure stooping in profile is Manet's younger brother Eugène, who married Berthe Morisot; and behind him, seated against a tree, is Offenbach, already famous composer of *opéra bouffe*. Of the two ladies seated in the foreground, the one nearer to Manet is probably Mme Loubens, a lifelong friend. The other, Mme Le Josne, with her husband the Commandant, was often hostess to Manet and his friends.

When exhibited at Martinet's in 1863, the picture caused a scandal. It was one of Manet's first scenes from contemporary life, and it was perhaps the first picture to show his fully mature vision. Sketchily drawn and painted in places, it owes its construction largely to the colour values. Were there more modelling of the individual forms, there could hardly be such cohesion. The colours give an authentic impression of a crowd in summer light, and the rhythmical alternation of absorbent blacks and light, reflecting colours makes for unity and diversity in one.

The picture was part of the Lane Bequest of 1917.

PAUL CÉZANNE (1839–1906)
LA VIEILLE AU CHAPELET
Catalogue No. 6195

French School
Canvas
Height 0·81 m. (31¾″)
Width 0·655 m. (25¾″)

The gnarled hands over which her old head is bowed are fumbling with a rosary *(chapelet)*. She had been the inmate of a convent, but had lost her faith and, at the age of seventy, had taken a ladder and scaled the convent wall. Cézanne had found her wandering half-demented and taken her into his service. Though he himself never lost his faith, the difficulty that he had in making contact with the world except through his little-understood pictures may have made him find in her something of a kindred spirit. He said that she tore up his linen and sold it back to him as rag to wipe his brushes; but he used her to do what chores she could and to pose for him.

He worked on this picture intermittently for eighteen months, presumably at the Jas de Bouffan, the country house which he inherited outside Aix-en-Provence; but then he threw it into a corner. Afterwards he gave it to the young Joachim Gasquet, who was later to become the author of the most personal memoir of the painter. Gasquet relates that he had found the picture lying near the stove with a steampipe dripping on to it; and the effects of the steam are certainly to be seen in the lower left corner.

Similarly, there is a record of the difficult gestation in the thickness of the paint. It lies layer over layer in parts, especially in the left shoulder, of which the outline has been continually raised. Cézanne usually worked slowly and with difficulty. He was a scholarly painter; he spent much of his time in the Louvre and was constantly expressing admiration for the great Venetians of the sixteenth century and their followers. But unlike them, he became a professional artist only in his twenties. He had little success with their subjects. He had to see nature with his own eyes and discover his own way of creating form and light and colour. This originality is one with his sincerity. His compassion was shown by the way he treated this old woman, and the fact that he chose to paint her, not by any sentimentality or even sentiment expressed in the painting.

Cézanne sold the Jas de Bouffan in 1899. The picture should be one of the last that was painted there. It was bought for £32,000 in 1953.

WILLIAM HOGARTH (1697–1764) British School
THE SHRIMP GIRL Canvas
Catalogue No. 1162 Height 0·635 m. (25")
 Width 0·525 m. (20¾")

She is crying her wares, the mound of shrimps and the measure in the broad basket on her head. She may have come up the river from a fisherman's home on the shores of Essex or Kent; but she knew how to hold her own in London. Hogarth is the only Cockney painter. He was born in London and lived and worked nowhere else; it is London life that he portrayed. Had he been able to make a good living out of painting, he might perhaps have founded a school. He was at least the first good indigenous British painter since the Reformation, and many were to come after him.

From Holbein, who painted Henry VIII, to Kneller, who was still the mode when Hogarth appeared, the history of British painting had been mainly a succession of foreign-born portraitists. The great ceiling paintings of James Thornhill in St Paul's Cathedral or at Greenwich Hospital are deserving of more attention, for he was the first Englishman – and almost the last – with the ability to construct a large architectural design. But to many Thornhill is still best known as the man whose daughter eloped with Hogarth at the outset of his career.

The career was to be paradoxical. Hogarth hoped to step into Thornhill's shoes and carry on his private academy for students and the tradition of history painting. He painted a number of enormous Biblical scenes, less competent than Thornhill's. But it was only his satirical scenes from everyday life, worse, it was only the engravings from these, that brought him praise and gain. In chagrin he retired from painting for some years, to write *The Analysis of Beauty*. This was quickly translated into French, Italian and German, for, though in its disorder there is a little nonsense, there is also much common sense.

The picture was bought – at the same sale as the Giorgione – in 1884 for £262.

JOSHUA REYNOLDS (1723–92) *British School*
LORD HEATHFIELD, GOVERNOR OF GIBRALTAR Canvas
Catalogue No. 111 Height 1·42 m. (56″)
 Width 1·135 m. (44¾″)

With the key of Gibraltar in his hand, the Governor stands against a column of smoke from the guns of the beleaguered fortress.

George Augustus Eliott (1717–90) was made Governor of Gibraltar in 1775. The British had captured Gibraltar in 1704, and it had already been besieged twice when the French and Spanish laid siege to it in 1779. Eliott held out through the most famous of all its sieges until this was raised in 1783. Created Baron Heathfield of Gibraltar in 1787, he sat to Sir Joshua Reynolds in that year.

The picture has altered considerably since. It has thick glazes which seem to be bituminous; in any case their cracking has undone the effect which they must have been intended to promote, a smooth and glowing transparency. Considering his interest in the study of earlier paintings, Reynolds was a strangely bad technician, indulging in practices common among the minor English painters but eschewed by less academic artists like Hogarth and Gainsborough and Constable. He finished many of his pictures with coatings of resinous substances which become brown and opaque with time, and do not survive cleaning with solvents. Thus the original appearance of many pictures by Reynolds is at the present time difficult to guess.

Yet the sullied surface cannot altogether stale the grandeur of his characterization. This is a memorial of all British generals who have stoutly withstood a siege.

The portrait was no doubt intended as such, for it was commissioned not by the sitter but by Alderman John Boydell for the sake of the engraving by R. Earlom, published the next year. Boydell made a fortune on the publication and sale of engravings and eventually became Lord Mayor of London. After his death this portrait descended to his nephew Josiah, who sold it to the painter Lawrence in 1809.

The picture came to the Gallery with the Angerstein collection in 1824.

THOMAS GAINSBOROUGH (1727–88) *British School*
THE PAINTER'S DAUGHTERS TEASING A CAT (unfinished) Canvas
Catalogue No. 3812 Height 0·755 m. $(29\frac{3}{4}'')$
 Width 0·625 m. $(24\frac{3}{4}'')$

The title seems rather hard on the two girls, who seem to be musing in sisterly love. The cat seems to have been an unwilling sitter, but it was probably not to blame for the unfinished state of the picture. Gainsborough's slightly earlier portrait of his two daughters in the National Gallery is also unfinished.

The two daughters were Mary, who married J. C. Fischer, a musician, in 1780, and Margaret. Gainsborough had married a lady of somewhat mysterious origin in 1746 in London; but both his two children may well have been born at his native Sudbury in Suffolk. According to their joint tombstone, there were four years between them. This picture was almost certainly painted not long after 1759, when the family had made its second remove, from Ipswich, the county capital, to Bath, west-country resort of all Society.

Perhaps it shows Gainsborough at the height of his powers in portraiture. He was interested in his subject, as he by no means always was in the more fashionable ladies who were soon sitting to him by the score. The heads show his grasp of form fully developed: clean, firm, with the grace and apparent ease of the eighteenth century. But there is still the freshness of his early vision in the Suffolk sunlight, a vision then as untrammelled as Constable's was to be fifty years later in the same countryside.

The picture was bought for £3,329 10s. in 1923.

THOMAS GAINSBOROUGH (1727–88)　　　　　　British School
THE WATERING-PLACE　　　　　　　　　　　　Canvas
Catalogue No. 109　　　　　　　　　　Height 1·47 m. (58″)
　　　　　　　　　　　　　　　　　　　Width 1·80 m. (71″)

Gainsborough painted landscape from beginning to end of his career. Had painters been as free to choose their subjects then as they became in the nineteenth century, there would no doubt have been a great many more of his landscapes and a great many less of his portraits. Long before Gainsborough settled in London, Richard Wilson (1713/4–1782) had come to specialize in landscape; but his most profitable pictures may well have been the portraits which he was occasionally commissioned to paint of the parks surrounding great country-houses. It was not realized until after his death that he had founded a great tradition of landscape painting which grew lustily upon his foundations for a century, until the death of Turner.

The landscapes of Gainsborough waited just as long for recognition. He used to complain that those which he hung in his hall were invisible to the lords and ladies who passed through it on their way to sit for their portraits in his studio. This one at least seems to have remained on his hands, and indeed on those of his widow through the memorial exhibition the year after his death and the subsequent sale of his pictures in 1792.

It must have been painted about 1777, the year when it was exhibited at the Royal Academy. His landscape shows more clearly than his portraiture the evolution of his style: from the particular to the general, from detailed renderings of Suffolk woodland scenes, showing the influence of Dutchmen like Wynants and Ruisdael, to such passionate abstractions as this, the height of romanticism. Here are some cattle with their herd at their drinking-pool and a family of gypsies in the neglected countryside; but here also is the richest moment of colour which comes as a recompense and a promise before the dark of night, a reminder of all the cool and peaceful endings of all the long, warm summer days.

At Mrs Gainsborough's sale in 1797 it was bought by Charles Long, later Lord Farnborough. He was one of the original Trustees of the Gallery, and presented the picture in 1827.

264

THOMAS GAINSBOROUGH (1727–88) *British School*

THE MORNING WALK Canvas

Catalogue No. 6209 Height 2·36 m. (93″)

<div style="text-align:right">Width 1·79 m. (70½″)</div>

William Hallett and his wife Elizabeth Stephen are dressed in the height of fashion. They were married 30 July 1785, when both were about twenty-one. The picture is known to have been painted within a few months, and is evidently a marriage portrait. Pairs of portraits were sometimes painted in celebration of a marriage; but such a joint portrait is a strangely rare thing.

This quality of being something more than a portrait, of telling a story of newly-wedded-ness, has earned the picture – correctly or not – its special title and an equally special position in popular favour. The popularity is justified perhaps by the romance, though neither character can be said to represent Gainsborough's portraiture at its strongest, and the total effect of the colour has come to be rather flimsy as the paint has become more transparent with time.

But this is Gainsborough's last style. He had removed to London in 1774, though the removal is only a physical incident in a quarter of a century of fashionable portrait-painting. This was relieved by landscape-painting on the side; but the development of the two is parallel, so that the pure landscapes are not essentially different from the scene in which this loving couple take their walk. It is a grand romantic scene, rich in the breadth of its light and shade, strong in the umbrageous depths from which the forms emerge into the light, whole in the fusion of all the elements under Gainsborough's nervous but resourceful touch.

The picture was sold in 1884 by Major William Edward Hilliard, second son of Lettice Elizabeth, one of the Hallett's daughters. It was bought from Lord Rothschild in 1954.

THE 'FIGHTING TÉMÉRAIRE' TUGGED TO HER LAST BERTH
TO BE BROKEN UP Canvas
Catalogue No. 524 Height 0·91 m. $(35\frac{3}{4}'')$
 Width 1·22 m. $(48'')$

The English man-of-war was named after the French 'Téméraire' which had been captured in 1759. Launched at Chatham in 1798, she had forty years of service. She earned her name, the 'Fighting Téméraire', at the battle of Trafalgar in 1805.

The picture was exhibited at the Royal Academy in 1839 (No. 43) under the above title, with the poignant quotation 'The flag which braved the battle and the breeze* No longer owns her!'

She had been sold to the ship-breakers in August 1838. She was dismasted at Sheerness, at the mouth of the Thames, was fitted there with light masts, and tugged to the docks at Rotherhithe in East London. The picture shows this last ignominious voyage up the River Thames in early autumn.

Such a subject was tinder to Turner's romantic fire, always smouldering with visions of the sea and ships. There was little he did not know about either.

Twenty years before, when asked by his host in a country house to draw a man-of-war, he had produced out of his head the large watercolour now in the Cecil Higgins Art Gallery, Bedford, *A First-Rate taking in Stores*, with all its wealth of functional detail.

There was little he did not know about the Thames Estuary; but all is sacrificed here to his wider knowledge of the colours of the atmosphere, his passion for the grandness of nature.

Turner and Constable were born in the same decade as the poet William Wordsworth. All three were gifted with a new degree of awareness, with an almost novel consciousness of beauty in nature on which the arts of their century came to be founded, first in England, then in France. Now that this spiritual exploitation seems to have come to an end, it can be seen to have been as striking a phenomenon as the physical exploitation which it accompanied and which is by no means ended. Each was part of a new release of energy, of a new advance of man into the natural world, after the comparative stagnation of the eighteenth century.

The picture is part of the great Turner Bequest, exhibited mostly in the Tate Gallery and the British Museum.

JOHN CONSTABLE (1776–1837) *British School*
WEYMOUTH BAY Canvas
Catalogue No. 2652 Height 0·53 m. (21″)
 Width 0·75 m. (29½″)

After an engagement prolonged for many years by the opposition of her grandfather, Constable married Maria Bicknell on 2 October 1816. They went off to spend their honeymoon in a village near Weymouth.

The picture was evidently painted out of doors on the spot at that happy time. There is no lingering over details and the clouds are done with exceptional breadth and freedom. Many parts are by no means completely realized; yet the impression of light and space is so exact and convincing that one is almost impelled to tramp into the stony space.

Constable too spent a lifetime of research into the appearances of nature. Some of Turner's few direct studies would hang well beside some of his. But between their larger pictures there is so strong a contrast of idea and expression that they can hardly be enjoyed on the same day. Truly English in this also, the two owed nothing to each other.

It needed a honeymoon to bring Constable to paint so bare and wild a scene as this. He was entirely satisfied with nature as she was, saying, 'I never saw an ugly thing in my life. Neither were there ever two leaves of a tree alike since the creation of the world.'

His famous *The Hay-Wain* now in the National Gallery aroused no enthusiasm among the Academicians in 1821. Géricault, who attended their banquet that year, was described by Delacroix as stupefied by it, and, when Delacroix saw it himself three years later, at the Paris Salon, he noted in his Journal: *'Ce Constable m'a fait un grand bien.'* Thirty years later he wrote in a letter of the great influence exercised by Constable and Turner on French landscape-painting.

The English are known for their love of scenery, and Turner and Constable made landscape once more a self-sufficient form of art. But, unlike French painters, they kept apart, and neither had any generous circle of followers to admire and develop their ideas. In painting, as in so many things, the country of 'tradition' threw off ideas of great originality, and left their development to men of another nation prepared to construct tradition on their base.

Weymouth Bay was part of the Salting Bequest of 1910.

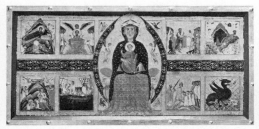

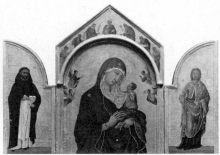

Margarito of Arezzo The Virgin and Child Enthroned, with
Scenes of the Nativity and the Lives of the Saints

Duccio The Virgin and Child with Saints

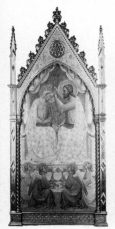

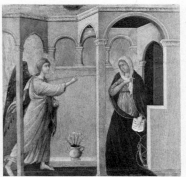

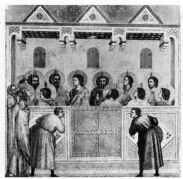

Agnolo Gaddi
Coronation of the Virgin

Duccio The Annunciation

Giotto Pentecost

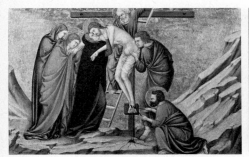

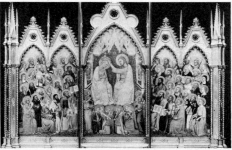

Ugolino The Deposition

Style of *Orcagna* The Coronation of the Virgin,
with Adoring Saints

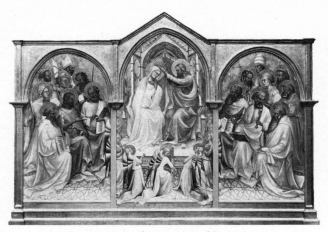

Lorenzo Monaco The Coronation of the Virgin

Giovanni di Paolo
St John the Baptist retiring to the Desert

Sassetta
The Stigmatization
of St Francis

Sassetta The Whim of the Young
St Francis to become a Soldier

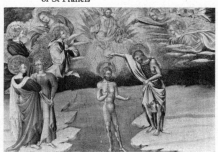

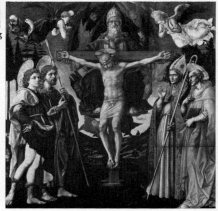

Giovanni di Paolo The Baptism of Christ

Pesellino The Trinity

274

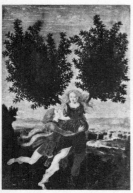

Antonio de Pollaiuolo
Apollo and Daphne

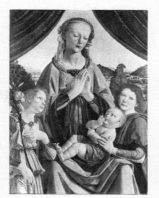

Verrocchio
The Virgin and Child with two Angels

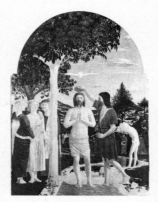

Piero della Francesca
The Baptism of Christ

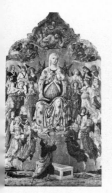

Matteo di Giovanni
Assumption of the Virgin

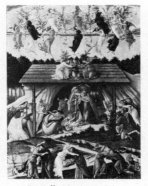

Botticelli Mystic Nativity

Signorelli The Triumph of Chastity:
Love disarmed and Bound

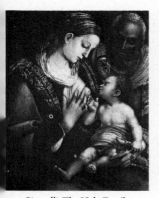

Signorelli The Holy Family

Perugino The Virgin and Child with St Raphael and St Michael

Pisanello The Virgin and Child
with St George and St Anthony Abbot

Pisanello The Vision of St Eustace (?)

Mantegna The Agony in the Garden

Mantegna Samson and Delilah

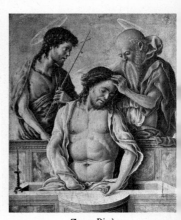

Tura St Jerome (fragment)

Tura An Allegorical Figure

Zoppo Pietà

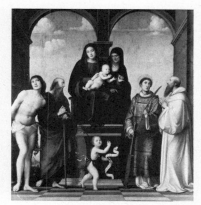

Cossa
St Vincent Ferrer (?)

Giovanni Ambrogio Preda
Francesco di Bartolomeo Archinto (?)

Francia The Virgin and Child with St Anne
and other Saints

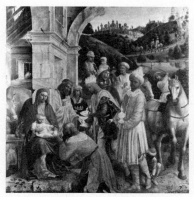

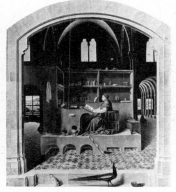

Foppa The Adoration of the Kings

Antonello da Messina St Jerome in his Study

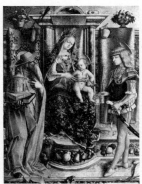

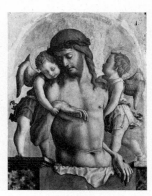

Antonello da Messina
Christ Crucified

Crivelli The Virgin and Child
with St Jerome and St Sebastian
(The 'Madonna della Rondine')

Crivelli Pietà

277

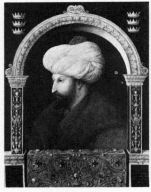

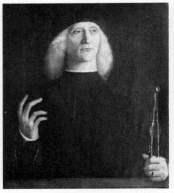

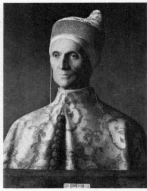

Gentile Bellini
The Sultan Mehmet II

Gentile Bellini
A Man with a Pair of Dividers (?)

Giovanni Bellini
The Doge Leonardo Loredan full-face

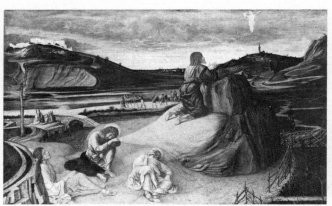

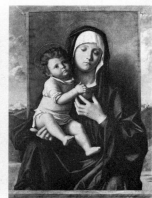

Giovanni Bellini The Agony in the Garden

Giovanni Bellini
The Virgin and Child

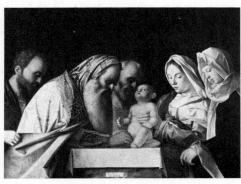

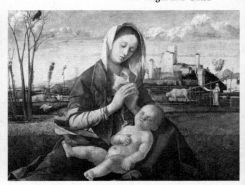

Giovanni Bellini The Circumcision

Giovanni Bellini 'The Madonna of the Meadow'

278

Costa A Concert

Costa and (?) *Gian Francesco de'Maineri* Virgin and Child with Saints

Ercole de'Roberti The Dead Christ

Ercole de'Roberti
The Adoration of the Shepherds

Jacometto Veneziano
Portrait of a Boy

Gerolamo dai Libri
The Virgin and Child
with St Anne

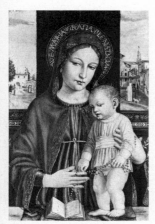

Bergognone The Virgin and Child

Carpaccio St Ursula taking leave of her Father (?)

Solari
Giovanni Cristoforo Longoni

Bramantino The Adoration of the Kings

Luini The Virgin and Child
with St John

NETHERLANDISH TO *c.* 1500

Campin A Man

Campin A Woman

Jan van Eyck A Man in a Turban

Jan van Eyck
Portrait of a Young Man

Van der Weyden The Magdalen Reading

Christus Portrait of a Young Man

Bouts The Virgin and Child

Gerard David The Adoration of the Kings

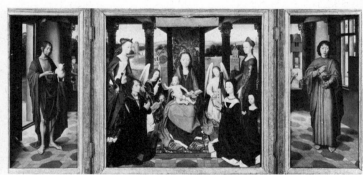

Bouts Portrait of a Man

Memlinc The Virgin and Child with Saints (The Donne Triptych)

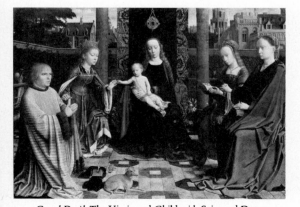

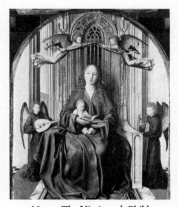

Gerard David The Virgin and Child with Saint and Donor

Massys The Virgin and Child

Massys
The Virgin and Child with St Barbara (?)
and St Catherine

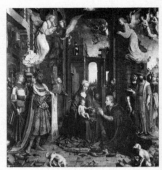

Mabuse The Adoration of the Kings

Mabuse An Elderly Couple

Ascribed to *Patenier*
St Jerome in a Rocky Landscape

GERMAN

Lochner St Matthew, St Catherine of
Alexandria and St John the Evangelist

Master of the Life of the Virgin
The Presentation in the Temple

Circle of *Pacher* The Virgin and Child
with Angels and Saints

Master of Liesborn
The Presentation in the Temple

Master of the Life of the Virgin
The Mass of St Hubert

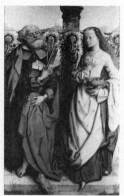

Master of St Bartholomew
St Peter and St Dorothy

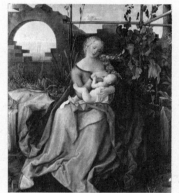

Style of *Dürer*
The Madonna with the Iris

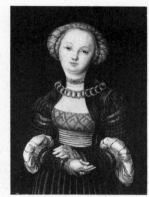

Lucas Cranach the Elder
Portrait of a Woman

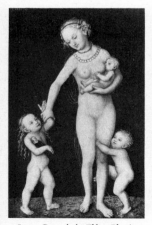

Lucas Cranach the Elder Charity

Holbein the Younger
Christina of Denmark

Baldung The Trinity and Mystic Pietà

Fra Bartolommeo
Adoration of the Child

Ascribed to *Michelangelo*
Madonna and Child with St John and Angels

Raphael The Crucifixion

Raphael An Allegory
(Vision of a Knight)

Raphael Madonna and Child with St John
the Baptist and St Nicholas of Bari
('The Ansidei Madonna')

Raphael Madonna and
Child with the Infant Baptist
('The Garvagh Madonna')

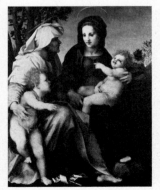

Andrea del Sarto Madonna and Child
with St Elizabeth and St John

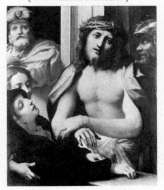

Correggio 'Ecce Homo'

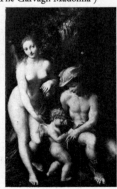

Correggio Mercury instructing
Cupid before Venus

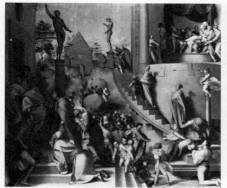

Pontormo Joseph in Egypt

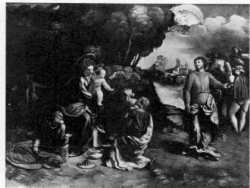

Dosso Dossi The Adoration of the Kings

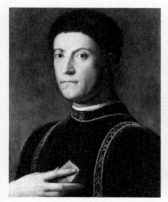

Bronzino Portrait of Piero de'Medici

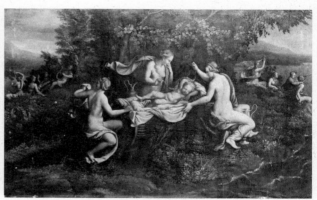

Studio of Giulio Romano The Infancy of Jupiter

VENETIAN AND BRESCIAN AFTER *c.* 1500

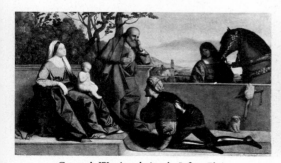

Catena A Warrior adoring the Infant Christ

Catena St Jerome in his Study

285

Palma Vecchio A Blonde Woman

Titian Holy Family with a Shepherd

Titian Portrait of a Lady

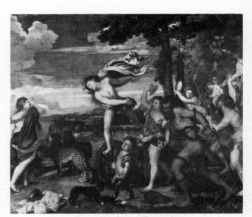

Titian Bacchus and Ariadne

Titian Madonna and Child with St John and St Catherine

Titian Venus and Adonis

Titian The Tribute Money

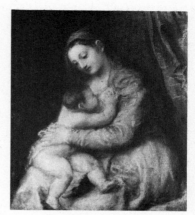

Titian Madonna and Child

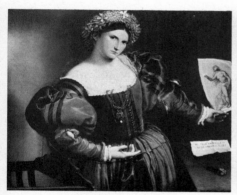

Lotto A Lady as Lucretia

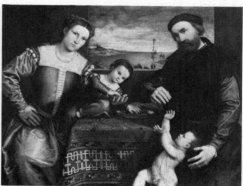

Lotto Family Group

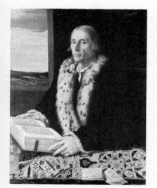

Lotto The Protonotary Apostolic,
Giovanni Giuliano

Salvoldo St Jerome

287

Sebastiano del Piombo Salome

Sebastiano del Piombo The Holy Family

Moretto
Conte Sciarra Martinengo Cesaresco

Moretto
An Italian Nobleman

Moroni The Tailor

Tintoretto
St George and the Dragon

Tintoretto
Portrait of Vincenzo Morosini

Moroni An Italian Nobleman

288

Veronese The Family of Darius before Alexander

Veronese Scorn

Veronese Happy Union

Veronese St Helen:
Vision of the Cross

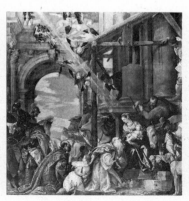

Veronese The Adoration of the Magi

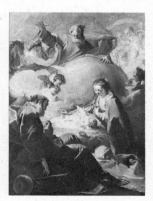

Pittoni The Nativity with God
the Father and the Holy Ghost

G. B. Tiepolo
The Trinity appearing to St Clement (?)

Canaletto Venice: Piazza S. Marco and
the Colonnade of the Procuratie Nuove

Longhi
Exhibition of a Rhinoceros at Venice

Guardi
A Caprice with Ruins on the Seashore

Guardi
An Architectural Caprice

FLEMISH 17th CENTURY

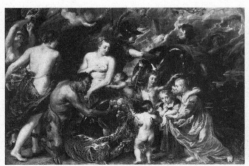

Rubens Peace and War

Rubens The Watering Place

Rubens Thomas, Earl of Arundel

Rubens The Apotheosis of the Duke of Buckingham

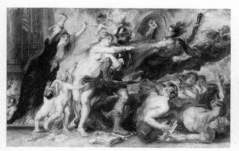

Rubens The Horrors of War

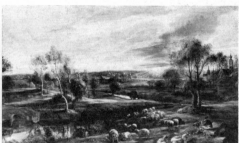

Rubens Sunset Landscape

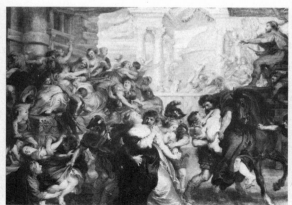

Rubens The Rape of the Sabines

Jordaens Portrait of a Man and Woman

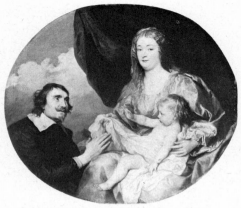

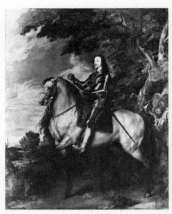

Van Dyck The Virgin and Child Adored by the Abbé Scaglia

Van Dyck Charles I on Horseback

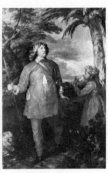

Van Dyck
The First Earl of Denbigh

Teniers the Younger Peasants playing Bowls

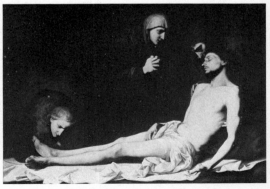

El Greco The Adoration of
the Name of Jesus

Ribera The Lamentation over the Dead Christ

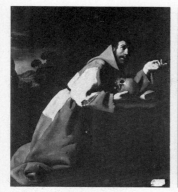

Zurbarán St Francis in Meditation

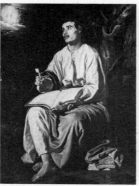

Velazquez St John the Evangelist
on the Island of Patmos

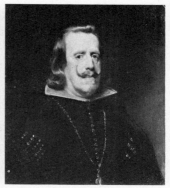

Velazquez
Philip IV of Spain: Bust Portrait

Velazquez Christ in the House of Martha and Mary

Velazquez Christ after the Flagellation
contemplated by the Christian Soul

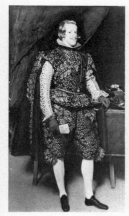

Velazquez Philip IV of Spain
in Brown and Silver

Murillo Self-portrait

Goya A scene from
'El Hechizado por Fuerza'

Frans Hals Portrait of a Middle-aged
Woman with Hands Folded

Avercamp A Winter Scene with Skaters
near a Castle

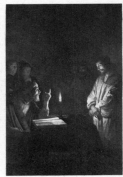

Honthorst
Christ before the High Priest

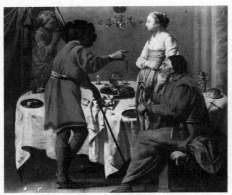

Ter Brugghen Jacob reproaching Laban for giving
him Leah in place of Rachel (?)

Van de Velde A Winter Landscape

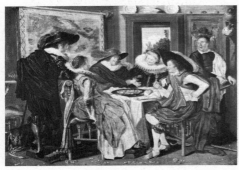

Dirck Hals A Party of Young Men and Women at Table

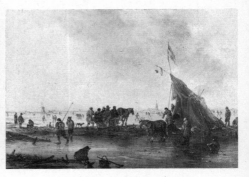

Jan van Goyen A Scene on the Ice

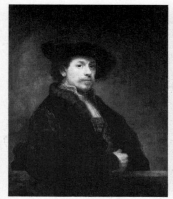

Rembrandt
Self-portrait at the age of 34

Rembrandt Portrait of Jacob Trip

Rembrandt Portrait of Margaretha
de Geer, Wife of Jacob Trip

Rembrandt Saskia van Ulenborch
in Arcadian Costume

Rembrandt
The Adoration of the Shepherds

Treck Still Life with a Pewter Flagon
and two Ming Bowls

Witte Adriana van Heusden and her Daughter
at the Fish-market in Amsterdam (?)

Ter Borch An Officer dictating a Letter
while a Trumpeter waits

295

Ter Borch The Swearing of the Oath of Ratification of the Treaty of Münster, 15 May 1648

Both A View on the Tiber, near the Ripa Grande, Rome (?)

Wouwermans A View on a Seashore, with Fishwives offering Fish to a Horseman

Berchem Peasants with Four Oxen and a Goat at a Ford by a Ruined Aqueduct

A. Cuyp A Hilly River Landscape with a Horseman talking to a Shepherdess

Dubbels A Dutch Yacht and other Vessels becalmed near the Shore

Fabritius A View in Delft, with a Musical
Instrument Seller's Stall

Capelle A Dutch Yacht firing a Salute as a Barge pulls
away, and Many Small Vessels at Anchor

Van Ruisdael An Extensive Landscape with a
Ruined Castle and a Village Church

Van Ruisdael The Shore at Egmond-aan-Zee

Metsu A Man and a Woman seated
by a Virginal

Pieter de Hoogh
The Courtyard of a House in Delft

Pieter de Hoogh A Woman and
her Maid in a Courtyard

Vermeer A Young Woman seated at a Virginal

W. van de Velde the Younger
Dutch Vessels close inshore at Low Tide, and Men Bathing

Hobbema The Ruins of Brederode Castle

Hobbema A View of the Haarlem Lock and the
Herring-packers' Tower, Amsterdam

Berckheyde The Interior of the Grote Kerk at Haarlem

Wijnants A Landscape with two Dead Trees, and
two Sportsmen with Dogs on a Sandy Road

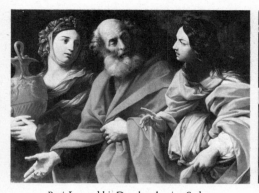

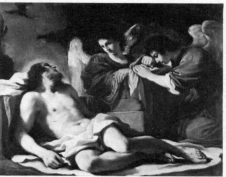

Reni Lot and his Daughter leaving Sodom

Guercino Angels weeping over the Dead Christ

FRENCH 17th, 18th and 19th CENTURIES

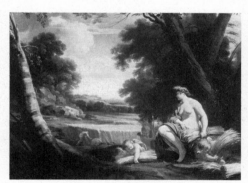

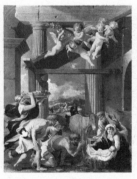

Vouet Ceres

N. Poussin The Adoration of the Shepherds

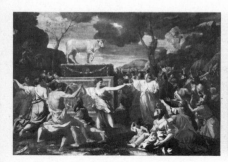

N. Poussin The Adoration of the Golden Calf

N. Poussin Landscape with a Snake

Claude The Marriage of Isaac and Rebekah ('The Mill') *Claude* Seaport: The Embarkation of the Queen of Sheba

Champaigne Triple Portrait of Richelieu *Nattier* Manon Balletti

Lancret Youth (L'Adolescence) *Chardin* The House of Cards

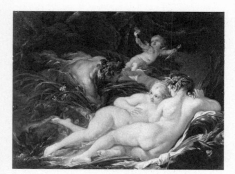

Boucher Pan and Syrinx

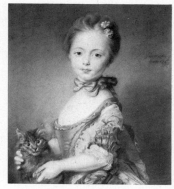

Perronneau A Girl with Kitten

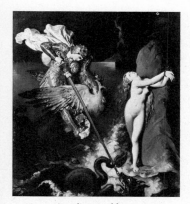

Ingres Angelica saved by Ruggiero

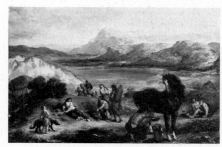

Corot Avignon from the West

Corot A Horseman (M. Pivot) in a Wood

Delacroix Ovid among the Scythians

Daumier Don Quixote and Sancho Panza

Manet Eva Gonzalès

Manet
The Waitress ('La Servante de Bocks')

Degas La La
à la Cirque Fernando, Paris

Courbet La Diligence dans la Neige

Renoir La Nymphe à la Source

Monet L'inondation

Degas Bains de Mer; Petite Fille Peignée par sa Bonne

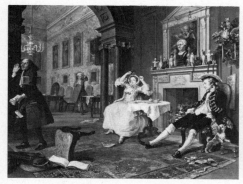

Hogarth Marriage à la Mode – Shortly the Marriage

Gainsborough Gainsborough's Forest ('Cornard Wood')

Reynolds Anne, Countess of Albemarle

Gainsborough Mr and Mrs Andrews

Stubbs A Lady and Gentleman in a Carriage

Gainsborough Mrs Siddons

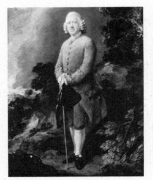

Gainsborough
Dr Ralph Schomberg

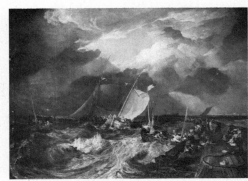

Turner Calais Pier: An English Packet arriving

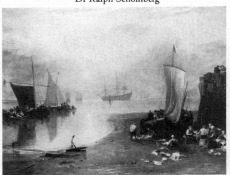

Turner Sun Rising through Vapour:
Fishermen cleaning and selling Fish

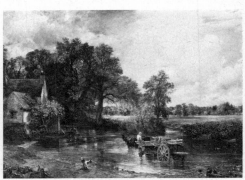

Constable The Hay-Wain

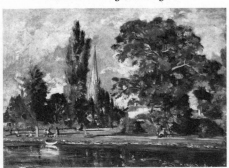

Constable Salisbury Cathedral and Archdeacon
Fisher's House from the River

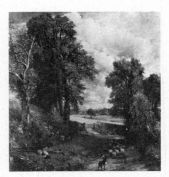

Constable Cornfield

LIST OF ILLUSTRATIONS

Colour plates are indicated by the page numbers in italic

ALTDORFER, ALBRECHT, before 1480–1538:
Landscape with a Footbridge. 0·420 m.× 0·355 m. (16½″× 14″) — *157*

ANDREA DEL SARTO (ANDREA DI AGNOLO), 1486–1530:
Portrait of a Young Man. Fine linen. 0·72 m.× 0·57 m. (28½″× 22½″) — 166
Madonna and Child with St Elizabeth and St John.
Wood. 1·06 m.× 0·81 m. (41¾″× 32″) — 284

ANGELICO, FRA, 1368/7?–1455: *Christ Glorified in the Court of Heaven.*
Panel. 0·32 m.× 0·73 m. (12½″× 28¾″) — *85*

ANTONELLO DA MESSINA, active 1456–1479: *Portrait of a Man.*
Wood. 0·355 m.× 0·255 m. (14″× 10″) — 119
St Jerome in his Study. Wood. 0·46 m.× 0·365 m. (18″× 14¼″) — 277
Christ Crucified. Wood. 0·42 m.× 0·255 m. (16½″× 10″) — 277

AUSTRIAN SCHOOL, early 15th C.: *The Trinity with Christ Crucified.*
Wood. 1·18 m.× 1·15 m. (46½″× 45¼″) — *150*

AVERCAMP, HENDRICK, 1585–1634: *A Winter Scene with Skaters near a Castle.*
Wood. Diameter 0·407 m. (16″) — 294

BALDOVINETTI, ALESSO, c. 1426–1499: *Portrait of a Lady in Yellow.*
Wood. 0·63 m.× 0·405 m. (24¾″× 16″) — *101*

BALDUNG, HANS, c. 1484–1545: *Portrait of a Man.*
Wood. 0·593 m.× 0·49 m. (23⅝″× 19¼″) — *161*
The Trinity and Mystic Pietà. Wood. 1·123 m.× 0·89 m. (44⅜″× 35⅛″) — 283

BARTOLOMMEO, FRA (BARTOLOMMEO DELLA PORTA), 1472(?)–1517:
Adoration of the Child. Wood. 1·38 m.× 1·05 m. (54¼″× 41¼″) — 284

BELLINI, GENTILE, active c. 1460–1507: *The Sultan Mehmet II.*
Canvas. 0·70 m.× 0·52 m. (27½″× 20½″) — 278
A Man with a Pair of Dividers(?)
Canvas. 0·69 m.× 0·59 m. (27½″× 23¼″) — 278

BELLINI, GIOVANNI, c. 1430–1516: *The Blood of the Redeemer.*
Wood. 0·47 m.× 0·34 m. (18½″× 13½″) — *121*
St Dominic. Canvas. 0·63 m.× 0·495 m. (24¾″× 19½″) — *130*
The Agony in the Garden. Wood. 0·81 m.× 1·27 m. (32″× 50″) — 278
The Virgin and Child. Wood. 0·91 m.× 0·65 m. (35¾″× 25½″) — 278
The Circumcision. Wood. 0·75 m.× 1·02 m. (29½″× 40¼″) — 278
'*The Madonna of the Meadow*'.
Transferred from panel. 0·67 m.× 0·86 m. (26½″× 34″) — 278
The Doge Leonardo Loredan full-face.
Wood. 0·615 m.× 0·45 m. (24¼″× 17¾″) — 278

BERCHEM, NICOLAES, 1620–1683: *Peasants with Four Oxen and a Goat at a Ford
by a Ruined Aqueduct.* Wood. 0·471 m.× 0·387 m. (18½″× 15¼″) — 296

BERCKHEYDE, GERRIT, 1638–1698: *The Interior of the Grote Kerk at Haarlem.*
Wood. 0·608 m.× 0·849 m. (23$\frac{15}{16}$″× 33$\frac{1}{16}$″) 298

BERGOGNONE, AMBROGIO, active 1481–1523: *The Virgin and Child.*
Wood. 0·55 m.× 0·355 m. (21$\frac{3}{4}$″× 14″) 279

BORCH, GERARD TER, 1617–1681: *An Officer dictating a Letter while a Trumpeter waits.* Canvas. *c.* 0·745 m.× *c.* 0·51 m. (*c.* 29$\frac{3}{8}$″× *c.* 20″) 295
The Swearing of the Oath of Ratification of the Treaty of Münster, 15 May, 1648.
Copper. 0·454 m.× 0·595 m. (17$\frac{1}{8}$″× 23″) 296

BORGOGNONE see BERGOGNONE

BOSCH, HIERONYMUS, active 1480/1–1516: *Christ Mocked (The Crowning with Thorns).* Wood. 0·735 m.× 0·59 m. (29″× 23$\frac{1}{4}$″) 189

BOTH, JAN, 1618(?)–1652: *A View on the Tiber, near the Ripa Grande, Rome* (?).
Wood. 0·421 m.× 0·550 m. (16$\frac{9}{16}$″× 21$\frac{5}{8}$″) 296

BOTTICELLI, SANDRO, *c.* 1445–1510: *Venus and Mars.*
Wood. 0·69 m.× 1·735 m. (27$\frac{1}{4}$″× 68$\frac{1}{4}$″) 105
Portrait of a Young Man. Wood. 0·375 m.× 0·282 m. (14$\frac{3}{4}$″× 11$\frac{1}{8}$″) 106
Mystic Nativity. Canvas. 1·085 m.× 0·75 m. (42$\frac{3}{4}$″× 29$\frac{1}{2}$″) 275

BOUCHER, FRANÇOIS, 1703–1770: *Pan and Syrinx.*
Canvas. 0·325 m.× 0·415 m. (12$\frac{3}{4}$″× 16$\frac{1}{2}$″) 301

BOUTS, DIERIC, living *c.* 1448, died 1475: *The Entombment.*
Cotton. 0·90 m.× 0·74 m. (35$\frac{1}{2}$″× 29$\frac{1}{4}$″) 145
The Virgin and Child. Wood. 0·37 m.× 0·275 m. (14$\frac{5}{8}$″× 10$\frac{7}{8}$″) 281
Portrait of a Man. Wood. 0·315 m.× 0·205 m. (12$\frac{1}{2}$″× 8″) 281

BRAMANTINO, active 1503–1536: *The Adoration of the Kings.*
Wood. 0·57 m.× 0·55 m. (22$\frac{3}{8}$″× 21$\frac{5}{8}$″) 280

BRONZINO (AGNOLO DI COSIMO), 1503–1572: *An Allegory of Time and Love.*
Wood. 1·46 m.× 1·16 m. (57$\frac{1}{2}$″× 45$\frac{3}{4}$″) 170
Portrait of Piero de' Medici ('The Gouty').
Wood. 0·58 m.× 0·45 m. (23″× 17$\frac{3}{4}$″) 285

BRUEGEL THE ELDER, PIETER, active 1551–1569: *The Adoration of the Kings.*
Wood. 1·11 m.× 0·835 m. (43$\frac{3}{4}$″× 32$\frac{3}{4}$″) 190

BRUGGHEN, HENDRICK TER, 1588(?)–1629:
Jacob reproaching Laban for giving him Leah in place of Rachel (?).
Canvas. 0·975 m.× 1·143 m. (38$\frac{3}{8}$″× 45″) 294

BUONARROTI see MICHELANGELO

CAMPIN, ROBERT, 1378/9–1444: *The Virgin and Child before a Fire-Screen.*
Wood. 0·635 m.× 0·49 m. (25″× 19$\frac{1}{4}$″) 132
A Man. Wood. 0·407 m.× 0·279 m. (16″× 11″) 280
A Woman. Wood. 0·407 m.× 0·279 m. (16″× 11″) 280

CANALETTO, 1697–1768: *Venice: Campo S. Vidal and S. Maria della Carità ('The Stonemason's Yard').*
Canvas. 1·238 m.× 1·629 m. (48$\frac{3}{4}$″× 64$\frac{1}{4}$″) 185
Venice: Piazza S. Marco and the Colonnade of the Procuratie Nuove.
Canvas. 0·464 m.× 0·38 m. (18$\frac{1}{4}$″× 15″) 290

CAPPELLE, JAN VAN DE, *c.* 1623/5–1679: *A Dutch Yacht firing a Salute as a Barge pulls away, and Many Small Vessels at Anchor.*
Wood. 0·855 m.× 1·145 m. (33⅝″× 45″) 297

CARAVAGGIO, 1573–1610: *The Supper at Emmaus.*
Canvas. 1·39 m.× 1·95 m. (55″× 77½″) 201

CARPACCIO, VITTORE, active 1490–1523/6: *St Ursula taking leave of her Father(?).*
Wood. 0·75 m.× 0·885 m. (29½″× 35″) 279

CATENA, VINCENZO, active 1506–1531: *St Jerome in his Study.*
Canvas. 0·75 m.× 0·98 m. (29⅞″× 38¾″) 285
A Warrior adoring the Infant Christ.
Canvas. 1·55 m.× 2·63 m. (61⅛″× 103¾″) 285

CÉZANNE, PAUL, 1839–1906: *La Vieille au Chapelet.*
Canvas. 0·81 m.× 0·655 m. (31¾″× 25¾″) 257

CHAMPAIGNE, PHILIPPE DE, 1602–1674: *Triple Portrait of Richelieu.*
Canvas. 0·58 m.× 0·72 m. (23″× 28½″) 300

CHARDIN, JEAN-BAPTISTE-SIMÉON, 1699–1779: *The Young Schoolmistress.*
Canvas. 0·615 m.× 0·665 m. (24½″× 26¼″) 238
The House of Cards. Canvas. 0·60 m.× 0·72 m. (23¾″× 28¼″) 300

CHRISTUS, PETRUS, active 1442(?)–1472/3: *Portrait of a Young Man.*
Wood. 0·355 m.× 0·263 m. (14″× 10⅜″) 280

CIMA DA CONEGLIANO, GIOVANNI BATTISTA, 1459/60–1517/18: *St Jerome in a Landscape.* Wood. 0·32 m.× 0·255 m. (12⅝″× 10″) 125

CLAUDE LORRAIN, 1600–1682: *Landscape: Cephalus and Procris reunited by Diana.*
Canvas. 1·02 m.× 1·32 m. (40″× 52″) 234
The Marriage of Isaac and Rebekah ('The Mill')
Canvas. 1·49 m.× 1·97 m. (58¾″× 77½″) 300
Seaport: The Embarkation of the Queen of Sheba.
Canvas. 1·485 m.× 1·94 m. (58½″× 76¼″) approx. 300

CONSTABLE, JOHN, 1776–1837: *Weymouth Bay.*
Canvas. 0·53 m.× 0·75 m. (21″× 29½″) 270
The Hay-Wain. Canvas. 1·305 m.× 1·855 m. (51¼″× 73″) 304
The Cornfield. Canvas. 1·43 m.× 1·22 m. (56¼″× 48″) 304
Salisbury Cathedral and Archdeacon Fisher's House from the River.
Canvas. 0·525 m.× 0·77 m. (20¾″× 30¼″) 304

COROT, JEAN-BAPTISTE-CAMILLE, 1796–1875: *Avignon from the West.*
Canvas. 0·34 m.× 0·73 m. (13¼″× 28¾″) 301
A Horseman (M. Pivot) in a Wood.
Canvas. 0·39 m.× 0·30 m. (15¾″× 11¾″) 301

CORREGGIO (ANTONIO ALLEGRI), *c.* 1489–1534: *'The Madonna of the Basket'.*
Wood. 0·33 m.× 0·25 m. (13¼″× 9⅞″) 169
'Ecce Homo'. Wood. 1·003 m.× 0·788 m. (39½″× 31″) 284
Mercury instructing Cupid before Venus ('The School of Love').
Canvas. 1·55 m.× 0·915 m. (61¼″× 36″) 284

COSSA, FRANCESCO DEL, *c.* 1435– *c.* 1477: *St Vincent Ferrer*(?).
Wood. 1·535 m.× 0·60 m. (60½″× 23½″) 277

COSTA, LORENZO, 1459/60–1535: *A Concert.*
Wood. 0·95 m.× 0·75 m. (37½″× 29¾″) 279

COURBET, JEAN-DÉSIRÉ-GUSTAVE, 1819–1877: *Still-Life: Apples and Pomegranate.*
Canvas. 0·445 m.× 0·61 m. (17½″× 24″) 245
La Diligence dans la Neige. Canvas. 1·37 m.× 2·00 m. (54″× 78⅜″) 302

CRANACH THE ELDER, LUCAS, 1472–1553: *Portrait of a Woman.*
Wood. 0·36 m.× 0·251 m. (14⅛″× 9⅞″) 283
Charity. Wood. 0·563 m.× 0·362 m. (22⅜″× 14¼″) 283

CRISTUS see CHRISTUS

CRIVELLI, CARLO, active 1457–1493: *The Annunciation, with St Emidius.*
Canvas. 2·07 m.× 1·465 m. (81½″× 57¾″) 126
The Virgin and Child with St Jerome and St Sebastian. (*The 'Madonna della Rondine'*).
Wood. 1·505 m.× 1·07 m. (59¼″× 42¼″) 277
Pietà. Poplar. 0·725 m.× 0·555 m. (28½″× 21¾″) 277

CUYP, AELBERT, 1620–1691: *A Herdsman with Five Cows by a River.*
Wood. 0·454 m.× 0·740 m. (17⅞″× 29⅛″) 222
A Hilly River Landscape with a Horseman talking to a Shepherdess.
Canvas. 1·35 m.× 2·015 m. (53¼″× 78¾″) 296

DAUMIER, HONORÉ-VICTORIN, 1808–1879: *Don Quixote and Sancho Panza.*
Wood. 0·405 m.× 0·64 m. (15⅞″× 25¼″) 301

DAVID, GERARD, active 1484–1523: *The Deposition.*
Wood. 0·63 m.× 0·62 m. (24¾″× 24½″) 146
The Adoration of the Kings. Wood. 0·595 m.× 0·585 m. (23½″× 23″) 281
The Virgin and Child with Saints and Donor.
Wood. 1·06 m.× 1·44 m. (41¾″× 56¾″) 281

DEGAS, HILAIRE-GERMAIN-EDGAR, 1834–1917: *Combing the Hair.*
Canvas. 1·14 m.× 1·46 m. (45″× 57½″) 250
Bains de Mer; Petite Fille Peignée par sa Bonne.
Paper on canvas. 0·47 m.× 0·825 m. (18½″× 32½″) 302
La La à la Cirque Fernando, Paris.
Canvas. 1·17 m.× 0·775 m. (46″× 30½″) 302

DELACROIX, FERDINAND-VICTOR-EUGÈNE, 1798–1863: *Baron Schwiter.*
Canvas. 2·18 m.× 1·435 m. (85¾″× 56½″) 242
Ovid among the Scythians. Canvas. 0·88 m.× 1·30 m. (34½″× 51¼″) 301

DOSSO DOSSI (GIOVANNI DI LUTERI), active 1512–1542:
The Adoration of the Kings. Wood. 0·84 m.× 1·07 m. (33½″× 42½″) 285

DUBBELS, HENDRICK, 1621(?)–1676(?): *A Dutch Yacht and other Vessels becalmed
near the Shore.* Canvas. 0·483 m.× 0·481 m. (19″× 18¹⁵⁄₁₆″) 296

DUCCIO, active 1278–1319: *The Transfiguration.*
Wood. 0·44 m.×0·46 m. (17⅜″×18⅛″) — 81
The Virgin and Child with Saints.
Wood. 0·425 m.×0·345 m. (16¾″×13½″) — 273
The Annunciation. Wood. 0·43 m.×0·44 m. (17″×17¼″) — 273

DÜRER, ALBRECHT, 1471–1528: *The Painter's Father.*
Wood. 0·51 m.×0·39 m. (20 1/16″×15⅜″) — 154

DÜRER, STYLE OF: *The Madonna with the Iris.*
Wood. 1·492 m.×1·172 m. (58¾″×46½″) — 283

DYCK, SIR ANTHONY VAN, 1599–1641: *Cornelius van der Geest.*
Wood. 0·375 m.×0·32 m. (14¾″×12½″) — 198
The Virgin and Child Adored by the Abbé Scaglia.
Canvas. 1·07 m.×1·21 m. (42″×47½″) — 292
Charles I on Horseback. Canvas. 3·65 m.×2·89 m. (144″×114″) — 292
The First Earl of Denbigh. Canvas. 2·475 m.×1·485 m. (97½″×58½″) — 292

EYCK, JAN VAN, active 1422–1441:
The Marriage of Giovanni(?) Arnolfini and Giovanna Cenami(?).
Wood. 0·818 m.×0·597 m. (32¼″×23½″) — 134
A Man in a Turban. Wood. 0·257 m.×0·19 m. (10⅛″×7½″) — 280
Portrait of a Young Man. Wood. 0·334 m.×0·19 m. (13⅛″×7½″) — 280

FABRITIUS, CAREL, 1622–1654: *A View in Delft, with a Musical Instrument Seller's*
Stall. Canvas on wood. 0·155 m.×0·316 m. (6 1/16″×12 7/16″) — 297

FOPPA, VINCENZO, active 1456–1515/16: *The Adoration of the Kings.*
Wood. 2·39 m.×2·105 m. (94″×83″) — 277

FRANCESCA see PIERO DELLA FRANCESCA

FRANCIA, FRANCESCO, c. 1450–1517/18:
The Virgin and Child with St Anne and other Saints.
Canvas (transferred from wood). 1·95 m.×1·805 m. (76¾″×71″) — 277

FRENCH(?) SCHOOL, c. 1395: *Richard II presented to the Virgin and Child by his*
Patron Saints ('The Wilton Diptych').
Wood, two panels, each 0·46 m.×0·29 m. (18″×11½″) — 141

GADDI, AGNOLO, active 1369–1396: *The Coronation of the Virgin.*
Wood. 1·82 m.×0·94 m. (71¾″×37″) — 273

GAINSBOROUGH, THOMAS, 1727–1788: *The Painter's Daughters teasing a Cat.*
Canvas. 0·755 m.×0·625 m. (29¾″×24¾″) — 262
The Watering-Place. Canvas. 1·47 m.×1·80 m. (58″×71″) — 265
The Morning Walk. Canvas. 2·36 m.×1·79 m. (93″×70½″) — 266
Gainsborough's Forest. ('Cornard Wood').
Canvas. 1·22 m.×1·55 m. (48″×61″) — 303
Mrs Siddons. Canvas. 1·26 m.×0·995 m. (49¾″×39¼″) — 303
Mr and Mrs Robert Andrews. Canvas. 0·69 m.×1·19 m. (27½″×47″) — 304
Dr Ralph Schomberg. Canvas. 2·33 m.×1·535 m. (91¾″×60½″) — 304

GELLÉE see CLAUDE

GEROLAMO DAI LIBRI, c. 1474–1555(?): *The Virgin and Child with St Anne.*
 Canvas. 1·58 m.×0·94 m. (62¼″×37″) 279

GIORGIONE, 1477–1510: *The Adoration of the Magi.*
 Wood. 0·29 m.×0·81 m. (11¾″×32″) *173*

GIOTTO, 1266(?)–1337: *Pentecost.* Wood. 0·455 m.×0·44 m. (18″×17¼″) 273

GIOVANNI DI PAOLO, active 1420–1482: *St John the Baptist retiring to the Desert.*
 Wood. 0·31 m.×0·385 m. (12¼″×15¼″) 274
 The Baptism of Christ. Wood. 0·31 m.×0·445 m. (12⅝″×17½″) 274

GOSSAERT, JAN, called MABUSE, active 1503–c. 1533(?):
 A Little Girl (Jacqueline de Bourgogne(?)).
 Wood. 0·38 m.×0·29 m. (15″×11⅜″) *148*
 The Adoration of the Kings. Wood. 1·77 m.×1·61 m. (69¾″×63½″) 282
 An Elderly Couple. Vellum(?) 0·455 m.×0·67 m. (18″×26½″) 282

GOYA, FRANCISCO DE, 1746–1828: *Portrait of the Duke of Wellington.*
 Canvas. 0·603 m.×0·515 m. (23¾″×20¼″) *209*
 A scene from 'El Hechizado por Fuerza'.
 Canvas. 0·425 m.×0·308 m. (16¾″×12⅛″) 293

GOYEN, JAN VAN, 1596–1656: *A Scene on the Ice.*
 Wood. 0·82 m.×1·12 m. (10″×13¼″) 294

EL GRECO, 1541–1614: *Christ driving the Traders from the Temple.*
 Canvas. 1·063 m.×1·297 m. (41⅞″×51⅛″) *202*
 The Adoration of the Name of Jesus.
 Wood. 0·578 m.×0·348 m. (22¾″×13 11/16″) 292

GUARDI, FRANCESCO, 1712–1793: *The Doge's Palace, Venice.*
 Canvas. 0·581 m.×0·764 m. (22⅞″×30 1/10″) *186*
 A Caprice with Ruins on the Seashore.
 Canvas. 0·368 m.×0·261 m. (14½″×10¼″) 290
 An Architectural Caprice. Canvas. 0·221 m.×0·172 m. (8⅗″×6¾″) 290

GUERCINO, 1591–1666: *Angels weeping over the Dead Christ.*
 Copper. 0·36 m.×0·44 m. (14½″×17½″) 299

HALS, DIRCK, 1591–1656: *A Party of Young Men and Women at Table.*
 Wood. 0·280 m.×0·388 m. (11″×15¼″) 294

HALS, FRANS, c. 1580(?)–1666: *Portrait of a Man Holding Gloves.*
 Canvas. 0·785 m.×0·673 m. (30⅞″×26½″) *210*
 Portrait of a Middle-aged Woman with Hands Folded.
 Canvas. 0·614 m.×0·470 m. (24⅛″×18¾″) 294

HOBBEMA, MEIJNDERT, 1638–1709: *The Avenue, Middelharnis.*
 Canvas. 1·035 m.×1·41 m. (40¾″×55½″) *230*
 The Ruins of Brederode Castle. Canvas. 0·820 m.×1·06 m. (32¼″×41¼″) 298
 A View of the Haarlem Lock and the Herring-packers' Tower, Amsterdam.
 Canvas. 0·77 m.×0·98 m. (30¼″×38⅝″) 298

HOGARTH, WILLIAM, 1697–1764: *The Shrimp Girl.*
Canvas. 0·635 m.× 0·525 m. (25″× 20¾″) 258
Marriage à la Mode: Shortly After the Marriage.
Canvas. 0·70 m.× 0·91 m. (27½″× 35¾″) 303

HOLBEIN THE YOUNGER, HANS, 1497/8–1543: *Jean de Dinteville and Georges de
Selve ('The Ambassadors').* Wood. 2·07 m.× 2·095 m. (81½″× 82½″) 159
Christina of Denmark, Duchess of Milan.
Wood. 1·79 m.× 0·825 m. (70½″× 32½″) 283

HONTHORST, GERRIT VAN, 1590–1656: *Christ before the High Priest.*
Canvas. 2·72 m.× 1·83 m. (106″× 72″) 294

HOOGH, PIETER DE, 1629(?)–after 1684(?):
An Interior with a Woman drinking with two Men, and a Maidservant.
Canvas. 0·737 m. × 0·646 m. (29″× 25 7/16″) 229
The Courtyard of a House in Delft.
Canvas. 0·735 m.× 0·600 m. (28 15/16″× 23 5/8″) 297
A Woman and her Maid in a Courtyard.
Canvas. 0·737 m.× 0·626 m. (29″× 24⅝″) 297

INGRES, JEAN-AUGUSTE-DOMINIQUE, 1780–1867: *Madame Moitessier seated.*
Canvas. 1·20 m.× 0·92 m. (47¼″× 36¼″) 241
Angelica saved by Ruggiero. Canvas. 0·475 m.× 0·395 m. (18¾″× 15½″) 301

JACOMETTO VENEZIANO, active c. 1422–c. 1498: *Portrait of a Boy.*
Wood. 0·23 m.× 0·195 m. (9″× 7¾″) 279

JORDAENS, JACOB, 1593–1678: *Portrait of a Man and Woman.*
Canvas. 2·15 m.× 1·90 m. (84½″× 74¾″) 291

KONINCK, PHILIPS, 1619–1688: *An Extensive Landscape with a Hawking Party.*
Canvas. 1·325 m.× 1·605 m. (52¼″× 63⅛″) 218

LANCRET, NICOLAS, 1690–1743: *The Four Ages of Man: Youth (L'Adolescence).*
Canvas. 0·33 m.× 0·445 m. (13″× 17½″) 300

LEONARDO DA VINCI, 1452–1519: *The Virgin of the Rocks.*
Wood. 1·895 m.× 1·20 m. (74⅝″× 47¼″) 117

LIBRI see GEROLAMO DAI LIBRI

LIPPI, FRA FILIPPO, c. 1406(?)–1469: *The Annunciation.*
Wood. 0·685 m.× 1·52 m. (27″× 60″) 97

LOCHNER, STEFAN, c. 1400–1451: *St Matthew, St Catherine of Alexandria and
St John the Evangelist.* Wood. 0·686 m.× 0·581 m. (27″× 22⅞″) 282

LONGHI, PIETRO, 1702–1785: *Exhibition of a Rhinoceros at Venice.*
Canvas. 0·604 m.× 0·470 m. (23¾″× 18½″) 290

LORENZO MONACO, DON, before 1372–c. 1422: *The Coronation of the Virgin.*
Wood. 2·17 m.× 1·15 m. (85½″× 45½″) 274

LORRAIN see CLAUDE

LOTTO, LORENZO, c. 1480–1556/7: *The Protonotary Apostolic, Giovanni Giuliano.*
Canvas. 0·94 m.× 0·714 m. (37″× 28⅛″) 287
Family Group. Canvas. 1·149 m.× 1·397 m. (45¼″× 55″) 287
A Lady as Lucretia. Canvas. 0·959 m.× 1·105 m. (37¾″× 43½″) 287

LUINI, BERNARDINO, active 1512–1532: *The Virgin and Child with St John.*
Wood. 0·885 m.× 0·66 m. (34¾″× 26″) 280

MABUSE see GOSSAERT, JAN

MAINERI, GIAN FRANCESCO DE, active 1489–1506
and COSTA, LORENZO, 1459/60–1535: *Virgin and Child with Saints.*
Wood. 2·47 m.× 1·63 m. (97¼″× 64½″) 279

MANET, ÉDOUARD, 1832–1883: *La Musique aux Tuileries.*
Canvas. 0·76 m.× 1·18 m. (30″× 46½″) *254*
Eva Gonzalès. Canvas. 1·91 m.× 1·33 m. (75¼″× 52½″) 302
The Waitress ('La Servante de Bocks').
Canvas. 0·975 m.× 0·775 m. (38¼″× 30½″) 302

MANTEGNA, ANDREA, c. 1430/1–1506: *The Virgin and Child with the Magdalen and
St John the Baptist.* Canvas. 1·36 m.× 1·14 m. (53¾″× 45″) *128*
The Agony in the Garden. Wood. 0·63 m.× 0·80 m. (24¾″× 31½″) 276
Samson and Delilah. Canvas(?). 0·47 m.× 0·37 m. (18½″× 14½″) 276

MARGARITO OF AREZZO, active 1262(?): *The Virgin and Child Enthroned, with
Scenes of the Nativity and the Lives of the Saints.*
Wood. 0·76 m.× 1·69 m. (30″× 66½″) 273

MASACCIO, 1401–1427/9: *The Virgin and Child with Angels.*
Wood. 1·355 m.× 0·73 m. (53¼″× 28¾″) *94*

MASOLINO, c. 1383–1432(?): *St John the Baptist and St Jerome.*
Wood. 1·14 m.× 0·55 m. (45″× 21½″) *90*

MASSYS, QUINTEN, 1465/6–1530: *The Virgin and Child.*
Wood. 0·64 m.× 0·44 m. (25″× 17½″) 281
The Virgin and Child with St Barbara(?) and St Catherine.
0·93 m.× 1·10 m. (36½″× 43¼″) 282

MASTER OF ST BARTHOLOMEW, active late 15th, early 16th C.: *St Peter and
St Dorothy.* Wood. 1·255 m.× 0·71 m. (49½″× 27½″) 283

MASTER OF LIESBORN, active c. 1465: *The Presentation in the Temple.*
Canvas (transferred from panel). 0·985 m.× 0·702 m. (38¾″× 27⅝″) 283

MASTER OF THE LIFE OF THE VIRGIN, active c. 1463–1480: *The Conversion of
St Hubert.* Wood. 1·24 m.× 0·832 m. (48¾″× 32¾″) *152*
The Presentation in the Temple. Panel. 0·84 m.× 1·085 m. (33″× 42¾″) 282
The Mass of St Hubert.
Canvas (transferred from wood). 1·23 m.× 0·83 m. (48½″× 32¾″) 283

MASTER OF MÉRODE see CAMPIN

MASTER OF SAN FRANCESCO, active 1272: *The Crucifix.*
0·92 m.×0·70 m. (36⅛"×27⅝") *83*

MATSYS see MASSYS

MATTEO DI GIOVANNI, active 1452–1495: *St Sebastian.*
Wood. 1·265 m.×0·60 m. (49¾"×23½") *92*
The Assumption of the Virgin. Wood. 3·31 m.×1·73 m. (130½"×68½") *275*

MEMLINC, HANS, active 1465–1494: *St John the Baptist and St Lawrence.*
Wood. Each 0·57 m.×0·17 m. (22½"×6¾") *143*
The Virgin and Child with Saints ('The Donne Triptych'). Wood.
Centre 0·69 m.×0·71 m. (27"×28"), each wing 0·69 m.×0·31 m. (27"×12") *281*

METSU, GABRIEL, 1629–1667: *A Man and Woman seated by a Virginal.*
Wood. 0·384 m.×0·322 m. (15⅛"×12¹¹⁄₁₆") *297*

METSYS see MASSYS

MICHELANGELO (MICHELANGELO BUONARROTI), 1475–1564: *The Entombment.*
Panel. 1·61 m.×1·49 m. (63⅔"×59") *162*
Madonna and Child with St John and Angels.
Panel. 1·05 m.×0·76 m. (41½"×30¼") *284*

MONET, CLAUDE-OSCAR, 1840–1926: *Vétheuil, Sunshine and Snow.*
Canvas. 0·595 m.×0·81 m. (23½"×31¾") *253*
L'inondation. Canvas. 0·71 m.×0·92 m. (28"×36") *302*

MORETTO (ALESSANDRO BONVICINO), 1498–1555: *Conte Sciarra Martinengo
Cesaresco.* Canvas. 1·12 m.×0·98 m. (44"×37") *288*
An Italian Nobleman. Canvas. 1·98 m.×0·88 m. (78"×35") *288*

MORONI, GIAMBATTISTA, 1520/5–1578: *'The Tailor'.*
Canvas. 0·97 m.×0·74 m. (38½"×29½") *288*
An Italian Nobleman. Canvas. 2·0 m.×1·04 m. (79"×41") *288*

MURILLO, BARTOLOMÉ ESTEBAN, 1617–1682: *The Two Trinities ('The Pedroso
Murillo').* Canvas. 2·93 m.×*c.* 2·07 m. (115¼"×*c.* 81½") *206*
Self-portrait. Canvas. 1·220 m.×1·067 m. (48"×42") *293*

NATTIER, JEAN-MARC, 1685–1766: *Manon Balletti.*
Canvas. 0·54 m.×0·455 m. (21¼"×18") *300*

ORCAGNA, STYLE OF: *The Coronation of the Virgin, with Adoring Saints.*
Wood. 2·065 m.×1·135 m. (81½"×44¾") *273*

PACHER, MICHAEL, CIRCLE OF, *c.* 1430/5–1498(?): *The Virgin and Child with
Angels and Saints.* Wood. 0·403 m.×0·394 m. (15⅞"×15½") *283*

PALMA VECCHIO (IACOMO NEGRETI), active 1510–1528: *A Blonde Woman.*
Wood. 0·77 m.×0·64 m. (30½"×25¼") *286*

PATENIER, JOACHIM, ASCRIBED TO, active 1515–*c.* 1524: *St Jerome in a Rocky
Landscape.* Wood. 0·365 m.×0·34 m. (14¼"×13½") *282*

PERRONNEAU, JEAN-BAPTISTE, 1715(?)–1783: *A Girl with a Kitten.*
Pastel on paper. 0·59 m.× 0·50 m. (23¼″× 19⅝″) 301

PERUGINO, PIETRO, active 1478–1523: *St Michael.*
Wood. 1·265 m.× 0·58 m. (49¾″× 22¾″) 114
The Virgin and Child with St Raphael and St Michael.
Wood. Centre panel 1·27 m.× 0·64 m. (50″× 25¼″).
Side panels 1·265 m.× 0·58 m. (49¾″× 22¾″) 275

PESELLINO, *c.* 1422–1457: *The Trinity.* Wood. 1·48 m.× 1·82 m. (72½″× 71½″) 274

PIERO DI COSIMO, *c.* 1482–*c.* 1515: *A Mythological Subject.*
Wood. 0·65 m.× 1·83 m. (25¾″× 72¼″) 123

PIERO DELLA FRANCESCA, active 1439–1492: *The Nativity.*
Wood. 1·245 m.× 1·23 m. (49″× 48¼″) 108
The Baptism of Christ. Wood. 1·67 m.× 1·16 m. (66″× 45¾″) 275

PISANELLO, living 1395–1455(?): *The Virgin and Child with St George and St Anthony Abbot.* Wood. 0·47 m.× 0·29 m. (18½″× 11½″) 276
The Vision of St Eustace(?). Wood. 0·545 m.× 0·655 m. (21½″× 25¾″) 276

PISSARRO, CAMILLE, 1830–1903: *View from Louveciennes.*
Canvas. 0·525 m.× 0·82 m. (20¾″× 32¼″) 249

PITTONI, GIOVANNI BATTISTA, 1687–1767: *The Nativity with God the Father and the Holy Ghost.* Canvas. 2·25 m.× 1·59 m. (88½″× 62¾″) 289

POLLAIUOLO, ANTONIO DEL, *c.* 1432–1498, and PIERO DEL, *c.* 1441–*c.* 1496:
The Martyrdom of St Sebastian.
Wood. 2·915 m.× 2·025 m. (114¾″× 79¾″) 103
Apollo and Daphne. Wood. 0·295 m.× 0·20 m. (11⅝″× 7⅞″) 275

PONTORMO (JACOPO CARUCCI), 1494–1557: *Joseph in Egypt.*
Wood. 0·96 m.× 1·09 m. (38″× 43⅛″) 285

POUSSIN, NICOLAS, 1594(?)–1665: *Bacchanalian Revel before a Term of Pan.*
Canvas. 1·00 m.× 1·425 m. (39¼″× 56¼″) 233
The Adoration of the Shepherds. Canvas. 0·545 m.× 0·71 m. (21½″× 28″) 299
The Adoration of the Golden Calf.
Canvas. 1·54 m.× 2·14 m. (60¾″× 84¼″) 299
Landscape with a Snake. Canvas. 1·195 m.× 1·985 m. (47″× 78¼″) 299

PREDA, GIOVANNI AMBROGIO, *c.* 1455–after 1508: *Francesco di Bartolomeo Archinto(?).* Wood. 0·535 m.× 0·38 m. (21″× 15″) 277

RAPHAEL (RAFFAELLO SANTI), 1483–1520: *St Catherine of Alexandria.*
Wood. 0·715 m.× 0·557 m. (28½″× 21¾″) 165
The Crucifixion. Wood. 2·807 m.× 1·65 m. (110½″× 65″) 284
An Allegory (Vision of a Knight). Wood. 0·171 m.× 0·171 m. (6¾″× 6¾″) 284
Madonna and Child with St John the Baptist and St Nicholas of Bari ('The Ansidei Madonna'). Wood. 2·096 m.× 1·486 m. (82½″× 58½″) 284
Madonna and Child with the Infant Baptist ('The Garvagh Madonna').
Wood. 0·387 m.× 0·237 m. (15¼″× 12⅞″) 284

REMBRANDT VAN RIJN, 1606–1669: *The Woman taken in Adultery.*
Wood. 0·838 m.× 0·654 m. (33″× 25¾″) 213
A Woman bathing in a Stream (Hendrickje Stoffels?).
Wood. 0·618 m.× 0·470 m. (24⁵⁄₁₆″× 18½″) 214
Portrait of the Painter in Old Age; in a Red Jacket with a Fur Collar, his Hands Clasped.
Canvas. 0·860 m.× 0·705 m. (33⅞″× 27¾″) 217
Self-portrait at the age of 34. Canvas. 1·020 m.× 0·800 m. (40⅛″× 31½″) 295
Saskia van Ulenborch in Arcadian Costume.
Canvas. 1·235 m.× 0·975 m. (48⅝″× 38⅜″) 295
The Adoration of the Shepherds.
Canvas. 0·655 m.× 0·550 m. (25¾″× 35⅜″) 295
Portrait of Jacob Trip. Canvas. 1·305 m.× 0·97 m. (51⅜″× 38¼″) 295
Portrait of Margaretha de Geer, Wife of Jacob Trip.
Canvas. 1·305 m.× 0·975 m. (51⅜″× 38⅜″) 295

RENI, GUIDO, 1575–1642: *Lot and his Daughter leaving Sodom.*
Canvas. 1·15 m.× 1·48 m. (45½″× 58½″) 299

RENOIR, PIERRE-AUGUSTE, 1841–1919: *Les Parapluies.*
Canvas. 1·180 m.× 1·15 m. (71″× 45¼″) 246
La Nymphe à la Source. Canvas. 0·665 m.× 1·24 m. (26¼″× 48⅜″) 302

REYNOLDS, SIR JOSHUA, 1723–1792: *Lord Heathfield, Governor of Gibraltar.*
Canvas. 1·42 m.× 1·135 m. (56″× 44¾″) 261
Anne, Countess of Albemarle. Canvas. 1·265 m.× 1·01 m. (49¾″× 39¾″) 303

RIBERA, JUSEPE DE, 1591(?)–1652: *The Lamentation over the Dead Christ.*
Canvas. 1·295 m.× 1·810 m. (51″× 71¼″) 292

ROBERTI, ERCOLE DE', active 1479–1496: *The Adoration of the Shepherds.*
Wood. 0·178 m.× 0·135 m. (7″× 5⅜″) 279
The Dead Christ. Wood. 0·178 m.× 0·135 m. (7″× 5⅜″) 279

ROBUSTI, JACOPO, see TINTORETTO

ROGIER see WEYDEN, ROGIER VAN DER

ROMANO, GIULIO, STUDIO OF, active in Rome and from 1524 at Mantua, d. 1546:
The Infancy of Jupiter. Wood. 1·05 m.× 1·75 m. (41½″× 69″) 285

RUBENS, PETER PAUL, 1577–1640: *The Judgment of Paris.*
Wood. 1·44 m.× 1·90 m. (57″× 75″) 193
Le Chapeau de Paille. Wood. 0·79 m.× 0·545 m. (31″× 21½″) 194
Le Château de Steen. Wood. 1·34 m.× 2·36 m. (53″× 93″) 197
Peace and War. Canvas. 1·98 m.× 2·95 m. (78″× 116″) 290
Thomas, Earl of Arundel. Canvas. 0·66 m.× 0·52 m. (26″× 20¾″) 291
The Watering Place. Wood. 0·98 m.× 1·34 m. (38¾″× 52¾″) 290
The Apotheosis of the Duke of Buckingham.
Wood. 0·64 m.× 0·64 m. (25⅛″× 25⅛″) 291
The Horrors of War. Paper on canvas. 0·49 m.× 0·76 m. (19½″× 30¼″) 291
Sunset Landscape. Wood. 0·495 m.× 0·835 m. (19½″× 32⅞″) 291
The Rape of the Sabines. Wood. 1·695 m.× 2·34 m. (66¾″× 92″) 291

Rusidael, Jacob van, 1628/29(?)–1682: *An Extensive Landscape with Ruins.*
Canvas. 0·340 m.× c. 0·40 m. (13⅜″× 15¾″) 221
An Extensive Landscape with a Ruined Castle and a Village Church.
Canvas. 1·09 m.× 1·46 m. (43″× 57½″) 297
The Shore at Egmond-aan-Zee.
Canvas. 0·537 m.× 0·662 m. (21⅛″× 26 1/16″) 297

Sarto see Andrea del Sarto

Sassetta see Stefano di Giovanni

Savoldo, Giovanni Girolamo, c. 1480–after 1548: *St Jerome.*
Wood. 1·2 m.× 1·59 m. (47½″× 62½″) 287

Sebastiano del Piombo (Sebastiano Luciani), 1485(?)–1547: *Salome.*
Wood. 0·54 m.× 0·43 m. (21⅜″× 17″) 288
The Holy Family. Wood. 0·984 m.× 1·073 m. (38¾″× 42¼″) 288

Signorelli, Luca, 1441(?)–1523: *The Holy Family.*
Wood. 0·81 m.× 0·65 m. (31¾″× 25½″) 275
The Triumph of Chastity: Love Disarmed and Bound.
Fresco, transferred to canvas. 1·255 m.× 1·335 m. (49½″× 52½″) 275

Solari, Andrea, active c. 1495–1524: *Giovanni Cristoforo Longoni.*
Wood. 0·79 m.× 0·605 m. (31¼″× 23¾″) 280

Spagnoletto see Ribera

Steen, Jan, 1625/6–1679: *Skittle Players outside an Inn.*
Wood. 0·335 m.× 0·270 m. (13 3/16″× 10⅝″) 226

Stefano di Giovanni, called Sassetta, 1392(?)–1450: *St Francis renounces his
Earthly Father.* Wood. 0·875 m.× 0·525 m. (34½″× 20¾″) approx. 99
The Whim of the Young St Francis to become a Soldier.
Wood. 0·87 m.× 0·525 m. (34¼″× 20¾″) 274
The Stigmatization of St Francis.
Wood. 0·875 m.× 0·525 m. (34½″× 20¾″) 274

Stubbs, George, 1724–1806: *A Lady and Gentleman in a Carriage.*
Wood. 0·825 m.× 1·015 m. (32½″× 40″) 303

Suardi, Bartolomeo see Bramantino

Teniers the Younger, David, 1610–1690: *Peasants playing Bowls.*
Canvas. 1·19 m.× 1·90 m. (47″× 75″) 292

Terborch see Borch, ter

Terbrugghen see Brugghen, ter

Theotokopoulos, Domenikos, see El Greco

Tiepolo, Giovanni Battista, 1696–1770: *The Trinity appearing to St Clement(?).*
Canvas. 0·69 m.× 0·55 m. (27¼″× 21¾″) 290

Tintoretto (Jacopo Robusti), 1518–1594: *The Origin of the Milky Way.*
Canvas. 1·48 m.× 1·65 m. (58¼″× 65″) 181
St George and the Dragon. Canvas. 1·575 m.× 1·003 m. (62″× 39½″) 288
Portrait of Vincenzo Morosini. Canvas. 0·86 m.× 0·53 m. (33¾″× 20¾″) 288

TITIAN (TIZIANO VECELLIO), 1473–1576: *The Vendramin Family.*
Canvas. 2·06 m.× 3·01 m. (81″× 118½″) 174
Portrait of a Man. Canvas. 0·812 m.×0·663 m. (32″× 26″) 177
'Noli Me Tangere'. Canvas. 1·09 m.×0·91 m. (42¾″×35¾″) 178
Holy Family with a Shepherd. Canvas. 0·99 m.× 1·37 m. (39″× 54¾″) 286
Portrait of a Lady. Canvas. 1·18 m.×0·97 m. (47″× 38″) 286
Bacchus and Ariadne. Canvas. 1·75 m.× 1·9 m. (69″× 75″) 286
Madonna and Child with St John and St Catherine.
Canvas. 1·01 m.× 1·42 m. (39⅝″× 56″) 286
Venus and Adonis. Canvas. 1·77 m.× 1·872 m. (69¾″× 73¾″) 286
The Tribute Money. Canvas. 1·09 m.× 1·015 m. (43″× 40″) 287
Madonna and Child. Canvas. 0·756 m.×0·632 m. (29¾″× 24⅞″) 287

TRECK, JAN, *c.* 1606–1652(?): *Still-Life with a Pewter Flagon and two Ming Bowls.*
Canvas. 0·765 m.×0·638 m. (30⅛″× 25⅛″) 295

TURA, COSIMO, *c.* 1431–1495: *The Virgin and Child Enthroned.*
Wood. 2·39 m.× 1·02 m. (94¼″× 40″) 112
St Jerome. Wood. 1·01 m.×0·57 m. (39¾″× 22½″) 276
An Allegorical Figure. Wood. 1·16 m.×0·71 m. (45¾″× 28″) 276

TURNER, JOSEPH MALLORD WILLIAM, 1775–1851: *The 'Fighting Temeraire'
tugged to her last berth to be broken up.* Canvas. 0·91 m.× 1·22 m. (35¾″× 48″) 269
Calais Pier: An English Packet arriving.
Canvas. 1·72 m.× 2·40 m. (67¾″× 94½″) 304
Sun Rising through Vapour: Fishermen cleaning and selling Fish.
Canvas. 1·345 m.× 1·79 m. (53″× 70½″) 304

UCCELLO, PAOLO, *c.* 1397–1475: *Niccolò (Mauruzi) da Tolentino at the Battle of
San Romano*(?). Wood. 1·82 m.× 3·20 m. (71½″× 126″) 86
St George and the Dragon. Canvas. 0·565 m.×0·74 m. (22¼″× 29¼″) 88

UGOLINO DI NERIO, active 1317–1327: *The Deposition.*
Wood. 0·345 m.×0·525 m. (13½″× 20¾″) 273

VELAZQUEZ, DIEGO, 1599–1660: *The Toilet of Venus ('The Rokeby Venus').*
Canvas. *c.* 1·225 m.× 1·77 m. (*c.* 48¼″× 69¾″) 205
Christ in the House of Martha and Mary.
Canvas. 0·600 m.× 1·035 m. (23⅝″× 40¾″) 293
St John the Evangelist on the Island of Patmos.
Canvas. 1·35 m.× 1·02 m. (53¼″× 40¼″) 293
Christ after the Flagellation contemplated by the Christian Soul.
Canvas. 1·65 m.× 2·06 m. (65″× 81¼″) 293
Philip IV of Spain in Brown and Silver.
Canvas. 1·995 m.× 1·130 m. (78½″× 44½″) 293
Philip IV of Spain: Bust Portrait.
Canvas. 0·641 m.×0·537 m. (25¼″× 21⅛″) 293

VELDE, ESAIAS VAN DE, *c.* 1590(?)–1630: *A Winter Landscape.*
Wood. 0·258 m.×0·304 m. (10 3/16″× 11 15/16″) 294

VELDE THE YOUNGER, WILLEM VAN DE, 1633–1707: *Dutch Vessels close inshore at Low Tide, and Men Bathing.*
Canvas. 0·632 m.× 0·722 m. (24$\frac{7}{8}$″× 28$\frac{3}{8}$″) 298

VERMEER, JOHANNES, 1632–1675: *A Young Woman standing at a Virginal.*
Canvas. 0·517 m.× 0·452 m. (20$\frac{3}{8}$″× 17$\frac{13}{16}$″) 225
A Young Woman seated at a Virginal.
Canvas. 0·515 m.× 0·455 m. (20$\frac{1}{4}$″× 17$\frac{15}{16}$″) 298

VERONESE, PAOLO (PAOLO CALIARI), 1528–1588: *Allegory of Love, I.*
Canvas. 1·89 m.× 1·89 m. (74$\frac{3}{4}$″× 74$\frac{3}{4}$″) *182*
St Helen: Vision of the Cross. Canvas. 1·96 m.× 1·14 m. (77$\frac{1}{2}$″× 45″) 289
The Family of Darius before Alexander.
Canvas. 2·34 m.× 4·73 m. (92$\frac{1}{2}$″× 186$\frac{1}{2}$″) 289
Scorn. Canvas. 1·86 m.× 1·86 m. (73$\frac{1}{2}$″× 73$\frac{1}{2}$″) 289
Happy Union. Canvas. 1·86 m.× 1·86 m. (73$\frac{1}{2}$″× 73$\frac{1}{2}$″) 289
The Adoration of the Magi. Canvas. 3·52 m.× 3·22 m. (139″× 127″) 289

VERROCCHIO, ANDREA DEL, *c.* 1435–1488: *The Virgin and Child with two Angels.*
Wood. 0·965 m.× 0·705 m. (38″× 27$\frac{3}{4}$″) 275

VERROCCHIO, ANDREA DEL, FOLLOWER OF. *Tobias and the Angel.*
Wood. 0·84 m.× 0·66 m. (33″× 26″) *110*

VOUET, SIMON, 1590–1649: *Ceres.* Canvas. 1·47 m.× 1·88 m. (58″× 74″) 299

WATTEAU, ANTOINE, 1684–1721: *'La Gamme d'Amour'.*
Canvas. 0·51 m.× 0·60 m. (20″× 23$\frac{1}{2}$″) 237

WEYDEN, ROGIER VAN DER, *c.* 1399–1464: *Pietà.*
Wood. 0·355 m.× 0·45 m. (14″× 17$\frac{3}{4}$″) *137*
Portrait of a Lady. Wood. 0·365 m.× 0·27 m. (14$\frac{1}{4}$″× 10$\frac{1}{2}$″) *139*
The Magdalen Reading. Wood. 0·615 m.× 0·545 m. (24$\frac{1}{2}$″× 21$\frac{1}{2}$″) 280

WIJNANTS, JAN, *c.* 1630/35–1684: *A Landscape with two Dead Trees, and Two Sportsmen with Dogs on a Sandy Road.*
Wood. 0·290 m.× 0·368 m. (11$\frac{7}{16}$″× 14$\frac{1}{2}$″) 298

WITTE, EMANUEL DE, 1615/17–1691/92: *Adriana van Heusden and her Daughter at the Fish-market in Amsterdam*(?).
Canvas. 0·571 m.× 0·641 m. (22$\frac{1}{2}$″× 25$\frac{1}{4}$″) 295

WOUWERMANS, PHILIPS, 1619–1668: *A View on a Seashore, with Fishwives offering Fish to a Horseman.* Wood. 0·353 m.× 0·412 m. (13$\frac{7}{8}$″× 16$\frac{3}{16}$″) 296

ZOPPO, MARCO, *c.* 1432–*c.* 1478: *Pietà.*
Wood. 0·265 m.× 0·21 m. (10$\frac{3}{8}$″× 8$\frac{1}{4}$″) 276

ZURBARÁN, FRANCISCO DE, 1598–1664: *St Francis in Meditation.*
Canvas. 1·52 m.× 0·99 m. (60″× 39″) 293

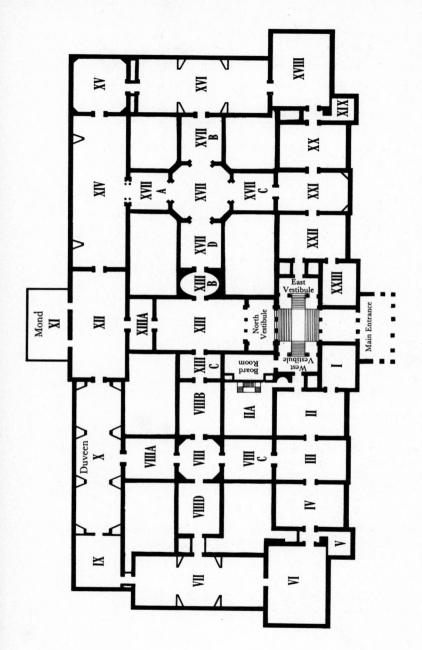

PLAN OF THE GALLERY
Key to plan overleaf

KEY TO PLAN OF THE GALLERY

BELLINI AND GIORGIONE	IX
BRITISH SCHOOL, 18TH/19TH C.	XVI
CRIVELLI	XIIIC
DOMENICHINO FRESCOES	XIIIA
DUTCH SCHOOL, 17TH C.	X, XI, XII, XV
FLEMISH SCHOOL, 17TH C.	XIV, XV
FRENCH SCHOOL, 17TH C.	XVIIB, XX
FRENCH SCHOOL, 18TH C.	XIX
FRENCH SCHOOL, 19TH C.	XXI, XXII, XXIII
GERMAN SCHOOL	VIIIA
THE LEONARDO CARTOON	V
ITALIAN SCHOOL (GOTHIC STYLE)	I, II
ITALIAN SCHOOL, 15TH C. (FLORENCE/CENTRAL ITALY)	III, IV, VIIIC
ITALIAN SCHOOL, 15TH/EARLY 16TH C. (MILAN)	IIA
ITALIAN SCHOOL, 15TH C. (NORTH ITALY)	VIIIB
ITALIAN SCHOOL, 16TH C. (OUTSIDE VENICE)	VI
ITALIAN SCHOOL, 16TH C. (NORTH ITALY)	XIII
ITALIAN SCHOOL, 16TH C. (VENICE)	VII
ITALIAN SCHOOL, 17TH C.	XVIIA, XVIIB, XVIIC
ITALIAN SCHOOL, 18TH C.	XIIIB, XVII, XVIID
NETHERLANDISH SCHOOL, 15TH/16TH C.	VIII, VIIID
SPANISH SCHOOL	XVIII
THE WILTON DIPTYCH	II